English portrait miniatures

English portrait miniatures

Revised Edition

Graham Reynolds

The right of the
University of Cambridge
to print and sell
all manner of books
was granted by
Henry VIII in 1534.
The University has printed
and published continuously
since 1584.

Cambridge University Press

Cambridge
New York New Rochelle
Melbourne Sydney

Published by the Press Syndicate of the University of Cambridge
The Pitt Building, Trumpington Street, Cambridge CB2 1RP
32 East 57th Street, New York, NY 10022, USA
10 Stamford Road, Oakleigh, Melbourne 3166, Australia

First edition published by A. & C. Black, 1952
This edition first published 1988

Printed in Great Britain by the Bath Press, Avon

British Library cataloguing in publication data

Reynolds, Graham
English portrait miniatures. – Rev. ed.
1. Portrait miniatures, English
I. Title
757'.7'0942 MD1337.G7

Library of Congress cataloguing in publication data

Reynolds, Graham.
English portrait miniatures / Graham Reynolds. – Rev. ed.
p. cm.
Bibliography: p.
Includes index.
ISBN 0-521-32625-7
1. Portrait miniatures, English. I. Title.
ND1337.G7R46 1988
751.7'7'0942 – dc 19 87–35925

ISBN 0 521 32625 7

03590409

Contents

Colour plates

Between pp. 108 and 109

Figures

The miniatures are reproduced approximately the same size as the originals with the exception of Figs. 12 and 49, which are reduced in scale. The support in the case of Plates I–XIII and Figures 1–31, 34–48, 51–2 is vellum; in the case of Plates XIV–XIX and Figures 56 and 65–118 it is ivory. Figure 32 is painted in oil on copper and Figures 33, 49–50 and 57–64 are enamels.

Preface

The first edition of this survey of English miniature painting was published in 1952. I then wrote in the Preface that it was time for a new attempt to tell the story of this characteristically native art since so many new discoveries about its practitioners had been made during the preceding forty years. Now, thirty-five years later, there is again a need to bring the story up-to-date by incorporating the fruits of recent research. An ever increasing interest in the subject has led to a more searching investigation of the records and a closer study of the miniatures themselves, with the result that certain sections of its history have been transformed. This is especially so for the first two centuries. We have now a clearer idea of the birth of portrait miniature painting in the 1520s. Luke Hornebolte has been rediscovered and provided with an impressive list of productions. Vital additions have been made to the biographies of Hilliard and Oliver. Coming to the seventeenth century, 'Laurence Crosse' has been found to be a chimera, and the works formerly believed to be by him are now assigned to Peter Cross. The gravest doubts have been cast on the existence of the presumed D. Gibson, who seems in all probability to be identical with the dwarf Richard Gibson. These and many other advances in knowledge have made it necessary for me to rewrite the first nine chapters of the book almost in their entirety.

The seemingly inexhaustible reserve of fine miniatures from the period of increased popularity of the art which began in the second half of the eighteenth century has ensured that the material dealt with in the later section of this survey is far more frequently encountered. Yet it has not been necessary to revise the last seven chapters so drastically. I believe this is not due to any lack of diligence on the part of scholars, but is because the preliminary groundwork had been thoroughly undertaken by the pioneering historians such as Dr G. C. Williamson and Basil Long. They found that a number of archives concerning the leading artists were accessible for their enquiries, and had the advantage that the growth of public exhibitions provided a chronological framework of established fact. Accordingly, in bringing the second half of this survey up-to-date I have confined myself to correcting mistakes and altering a few points of emphasis.

It remains the aim of this revised edition to provide as concisely as possible the story of an art which has flourished longer and with greater success in this country than in any other, and which includes amongst its practitioners many of our leading artists:

Holbein, Hilliard, Isaac Oliver, Samuel Cooper, Meyer, Cosway, Ross. Some disparity of scale is inevitable in dealing with its progress throughout four centuries. Up to the middle of the eighteenth century the number of miniaturists was not large, and an almost exhaustive enumeration is practicable. Thereafter the numbers of working miniature painters increased many fold to meet the vastly increased demand. I have therefore dealt at greater length with the chief late eighteenth-century miniaturists: Meyer, Cosway, Smart, Humphry, Engleheart. They set the standard for their contemporaries, though by dealing selectively with the lesser miniaturists as they emerged decade after decade I have done an injustice to many an artist with merit and a distinctive style.

Throughout I have tried to trace the internal developments in the work of the most outstanding artists and the relation of their styles to the movements in large-scale painting. I have also endeavoured to present the history of the art as a continuous process, mainly handed down from one master to his successors, but sometimes renewed by drafts of talent from outside sources.

My obligations to those recent writers who have contributed most to the revision of this edition are summarised in the select bibliography at the end of the book.

GRAHAM REYNOLDS

Chapter 1

The origins of the portrait miniature: Luke Hornebolte, Hans Holbein

The portrait miniature originated in the early years of the sixteenth century, through the junction of two separate streams of tradition. The lengthier tradition was that of the illuminated manuscript, which had a history extending over a thousand years, but was now approaching its close. The other tradition was that of the portrait medal; re-established on antique models barely one hundred years since in Italy, its greatest achievements were already past when the portrait miniature was born and it had little more than another century of active life before it. Of these two tributary causes of the portrait miniature, the contribution of the illuminated manuscript has generally been considered paramount. The medieval limner drew with exquisite finesse on vellum with his transparent water-colours and opaque body-colours; the pages of his books glowed like stained-glass windows; and both the materials and the delicacy of handling were adopted by the first masters of the portrait miniature. But the portraiture of living persons was only a late and incidental adjunct to the illuminated book. Like easel pictures in little, their normal subject-matter was drawn from religious history, mythology or legend. Occasionally, and indeed more frequently toward the close of the great period of illuminations, a donor or a king is portrayed with recognisable fidelity; but such a portrayal is adjusted to the rectangular shape of the page and to the function of the page in the volume of which it is a part.

The medal, on the other hand, was a typical Renaissance revival of an antique art; and the great medallists put into their works a quality at which the ancients rarely aimed, an interest in psychological portraiture reaching far beyond mere fidelity of image. It is no accident that the first and greatest of the Renaissance medallists, Pisanello, who modelled his first portrait medal in 1438, was a painter and interpreted his sitters in pictorial rather than sculptural terms. The medal gained impetus from the interest of the age in personality; it was the first attempt in modern times to produce small portable portraits. From the medal the portrait miniature took, at the outset, its circular form and its size, and its meticulous analysis of the contours and forms of the sitter's face; it was not, however, restricted in colour, as the medal was by its own nature, or obliged through the low relief to show the portrait in profile.

Even nearer than antique medals and cameos to the modern portrait miniature are the small portrait medallions engraved by the Romans in gold under glass in the fourth and fifth centuries of the Christian era. There is no evidence that the miniaturists of the

sixteenth century knew these medallions; if they did so they must have found a complete congruity of feeling and treatment between the expressive linear Roman portraiture and their own.

The earliest separate portrait miniature of the modern age is believed to be Jean Fouquet's self-portrait in enamel, painted about 1460 and now in the Louvre. But this remained an isolated venture, with no immediate successors. The miniature as a detached small portrait in watercolour emerged at almost the same time and in similar circumstances in both France and England in the 1520s. In France an illuminated manuscript in three volumes, *La Guerre Gallique* of *c.* 1519–20, contains all the individual elements which go to make up the constituents of the portrait miniature, and gives evidence of its medallic origins and its emergence from the illumination of books. The title of this seminal manuscript suggests that it is a direct translation of Caesar's *De Bello Gallico* but in fact the text, by Albert Pigghe, is cast as a dialogue between Caesar and Francis I. A parallel is drawn between the two rulers on the strength of the remarkable victory which Francis I had gained at the Battle of Marignano in 1515. These volumes contain three types of illumination which are crucial to the development of the portrait miniature. First, there is a series of rectangular representations of episodes, such as the assassination of Caesar, which are relevant to the text; these characteristic book illustrations are signed by Godefroy de Batave. A second group portrays the Roman emperors in profile; they are hatched in gold against a blue background as small roundels with a clear derivation from coins and medals. The truly revolutionary advance lies in the third series, which is concentrated in the second volume and consists of portraits of the seven most prominent commanders who supported the king at the Battle of Marignano, the *Preux de Marignan*. These are head-and-shoulders, three-quarters-face portraits painted with an illuminator's technique on the vellum page. These too have been given a blue background, and are round, about two inches in diameter, a size which set the norm for the scale of the independent small portrait. Comparison with the original drawings from which they are derived has established that they are by the Court Painter, Jean Clouet, known to his contemporaries as Janet. They are complemented by a portrait roundel of Francis I, a frontispiece to the first volume, which only differs in being in *grisaille* against a blue background.

The *Preux de Marignan* are portrait miniatures in every respect but one: they are not emancipated from the manuscript page. As John Pope-Hennessy has written 'with courage and a pair of scissors we could all of us turn . . . [one of them] . . . into a proper miniature'. But that final courageous step is not known to have been taken in France for another five or six years. Only two independent miniatures by Jean Clouet have so far come to light. The later of them is a roundel in the Metropolitan Museum of Art, New York, of Charles de Cossé, Comte de Brissac, one of the *Preux de Marignan*, some years older than in the manuscript *La Guerre Gallique*, and painted *c.* 1533–5. The earlier is a somewhat larger circular miniature in the Royal Collection, Windsor Castle, representing the Dauphin Francis, son of Francis I. On grounds of style it can be seen to be by the same hand as the *Preux de Marignan*; its dating, which is important in establishing whether it can be the earliest known example of its type, depends on the estimate we make of the age of the child depicted. This has been variously assessed as being

between six and ten years old, giving a date of *c.* 1524–8 for the miniature. This falls within the years for which there is documentary evidence for the existence of two other miniatures. Lockets containing portraits of Francis I and his two sons were sent to Henry VIII by Marguerite, Madame d'Alençon, towards the end of 1526. One of these elaborately decorated lockets contained a portrait of Francis I; it appears that the other locket contained a double portrait of the Dauphin and his brother on the same miniature. The object of this costly gift was to try to persuade Henry VIII to plead with the Emperor Charles V for the release of his sons, who were held as prisoners in Spain after the defeat of Pavia in 1525. We may guess that the miniatures were by Jean Clouet.

Jean Clouet's first independent portrait miniatures are paralleled by almost contemporary examples in England. These were produced, in all reasonable probability, by a member of the Hornebolte family of Ghent. Four members of that family settled for some time in England during the 1520s: Gerard, his wife Margaret, their son Lucas, and their daughter Susanna. The most recent and thorough investigation into the royal accounts and other possible documentary references has shown that there are so many gaps in these records for the relevant years that neither the dates of their arrival nor the order of their coming can at present be determined. For all we know to the contrary they may have arrived together, it has been suggested to escape religious persecution. Gerard is mentioned in Flemish accounts till 1522; nothing more is heard of him till he is found in the service of Henry VIII in 1528. His wife Margaret died here in 1529 and is buried in Fulham church. Gerard is believed to have left England in or after 1538 and to have died on the Continent in 1540 or 1541. Susanna, who was born about 1503, is recorded in Antwerp in 1521, when she sold a religious illumination to Albrecht Dürer; the next news of her finds her in England in 1529 married to John Parker, Yeoman of the Wardrobe. Widowed in 1537 she married again in 1539; she became first gentlewoman to Anne of Cleves and then an attendant to Catherine Parr, dying before July 1554, when her husband John Gilman married again. Her brother Lucas Hornebolte is first recorded receiving payment from Henry VIII in September 1525. A group of some twenty miniatures which can be associated with the Hornebolte family because it shows such strong signs of its origin in the Ghent school of illumination is generally and more specifically assigned to Luke Hornebolte. Although the evidence is only inferential, this conclusion in outline seems the most plausible one, because Luke Hornebolte was longest in the King's service, from at least 1525 till his death in 1544, because in extending his grant as King's Painter Henry VIII spoke of his personal knowledge and admiration for his skill, and because he is by general consent the 'Master Lukas' who, according to Van Mander, taught Holbein the art of limning. It is also noteworthy that he was paid rather more than Holbein: £33 6s. a year as against £30 a year. So it is reasonable to assign the best and mutually consistent limnings in that group to Luke Hornebolte. This enables us to deduce that his arrival in England occurred at the latest in 1524, since the illuminated letter H on letters patent of April 1524 is so close to the miniature portraits of Henry VIII which we are about to discuss that it is almost certainly by the same hand.

As is customary in such legal documents the initial letter of 'Henricus' is made to serve as a calligraphic framework for a portrait of the monarch. On this document the

head-and-shoulders portrait differs entirely in its conception and in its detailed execution from the customary historiated initial portraits of the time. Just as with the *Preux de Marignan* it needs only emancipation from the document to become a conventional portrait miniature. Hornebolte took this decisive step more rapidly than Jean Clouet had done. His first known essays in the new genre consist of four separate portraits of Henry VIII, similar in image and design to that on the legal document but refined so that they can have an independent existence. Two of these miniatures are in the Royal Collection, one is in the Buccleuch Collection and one is in the Fitzwilliam Museum, Cambridge. They vary in showing the King with or without a beard, and in details of the inscriptions, but are of the same year. The most elaborate and therefore prime version is that in the Fitzwilliam Museum, in which the round portrait has been placed in a rectangular surround with angels supporting the intertwined initials of Henry VIII and Katherine of Aragon (Plate I). The inscription which flanks the portrait reads *H R VIII AN° XXXV*. According to whether we choose to interpret this as meaning that the king is in his thirty-fifth year or has attained the age of thirty five this provides a term for the miniature between June 1525 and June 1527. The nice conjunction of this range of dates with that suggested for the earliest miniature by Jean Clouet leaves it an open question whether Hornebolte felt impelled to paint individual miniatures because he had been shown, or the king influenced by, Madame d'Alençon's gift of 1526, or whether he arrived at the idea on his own. The fact of the matter may be that the idea of the miniature portrait was in the air at the time, ready to be discovered independently by artists working on similar lines, just as Newton and Leibnitz had invented the differential calculus, or Adams and Leverrier had deduced the orbit of the unknown planet Neptune, without plagiarizing one another's ideas.

Whatever the truth about priority, if any, in this development, it is incontestable that the portrait miniature took earlier and stronger hold in England than in France. At present only the two independent miniatures by Jean Clouet already described are known. His son François Clouet, also known as Janet, to the confusion of the records, succeeded him as Court Painter in 1540. From then till his death in 1572 he painted a bare handful of finely contrived miniatures, and scarcely any further examples are assigned to his contemporaries. But Luke Hornebolte and his successors produced the large, almost continuous, range of works discussed in this and the two following chapters, thus creating a tradition which continued and grew till the late nineteenth century.

The utility of miniatures as gifts and instruments of diplomacy was appreciated at an early stage in England. The year after he had received Madame d'Alençon's lockets Henry VIII reciprocated with gifts to Francis I of small portraits of himself and the Princess Mary. We are not specifically told that they were miniatures, but in the context they may well have been. Their reception was certainly a gracious one. It was reported that the French king liked them 'singularly well, and at the first sight of Henry's "phisonamye" took off his bonnet, saying he knew well that face, and further, "Je prie Dieu qu'il luy done bone vie et longue". He then looked at the Princess's, standing in contemplation and beholding thereof a great while, and gave much co[mmendation] and laud unto the same.' When Thomas Cromwell was rising in the King's favour he received as the King's New Year Gift for 1532 'A ring with a ruby; and a box with the

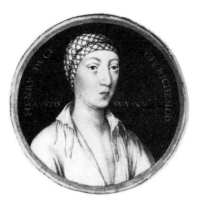

1　Luke Hornebolte,
Henry, Duke of Richmond

images of the French King's children', the latter probably one of the very miniatures which had been sent by Francis I to the king in 1526. Later that year Cromwell became Master of the Jewel House.

As has been remarked, the terms in which in 1544 Henry VIII renewed his grant to Luke Hornebolte of the title of King's Painter suggest a warm personal relationship. The king says, 'For a long time I have been acquainted not only by reports from others but also from personal knowledge with the science and experience in the pictorial art of Lucas Hornebolte', a phrase which suggests that Henry VIII sat for him more than once, and possibly watched him painting his illegitimate son Henry, Duke of Richmond, as well as his queens. The score of early Tudor miniatures which have been assembled round the portraits of Henry VIII described above, and assigned to Hornebolte on grounds of style, display sufficient variety of quality to justify a cautious approach before we attribute all of them to one master. Gerard is not known to have painted portrait miniatures, but Luke's sister Susanna enjoyed a Continental repute as a limner; Albrecht Dürer thought that the religious miniature – a Salvator Mundi – which he bought from her was remarkable for a girl of eighteen. Some of her work may be amongst the Hornebolte school pieces, and since Hilliard recorded that 'yet had the King [Henry VIII] in wages for limning divers others' there may be other hands to be discerned in the groups. We can, however, define a style for Luke Hornebolte from some of the most consistent examples: for instance, the four miniatures of Henry VIII, and the portrait of the king's illegitimate son, Henry, Duke of Richmond in the Royal Collection (Fig. 1). Many of the characteristics apparent in this set were to dominate English miniature painting until the end of the seventeenth century. It had been Hornebolte's task to translate the delicate brushwork and subtle tonal gradations of the book illuminators into the compressed format of a small, framed, circular and precious jewel. He painted his portrait miniatures in transparent and opaque watercolours and adopted a head-and-shoulder format. He posed his sitters three-quarter face left or right against a blue background on which he frequently wrote an inscription in gold capitals. His personal touch, defined from the handling of two of the miniatures most

confidently ascribed to him, the Henry VIII in the Fitzwilliam Museum and the Duke of Richmond at Windsor, is relatively broad, and his shadows are softly hatched. His fairly direct lighting gives a sense of flatness to the modelling of the features and the outline of the face merges into the background without a sharp contour. Unlike Clouet he is not known to have made preliminary drawings for his portraits, and for all we know to the contrary they may be *ad vivum*. These aspects were modified and subject to personal reinterpretation during the next two centuries, but remained the basis of portrait miniature painting for as long as they were painted on vellum.

Luke Hornebolte died in 1544, having served the king for over twenty years. His name was almost immediately forgotten, and his achievement as the true founder of the British school of miniatures has only been reconstructed in the last four decades. But a memory of him lingered on for his other great contribution to the national art, as the teacher of limning to Hans Holbein. Carel van Mander, in his biographical 'Het Schilderboek' of 1604, wrote of Holbein: 'With Lukas he kept up mutual acquaintance and intercourse, and learned from him the art of miniature painting, which since then he pursued to such an extent, that in a short time he as far excelled Lukas in drawing, arrangement, understanding, and execution, as the sun surpasses the moon in brightness.' This Master Lukas, it is generally agreed, can be no other than Luke Hornebolte.

Holbein came from a country in which the small medallion-like portrait was cultivated in various forms. Carved roundels in wood or stone were produced, for instance by the 'Meister der Dosenkopfe', and Lucas Cranach painted a small oil roundel of Luther at about the same time, *c*. 1525. Holbein himself had painted a small round portrait in oil on wood of Erasmus before his second visit to England. He is not known to have painted any portrait miniatures properly so-called until that second visit, which began in 1532. Having derived from Luke Hornebolte the technique of painting in watercolour and bodycolour on small roundels of vellum and interpreted these methods in terms of his own style, Holbein produced works which have always been numbered amongst the supreme examples of the art of the miniature painter. There has never been any serious dissent from the opinion quoted from van Mander that 'he as far excelled Lukas [Hornebolte] in drawing, arrangement, understanding, and execution, as the sun surpasses the moon in brightness'. The precise number of extant miniatures which can be ascribed to him has always been a matter of argument, and there is no current consensus. The most recent revisionary estimate credits him with twelve portrait miniatures; with the exercise of a less restrictive judgment this may be increased to nineteen. Fortunately, nine examples about which there is now no debate are either in public collections or otherwise accessible; therefore an understanding of his peculiar excellence can be obtained from established and available works, and these provide the standard from which the authenticity of any newly discovered claimants may be tested. These standard and accessible miniatures by Holbein are, in presumed date order, the *Thomas Wriothesley, Earl of Southampton*, *c*. 1536, *William Roper* (Fig. 2) and *Margaret Roper*, 1536, in the Metropolitan Museum of Art, New York; *Mrs Pemberton* (*c*. 1536–40) (Plate II) and *Anne of Cleves* (1539) (Fig. 3) in the Victoria and Albert Museum. Since by the generosity of Her Majesty the Queen the main treasures in the Royal Library, Windsor Castle, are often on view to the public,

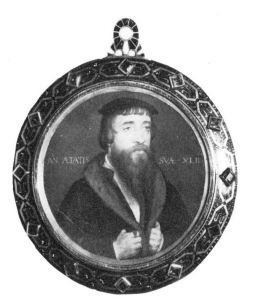

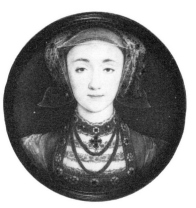

3 Hans Holbein, *Anne of Cleves*

2 Hans Holbein, *William Roper*

to these accessible examples may be added the four Holbein miniatures in her collection, *Elizabeth, Lady Audley, c.* 1538, the presumed portrait of *Catherine Howard, c.* 1540–2, *Henry, Duke of Suffolk,* 1541 and *Charles, Duke of Suffolk,* 1541 (Plate III). These are all prime examples of his style which demonstrate that Holbein's miniature painting, like his full-scale portraiture, is marked by the relentless penetration of his observation and a fidelity which swerves neither toward flattery nor caricature. He places great emphasis on the outline of the face, which in his *Anne of Cleves* approximates to a finely drawn line; and he achieves his modelling by the most subtle of nuances. In spite of the microscopic fineness of his touch the result is not finicky, and has no relation to such contemporary German *tours de force* as the carving of a crucifixion out of a walnut shell, but fully conveys the sense of a living person, narrowly but sympathetically observed. His *Mrs Pemberton,* in the Victoria and Albert Museum, portrays a young woman whose plainness is scarcely relieved by her simple costume of black-and-white materials, and yet there can be no question that this is one of the great portraits of the world. With remarkable objectivity Holbein has not added anything of himself or subtracted from his sitter's image; he has seen her as she appeared in a solemn mood in the cold light of his painting-room.

While the miniatures most acceptably assigned to Hornebolte are of the king and his more immediate family circle, those by Holbein range over a wider group. Such sitters as William Roper, Mrs Pemberton and Lady Audley are relatively obscure members of the court circle. No miniatures of the king by his hand are known, though his Whitehall portrait was the source for a number of miniature copies by other sixteenth-century artists, including Nicholas Hilliard.

His mission to Düren in 1540 to take the portrait of Anne of Cleves was a particularly

delicate one. He had to provide the evidence on which Henry VIII was to decide on his next marriage, after the death of Jane Seymour in 1538. To contemporary observers he appeared to have succeeded well. Dr Wootton wrote to the king while the portrait was awaited 'Your Grace's servant Hanze Albein hathe taken th'effigies of my ladye Anne and the ladye Amalye [her sister, who was also being considered as a possible bride] and hath expressed theyr imaiges verye lyvelye.' But after he had met Anne of Cleves in the flesh Henry could not summon up the will to consummate the marriage.

Some of Holbein's miniatures depend on drawings he had made of the sitters; these include the portraits of Lord Abergavenny (Buccleuch Collection), Lady Audley and Southampton. The drawing for Anne of Cleves was apparently fixed to the panel on which he made the oil painting of her in the Louvre, and so lost. In using drawings as a preliminary stage, Holbein was inclining more towards the practice of Jean Clouet than of Luke Hornebolte; in the main his successors preferred to work *ad vivum* direct from the sitters on to their vellum or ivory support.

Beside his portrait miniatures, numbering between a dozen and a score, Holbein made one subject picture in the limner's technique. This represents *Solomon receiving the Queen of Sheba* and is also in the Royal Library, Windsor Castle. Henry VIII is portrayed as Solomon and the composition symbolises his position as head of the Church. Though a grisaille tinted with blue and gold it resembles the compositions with many figures which Giulio Clovio was producing at the time. Furthermore, it stands at the beginning of a separate, though less powerful, current in British miniature painting, that of the limned history painting. The next important exponent of this genre was Isaac Oliver, but in the early seventeenth century it was replaced by the less original form of limned copies after Old Masters by Peter Oliver, Richard Gibson, Nicholas Dixon and others.

Holbein died in 1543; his mentor Hornebolte in 1544. Having dominated the newly invented art of portrait miniature painting for the best part of twenty years, these two artists were succeeded by a confused period of twenty-five years in which no distinctive figure is to be found. The actual number of known miniatures originating in the years 1545–70 is fairly sparse; almost as many artists are recorded as limners as there are limnings for these years, yet no satisfactory distribution of works among those names has yet been made. Amongst the artists looking for an *œuvre* are Susanna Hornebolte, Luke's sister, who died after 1549; Luke's wife may also have been a miniaturist. John Shute, who died in 1563, and John Bettes senior are mentioned by Richard Haydocke as limners, and William Scrots had the title of King's Limner in 1553. Cornelius Devosse, who was married in London in 1558, and Arthur van Brounckhurst both figure in the early adventures of Nicholas Hilliard and are described as miniature painters. Hans Eworth practised the less influential offshoot of oil painting on a miniature scale, achieving such success with his portrait of Mary I that Charles I reattributed it to Antonio Mor. Nicholas Hilliard refers to an otherwise unrecorded John Bossam when writing 'Yet had the King in wages for limning divers others.'

The name which stands out amongst these hazy indications is that of Levina Teerlinc. As the daughter of Simon Benninck and the grand-daughter of Sanders Benninck she was a descendant of a distinguished family of Flemish illuminators. Her position at

court earned her an annuity of £40, larger than that granted to Hornebolte. Between 1559 and 1576 she gave nine limnings to Queen Elizabeth I as New Year's gifts and received gifts from the queen in return. Her miniature paintings mainly showed the queen with her train of 'many other personages', but three are of the queen alone. The only known miniature which might tally with these descriptions of small pictures with many figures is that of a Maundy ceremony (Beauchamp Collection). It shows a crowded scene, in which the queen prepares to wash the feet of the poor in a setting containing about one hundred people. It is an animated *histoire* in the tradition of book illustration, but since even the largest faces in it are scarcely larger than grains of rice it hardly provides substantial evidence for ascribing more conventionally sized bust-length portrait miniatures to the same artist. Recent attempts to do so have resulted only in linking the work of at least three separate hands under the same hypothetical name.

Chapter 2

Nicholas Hilliard

The deaths of Hornebolte and Holbein were followed shortly after by that of their patron Henry VIII, in 1547. The brief and troubled reigns of his successors Edward VI and Mary I were not distinguished by any powerful influx of oil painters from the Continent. There were one or two flashes of brilliance, like the visit of Antonio Moro to paint Mary I; but portraiture was mainly in the hands of emigrés of limited talent, foremost amongst whom was Hans Eworth, whose work is known from 1549 till 1570. Queen Elizabeth I was so disturbed at the poor quality of the royal images produced early in her reign that she caused Cecil to draft in 1563 a proclamation forbidding the painting or engraving of her portrait until 'some speciall conning payntor might be permitted by access to hir Ma^ty to take ye naturall representation of her Ma^tie'. So far as miniature painting is concerned, these troubled and indecisive years were ended by the emergence of the first native-born artistic genius since the Middle Ages, Nicholas Hilliard. He gave the art which had been introduced and fostered by Hornebolte and Holbein a fresh start and fashioned it into an appropriate visual accompaniment to the literary explosion of the 1570s.

In the past a great deal of attention has been lavished on the influences which might have been supposed to have borne upon his style. How could the strong impress of French mannerism on his basically native vision be accounted for? The earlier discussions of this problem have largely been superseded by important new discoveries about Hilliard's upbringing. He was born in Exeter in 1547, the son of a goldsmith, Richard Hilliard, who was a zealous supporter of the Reformed religion. Around the age of ten Nicholas Hilliard is found in 1557 as a member of the household of John Bodley, a prominent Exeter merchant and militant Protestant, who had fled to Geneva to escape the Marian persecutions. Among the other members of this expatriate household was Thomas Bodley, the future founder of the Bodleian Library, a young man two years older than Nicholas Hilliard. He presumably shared in the humanistic and theological training given in Geneva to Thomas Bodley; he certainly learned the French language. As the son of a goldsmith he would have been very much aware of the great influx of goldsmiths from Rouen and Paris. From them he could have imbibed at an impressionable age the elements of French design in previous metals. That he consorted with them is virtually confirmed by the probability that his own most famous pupil, Isaac Oliver, was the son of one of the emigré goldsmiths from Rouen, Pierre Oliver.

John Bodley obtained leave to return to England in 1559, and it is supposed that Nicholas Hilliard accompanied him to London, rather than returning to Exeter. He produced his two earliest known works in 1560: a small self-portrait (Portland Collection) and a posthumous miniature of the Protector Somerset (Buccleuch Collection). These are both signed and dated and, though evidently immature, show a precocious talent for the art in which he was later to excel. They have other points of interest; he has already mastered the elements of the technique, basically in the application of watercolour to small roundels on vellum with a steady hand and a keen eye for minute detail. Whether he had learned these rudiments before he left Geneva, or acquired them from the examples he found awaiting his interest on his return to England, such as works by Teerlinc, cannot now be determined. And whilst it was fairly natural for an apprentice hand to experiment with a self-portrait, the other miniature, of Somerset, has an additional interest in being the only known authentic portrait of the sitter. It must have been copied from an original by a follower of Holbein; since Somerset was a great promoter of the Protestant cause, such a portrait, now lost, might well have belonged to a household so sympathetic to the Reformed religion as Bodley's.

Shortly after this early exercise in miniature painting Nicholas Hilliard was fully occupied in serving his seven-year apprenticeship to the London goldsmith, Robert Brandon. He was made free of the Goldsmiths' Company in 1569, and always regarded himself as a goldsmith as well as a limner. He had a great enthusiasm for gemstones and undertook a number of commssions for metalwork, notably the design for Queen Elizabeth I's second Great Seal. Toward the end of his life he was as frequently employed by James I on gold portrait medals as on miniatures. But this is a side of his activities which has not as yet attracted so much attention as his miniature painting, the art in which he was recognised in his own time as pre-eminent. Nonetheless his association with the Goldsmiths, who had wealth and influential connections, was important in furthering his career and introducing him into court circles.

Little is known for sure about the progress of his limning during his years of apprenticeship. Writing in 1706 B. Buckeridge recorded that Hilliard had painted Mary Queen of Scots when she was eighteen, that is, around 1560 when he produced his two known juvenilia. It is hard to match this claim with the known movements of the recently widowed queen, who did not at that time set foot in England, unless we are to suppose that this also was a copy of an existing portrait. Certainly Elizabeth I had a miniature of Mary in 1564; she showed it to the Scots ambassador Sir James Melville and kissed it, whereupon he 'adventured to kiss her hand, for the great love evidenced therein to my mistress'. We are on more certain ground with the rectangular miniature portrait of Elizabeth herself in Parliament robes in the Portland Collection. Although there have been some recent and unconvincing attempts to classify this as a copy made in the 1590s of an earlier original there can be little doubt that its style is consistent with a date in the 1560s suggested by the apparent age of the queen. It may be one of the first results of the queen's resolve to allow a 'speciall conning payntor' access to take a 'naturall representation of her' or again, a copy of an existing original. The earliest dated miniature of Hilliard's maturity is of 1571, two years after he had completed his apprenticeship with Robert Brandon. This is a small round portrait of an unidentified man

enriched with an inscription giving the sitter's age of thirty-five and the date 1571 written in gold in the fine Italic hand of which he was a master. The next year he painted a somewhat larger rectangular miniature of a man aged twenty-four in 1572 (Victoria and Albert Museum) in which the full excellence of his developed style is apparent (Plate IV). It shows a possible awareness and personal interpretation of the types of presentation then dominant in Continental portraiture, for instance in the hands of Antonio Mor and François Clouet. The way in which the sitter's black doublet and green ribbon are silhouetted against the blue background with its gold inscription reveals a refined colour sense and an assured feeling for composition. The characteristic signs by which Hilliard's autograph work is recognised are present; the broad treatment of the hair, the delicate modulation of the flesh tones, the sharp linear shadows under the upper eyelids. In the same year he painted his first dated portrait of Queen Elizabeth I (National Portrait Gallery), the forerunner of a score of images in which he sought to combine realism with symbolism and a degree of subservience to the queen's conception of herself. In this royal image he adopted the oval format which was to become the standard shape for miniatures from the late seventeenth century onwards. Although damaged, it is a straightforward unflattering portrayal. Its soft lighting suggests that it may have been painted in the open air, on the occasion when he had a conversation with the queen which he recorded in his treatise 'The Arte of Limning'. Hilliard reports the queen's discrimination between different schools of art and her observation that the Italians (unlike the Flemish) did not make much use of cast shadows in their portraiture. The artist and his patron agreed that 'best to show oneself needeth no shadow of place, but rather the open light'. Accordingly Elizabeth decided to sit for him 'in the open alley of a goodly garden, where no tree was near, nor any shadow at all'.

In 1576 Hilliard married Alice Brandon, a daughter of the goldsmith to whom he had been apprenticed. Shortly afterwards, with the queen's encouragement, he went to France in the train of the newly appointed ambassador, Sir Amyas Paulet. Elizabeth was again considering a marriage with François, Duc d'Alençon, the third son of Catherine de'Medici, and in 1577 Hilliard was employed as a member of his household and painted his portrait in miniature. A number of his finest miniatures were produced during his stay in France, including his own self-portrait (Plate V), and the portraits of his wife Alice (Fig. 4) and his father Richard Hilliard (all in the Victoria and Albert Museum). The knowledge he had acquired of French in Geneva enabled him to move easily in the learned world; he counted Ronsard amongst his friends and was well regarded by the artistic community. But he ran into financial difficulties, a recurring refrain throughout his life, and was forced to delay his return till five months after his first child had been born in London.

Much has been made of this two-year visit in the attempt to account for the supposedly French elements in his method of painting. But most of the characteristics of style in the works painted after his return to England are present in the miniatures of 1572 already described. Some changes in his practice are however attributable to his French sojourn. It was on this visit that he began to add mottoes and emblems to his portraits, following a fashion already established when Castiglione wrote *The Book of*

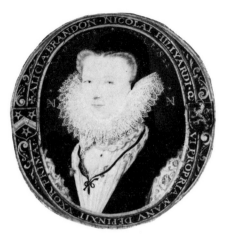

4 Nicholas Hilliard,
Alice Hilliard, aged 22 in 1578

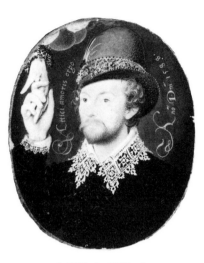

5 Nicholas Hilliard,
A man clasping a hand from a cloud, 1588

the Courtier for the invention of *imprese* in which an image is joined to a phrase to provide a clue to the bearer's identity. Such devices were hard enough to unriddle in their own day, and are now almost entirely obscure. Hilliard first adopted their use in a miniature of 1578, now known only from an engraving, of the young Francis Bacon, who was also attached to the English embassy to France. This he inscribed with the straightforward motto *Si tabula daretur digne, animum, mallem*. Ten years later his meanings have become impenetrable. The miniature of a man clasping a hand from a cloud, of 1588, which exists in two versions (one in the Victoria and Albert Museum (Fig. 5)) is inscribed *Attici amoris ergo*. Classical scholars disagree about the translation, the rendering 'Because of the love of Atticus' being flatly rejected by those who translate it 'Athenians because of love'. The latter rendering has encouraged Professor Leslie Hotson, who has contributed so much of value to the study of Hilliard, to identify the sitter, by no means plausibly, as Shakespeare clasping the hand of Apollo.

Interpretation is even more difficult for Hilliard's most famous miniature, the *Young man against a tree amongst roses* (Victoria and Albert Museum) (Fig. 6). The subject presents all the outward signs of a disconsolate lover encouraged by the roses but pricked by the thorns of love. The motto *Dat poenas laudata fides* at first sight supports this impression. Yet we know now that it comes from a speech in Lucan's *Pharsalia* in which the eunuch Photinus urges that Pompey should be assassinated. The implication is not 'my faithfulness as a lover is praiseworthy although I suffer for it' but 'it is dangerous to persist in loyalty to those who are unlucky'. This does not help the attempted identification on iconographical grounds with Robert Devereux, Earl of Essex, who would hardly have been advocating the assassination of the Queen as early as 1588, the date of the miniature, nor publicly approving of disloyalty to his less fortunate friends at court. Fortunately this uncertainty about the sitter does not affect the acceptance of

this Hilliard miniature as one of the representative masterpieces of English art. Its format, a full-length portrait, draws attention to a second change in the artist's approach after his return from France. This lay in the search for a more ambitious role for the miniature as a whole-length portrait in an appropriate setting and rivalling the compositions of the court oil painters. He seems first to have embarked on this development in his drawings for Queen Elizabeth's second Great Seal, in preparation from 1584 till 1586, and, for a miniature, when painting Robert Dudley, Earl of Leicester, shortly before his death in 1588. He persisted with the form through the 1590s in such elaborate compositions as the miniatures of George Clifford, Earl of Cumberland as Queen's Champion *c.* 1590 (National Maritime Museum, Greenwich), Henry Percy, Earl of Northumberland, as the wizard earl lying in an enclosed garden, and Sir Anthony Mildmay in his tent surrounded by all his soldierly accoutrements.

These large miniature paintings have been christened 'cabinet miniatures' because they may be supposed to take their place amongst other pictures as wall decorations. As such they are different in purpose from the main run of portrait miniatures, small ovals set as jewels which could be worn as a lover's token or sign of loyalty.

After he had expanded his art to these limits in the mid-1590s Hilliard seems to have suffered a reaction. The miniatures which he painted on a small scale after these larger pieces full of detail are often more timid in execution: for instance, a roundel of a young man on the back of which he inscribed a particularly florid signature and the date 1599 (Earl of Leicester's Collection). In these last years of the Elizabethan age he was frequently obliged to paint the queen in idealised youth to consort with her legend as the Virgin Queen. At least fifteen miniatures by Hilliard of Queen Elizabeth are known, but though many show her at the same period of life and even in the same ruff, no two are identical. In those which are most alike in other respects, the jewels which copiously adorn the ruff, the neck and the hair of the Queen are different and differently arranged. Their elegance could hardly be appreciated until the detachment required by a taste for historic costume had been developed. Horace Walpole thought that the massed ornaments with which her portraits are loaded 'leave no more room for a painter's genius that if he had been employed to copy an Indian idol, totally composed of hands and necklaces. A pale Roman nose, a head of hair loaded with crowns and powdered with diamonds, a vast ruff, a vaster fardingale and a bushel of pearls are the features by which everybody knows at once the pictures of Queen Elizabeth.' Or as Princess Charlotte put it more briefly on being shown a Hilliard miniature of Elizabeth I: 'Christ, what a fright.'

After the death of Queen Elizabeth, Hilliard's work loses, apart from a few exceptions, its old freedom and brilliance. His discouraging private circumstances might be considered reason enough for the dryness of the general run of his later miniatures; but it is difficult to resist the further conclusion that the court of James I had a depressing effect upon art, or at least upon Hilliard's art. James kept Hilliard to turning out stereotyped images in miniatures and on medals. He seems to have been content to see himself depicted as mean, ill-favoured and outlandish; and what is stronger evidence of his failure in constructive criticism, he was content to have this image repeated, with little variation, many times over.

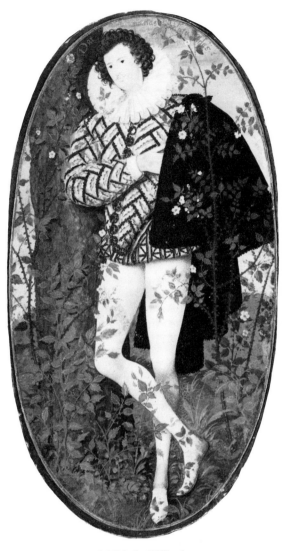

6 Nicholas Hilliard,
A young man leaning against a tree among roses

Hilliard persevered in his work for the King till the end of his life. In 1617 he obtained a monopoly over the engraving of royal portraits in recognition of his 'extraordinary art and skill in drawing, graving and imprinting of pictures and representations of us [James I] and others'. It was a privilege he used to authorise a posthumous portrait engraving of Queen Elizabeth I by Francis Delaram. In the autumn of 1618 he was paid for a miniature of the king delivered, presumably for framing, to the Court Jeweller,

James Heriot. Shortly after this, the last known payment to him for a royal commission, he died, in the first days of 1619, in his seventy-second year.

Sometimes in the midst of these unrewarding duties, which his financial difficulties must have required of him to the distress of his spirit, Hilliard had found in himself the old power, for example, when he painted a miniature of a beautiful young lady with low-bosomed dress and with loosened, bridal hair. Inscribed 'facies mutabilis sed amor stabilis semel missa semp fixa', it has all the poetry of his prime (Fig. 7).

The tally of his recorded miniatures verges upon two hundred; evidence of a large production when we take account of the perishable nature of these small portraits and in view of his other activities as a goldsmith. The range of his sitters extends beyond the notabilities of the court to rich merchants such as Leonard Darr of Devon and William Barbor, a London grocer, to unidentified beauties (Fig. 8), and to individuals in a private station such as the unfortunate John Molle who, when tutor to Lord Roos in Italy, was imprisoned by the Inquisition for thirty years. In the most productive period of his career Hilliard painted many of the figures who gave the Elizabethan age its distinctive fire, amongst them Leicester, Hatton, Southampton, Drake and Raleigh (Fig. 9).

He had reached the heights of achievement in this stirring age because he himself shared the adventurous spirit of his sitters and could enter fully into the interpretative aspect of their portraiture. He was always dogged by financial difficulties, and found the court a dilatory paymaster. In his search for reward he was as ready to speculate as any City merchant. In the 1570s he joined two fellow limners, Cornelius Devosse and Arthur van Brounckhurst, in an unsuccessful search for gold in Scotland.

Facts which have just been uncovered give an added piquancy to this association. As has been recorded, Susanna Hornebolte married John Gilman as her second husband. After her death he married, for the third time, in 1554. When he died four years later, in 1558, his widow Helen married Cornelius Devosse, with whom we now find Hilliard prospecting for gold in Scotland. It is within the bounds of conjecture that Gilman had some relics of the Hornebolte studio from Susanna and may have passed them on to Helen and thus to Devosse. If so both Devosse and Hilliard may have had direct knowledge of works by the originator of British limning. But their adventure did not cure his financial problems. His delay in returning from France was due to his desire to 'get a piece of money of the lords and ladies . . . for his better maintenance in England'. It was probably his improvidence which led to his being excluded, with his children, from his father-in-law's will when Robert Brandon died in 1591.

Certain obscure anecdotes which have survived hint at other adventures which were bizarre enough in the career of an artist, but which were common to all the men who rose to any distinction in those hazardous and exciting times; some of these episodes throw a sidelight upon his art. In 1591, for instance, we hear in the report of an informer that the English Catholics, plotting abroad to marry the Duke of Parma's son to Lady Arabella Stuart and thus secure a Catholic succession, are trying to get a portrait of that unfortunate lady from Hilliard. Another strange story comes to light in Sir Robert Cecil's correspondence, in connection with the examination of the baggage of Thomas Harrison after his return from France in 1601. In the luggage of this individual, who was apparently suspected of being a Papist because he had been in touch

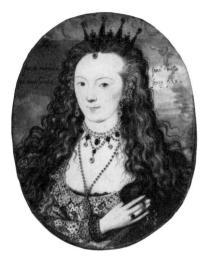

7 Nicholas Hilliard,
Lady Elizabeth Stanley

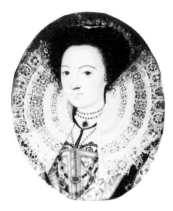

8 Nicholas Hilliard,
An unknown lady

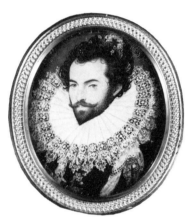

9 Nicholas Hilliard, *Sir Walter Raleigh*

with the Bishop of Boulogne, was found a small box in which was 'her Majesty's picture in metal and a kind of mercury sublimate which had eaten in the metal'. The examiner of this suspicious cargo concludes, 'I cannot conceive he can have a good meaning that will place the picture of her Majesty's sacred person with such poison as hath endangered the pothecary's man that did but put it to his tongue.' Thus accused of practising witchcraft against the queen, Thomas Harrison replied that the Bishop of Boulogne made much of him because he had taught him certain secrets in alchemy. He said that the picture of the queen was one of the models Hilliard made for the Great Seal, that its metal was 'mercury congealed with vinegar and verdigris and will [. . .] with aqua fortis be dissolved again into quicksilver'.

Whatever its meaning this story, which refers to new designs for a third Great Seal which was never made, brings Hilliard into contact with those practising alchemy; not very surprising company for a goldsmith in those enquiring times. He seems also to have been fated to be used as an excuse or stalking-horse by Papists, though there is no reason to suppose that he was himself a Catholic. For again, in 1613, one Abraham Savery was questioned, being suspect of having a picture of the late Prince of Wales (Henry Frederick) in the Netherlands 'for some bad purpose'; he defended himself by saying that his mother-in-law brought over to Brussels a portrait of her daughter's husband (presumably Savery himself) by Hilliard, 'which, for the fame of the workman and curiosity of the science, was much admired by this people, things of that nature being here in great estimation'. Nonetheless, Savery was charged two years later with importing Popish books 'from beyond the seas' for distribution in England.

In spite of his chequered and harassed career, Hilliard's spirit remained buoyant. The ineffaceable impression left by an acquaintance with his miniatures and writings is that of his charm; it lingers in the features of his self-portrait, in his portraits of Queen Elizabeth's courtiers, in the letters he wrote to his patron Robert Cecil, often under circumstances of exasperating difficulty, and above all it is to be found in his one prose composition of any length, *A Treatise Concerning the Arte of Limning*, which he wrote about 1600. The attraction of this book lies as much in its weaknesses as in its positive merits. Hilliard had been asked to write a formal treatise as a companion to Haydocke's translation of Lomazzo's work on painting, and he does every now and then remember his brief; but he is clearly in a hurry to get past the more theoretical points, which bore him intensely, to those which interest him more; he dismisses Dürer's rules of human proportion with the remark, 'which rules of Albert for the most part are hard to be remembered, and tedious to be followed of painters, being so full of divisions', and adds a devastatingly frank parenthesis to the effect that 'Paulo Lamatius in the last chapter of his fourth book very truly (but absurd) showeth that everything must be shadowed in his kind'. But when he is writing of his own practice as a limner and of the gems he handled as a goldsmith his enthusiasm gives him eloquence:

> For who seeth an excellent precious stone . . . and is not moved above others with an amorous joy and contentment than the vulgar (howbeit, gentle or vulgar we are all generally commanded to turn away our eyes from beauty of human shape, lest it inflame the mind)? How then [shall] the curious drawer watch and as it [were] catch those lovely graces, witty smilings and those stolen glances which suddenly like lightning pass and another countenance taketh place except he behold and very well note and conceit to like? So that he can hardly take them truly and express them without an affectionate good judgment and without blasting his young and simple heart although (in pleasing admiration) he be very serious busied. So hard a matter he hath in hand calling these graces one by one to their due places, noting how in smiling how the eye changeth and narroweth holding the sight just between the lids as a centre, how the mouth a little extendeth both ends of the line upwards, the cheeks raise themselves to the eyewards, the nostrils play and are more open, the veins in the temple appear more and the colour by degrees increaseth, the neck commonly erecteth itself, the eyebrows make the straighter arches and the forehead casteth itself into a plain as it were for peace and love to walk upon.

The joy of the portrait painter in his work and the Elizabethan delight in personal

beauty have never been more feelingly expressed. He places portraiture far above history painting and uses the amorous perils in which it places the painter as a support to his humanistic contention that miniature painting should only be practised by those of true gentility.

In the more directly technical parts of the treatise he includes such prescripts as that the circle of the sight must be a perfect round; that 'parchment is the only good and best thing to limn on but it must be virgin parchment such as never bore hair, but young things found in the dame's belly', and he excuses himself from giving an account of how to make the artificial embossed rubies and jewels which are so colourful a feature of his own limning.

The passage in which he discusses the place of shadows in limning is of great importance in relation to his own practice, and as the doctrine he advances had the blessing of Queen Elizabeth it was the current English fashion. Hilliard asks

> that no wise man longer remain in error of praising much shadows in pictures after the life, especially small pictures which are to be viewed in hand . . . for beauty and good favour is like clear truth, which is not shamed with the light, nor need to be obscured, so a picture a little shadowed may be borne withal for the rounding of it, but so greatly smutted or darkened as some use disgrace it and is like truth ill told. If a very well favoured woman stand in place where is great shadow, yet showeth she lovely, not because of the shadow but because of her sweet favour.

In accordance with his doctrine Hilliard used darker flesh tones to achieve the modelling of his faces, and the fading of these delicate colours has given rise to an erroneous notion that he aimed at, or was unable to achieve any other result than, flatness of feature.

The *Treatise* also contains passages of direct biographical interest. There are oblique references to the poverty and lack of recognition which were already the common experience of English artists, and a defence of himself against implied charges of extravagance. 'Such men are commonly no misers, but liberal above their little degree, knowing how bountiful God hath endowed them with skill above others.' From another passage we learn, as indeed we might have guessed, that the behaviour of some sitters and studio visitors was no better then than now, that those who knew least criticised most, and that work was at times left on his hands unpaid for:

> I have ever noted that the better and wiser sort will have a great patience and mark the proceedings of the workman [*i.e.* the miniaturist] and never find fault till all be finished . . . but the ignoranter and baser sort will not only be bold precisely to say, but vehemently swear that it is thus or so, and swear so contrarily that this volume would not contain the ridiculous absurd speeches which I have heard upon such occasions. These teachers and bold speakers are commonly servants of rude understanding, which partly would flatter and partly show but how bold they may be to speak their opinions. My counsel is that a man should not be moved to anger for the matter but proceed with his work in order, and pity their ignorance, being sure they will never rob men of their cunning, but of their work peradventure if they can, for commonly where the wit is small the conscience is less.

Furthermore, the *Arte of Limning* tells us something about the artists whom Hilliard suggested as models for the aspiring limner. He praises the line engravings of Dürer and Lucas van Leyden, and recommends the would-be limner to copy them by pen as closely

as possible, to gain proficiency in the cross-hatching needed for the roundness of modelling. He also praises the style of Goltzius, and this evidence of his admiration for the great Flemish mannerist is of interest in view of the mannerist elements in his own art. These influences were reinforced by those of Rosso, the decorator of Fontaine-bleau, and Lambert Suavius, the engraver of mannerist saints and portraits in roundels. Dürer, Lucas van Leyden, Goltzius and Suavius he may well have known only from engravings. Hilliard reserves his greatest praise for Holbein and states explicitly that he modelled his own style upon him– 'Holbein's manner of limning I have ever imitated and hold it for the best.' We need not doubt that, as these remarks suggest, he was largely self-trained, and that he studied the technical practices which he saw in Holbein's miniatures. Yet his use of broader hatching and his more linear design are closer to Luke Hornebolte, whom he does not mention.

Hilliard made his own unique amalgam of the models he admired, and the basis of his originality lies in his flowing, calligraphic drawing. In a typical Hilliard miniature the face is generally placed three-quarters left, an angle which gives a striking indentation of the profile at the level of the eye. The edge of the cheek further from the painter is sharply defined, as though it were a mask or cut from paper. The modelling of the face is unobtrusive and, as Hilliard would not allow the use of smutty greys and blacks, the pinks and 'carnations' with which it was achieved have faded in all but a few well-preserved specimens. The eye is a perfect round so far as it is visible in accordance with his precept, and above it the eyelid is drawn with a bold curving stroke. In his best period, from 1572 till about 1600, the hair is drawn with the utmost breadth and freedom, in darker curls over a lighter ground. However elaborate the neckwear may be in that age of ceaseless experiments with ruffs and collars, Hilliard is always master of its form and its relation to the neck and doublet of his sitter; when he is called upon to draw the intricate geometrical patterns of the reticella lace adorning collars and cuffs, the way in which he combines freedom of line with exactness of detail is always a source of the keenest aesthetic pleasure. He draws a hand in a strangely mannered way, with elongated fingers and jointless, like a puffed-out glove; and he drew legs and feet, in his full-length miniatures, in the same linear and unrealistic way. The formula *Ano Dni . . . Ætatis Suae . . .* written in gold on a blue background in Hilliard's fine Italic hand is often an essential decorative feature of his miniatures. The use of *imprese* gave both verbal and pictorial overtones to the poetry of his interpretation of character. Sometimes, too, he adds to the symbolism with a flower painted against the corsage or doublet. This is a continuation of the well-established custom, in Flemish and German portraiture, of showing the sitter carrying a flower in her hand; but the unusual aspect in Hilliard's practice is that the flower is neither held nor pinned to the bosom but painted against it. These symbols are never repeated – inscriptions, emblems and flowers are varied for each sitter. All these details are part of the generosity of approach which make him one of the outstanding English artists in any medium and in any period.

Isaac Oliver

Hilliard began to take pupils soon after he had served his own term of apprenticeship. Most of their names have left no mark on the artistic history of the times. His son Laurence Hilliard, and his pupil Rowland Lockey, made contemporary reputations. It may be supposed that some of the other apprentices were trained as goldsmiths and jewellers rather than limners. Unquestionably his most eminent protégé was Isaac Oliver, described by Richard Haydocke in 1598 as the 'well-profiting scholar' of the 'most ingenious, painful and skilful Master Nicholas Hilliard'.

We have seen that Isaac Oliver's father, the goldsmith Pierre Oliver, was a fugitive in Geneva when Hilliard was there as a young dependant of John Bodley. Their common interests may have brought them together, and this may account for the subsequent choice of a teacher for the Olivers' son. The first mention of Pierre Oliver in England occurs in 1571, when he is recorded as having come over with his wife and son about three years before, that is in 1568. The date of Isaac Oliver's birth is not more exactly known. However his earliest dated miniature is of 1587. If we may assume that, following the usual custom, he began his training when he was about fifteen and studied for the then normal seven years, he will have been born *c.* 1565. Hilliard evidently started to teach him shortly after his return from France and his fluency in French may have been a contributory factor in Oliver's parents' decision to place their son with the leading limner of the day.

Isaac Oliver never became really assimilated in the country of his adoption. He became a naturalised denizen only in 1606 and for most of his life he laid stress upon his French origins. He wrote the word *Francese* after his signature on the miniature of '*Sir Arundel Talbot*' of 1596, and if a notebook from which George Vertue quotes was really one compiled by him in 1609 and 1610 (as there seems no reason to doubt) he had barely mastered the English tongue after more than forty years' residence. Such entries as 'Ser Hari Ro', 'me lade Aleta talbot' are eccentric even by the none too exacting orthographical standards of the time, and are interspersed with entries in fairly correct French.

Oliver shows from the earliest of his miniatures a decidedly Continental cast of vision. This is so pronounced that various attempts have been made to postulate a visit in the late 1580s to the Low Countries and elsewhere. So far these hypotheses have not been substantiated. His miniature of the Dutchman Diederik Sonoy was probably

painted in England in 1588, the year the sitter settled here. A recent attempt to read the date 1586 and the town Tournai in the defaced inscription on the drawing *The Lamentation over the Dead Christ* is almost certainly fanciful. There is in fact no reason to suppose that at this time Oliver had any deeper knowledge of, or more direct contact with, Continental art than Hilliard enjoyed. Hilliard had travelled in Switzerland and France, and the engravings of Dürer and Suavius which he commended were just as accessible to his pupil in England. A close parallel has quite correctly been drawn between Oliver's early portraits, notably his self-portrait (National Portrait Gallery; Plate VI), and the engravings of Hendrik Goltzius. In *The Arte of Limning* Hilliard links Goltzius with Dürer as an exponent of 'well engraven portraiture'. Both Hilliard and Oliver were subject to the same Continental influences; the widely different response they made depends upon their radically different temperaments. Hilliard modified them with his own English preferences for linear design, delicate shadowing, bright colour and innocence of expression. Oliver preferred his shadows 'greatly smutted', which Hilliard compared with 'truth ill told', and his early portraits are more sombre. His more cosmopolitan approach however made him a more up-to-date painter for the 1590s and contributed to his success.

It is a thoroughly Flemish manner we see in such characteristic examples as the miniature of *A man aged 27 in 1590* (Victoria and Albert Museum (Fig. 10); the face is caught in a hard, clear focus and the lighting is dramatic. The shadows cast by this dramatic lighting are carried out in the dark smutty greys and blacks which Hilliard condemned; the little dots of which they are formed fuse together in a continuous area of tone. There is already no trace of Hilliard's emphasis on line as opposed to tone, except in the drawing of the hair in these earliest miniatures; and then the drawing is made with a much finer and sharper stroke. When Oliver draws a hand, and he is fond of showing one in front of the bosom, it is a fully modelled three-dimensional hand and not one of Hilliard's stylised abstractions. At the same time, a theatrical effect about the gesture of the hand suggests that he neglected the advice Hilliard gave and followed: 'Tell not a body when you draw the hands, but when you spy a good grace in their hand take it quickly or pray them to stand but still, for commonly when they are told they give the hand the worse and more unnatural or affected grace.'

Whether or not he travelled abroad in the late 1580s Oliver soon displayed a disposition to attempt more ambitious compositions than simple head-and-shoulders portraits. His ability to do so is demonstrated in his *A love theme* (State Museum of Art, Copenhagen), an animated *fête champêtre* of many figures hawking, hunting and embracing which is perhaps an allegory on virtuous and sensual love. It is a skilfully grouped scene of a kind most recently seen in England in the work of the visiting Flemish painter Joris Hoefnagel.

Oliver's desire to widen the existing limitations of limning was encouraged by his stay in Venice in 1596. This visit is known from the inscription on the back of his miniature of the so-called '*Sir Arundel Talbot*' in which he proclaimed himself a Frenchman: '*adi 13 Magio. 1596. In Venetia. Fecit m. Isacq oliviuero Francese I O v. 14 da L8*' (Plate VII). Here he made a copy of Veronese's *Mystic marriage of St Catherine*, which was bought by Charles I while Prince of Wales. The vogue for small

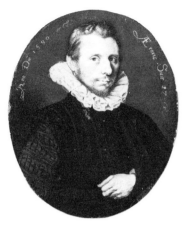

10 Isaac Oliver,
A man aged 27 in 1590

figurative mannerist compositions was then being pursued in Venice by Hans Rotten-hammer, and Oliver's historical drawings show an affinity with such genre scenes. But his approach was so eclectic that the influences which have been discerned in his religious drawings and mythologies – ranging from Parmigianino to Barocci, from Cornelisz van Haarlem to Spranger, and from Rosso to Primaticcio – read like an inventory of European mannerism. In attaching so much importance to figurative composition Oliver was reversing the order of priorities defined by Hilliard, who wrote that the perfection of painting 'is to imitate the face of mankind' and that this high task should not be attempted by the painter 'until he were meetly good in story work'.

Oliver was always able to demonstrate his knowledge of Continental art in large portrait limnings such as *The three brothers Browne with their attendant* of 1598 (Burghley House), a composition of four figures in an interior which derives from the engraving by Marc Duval of *Les Frères Coligny* (1579).

He continued with more conventional face-making. A great deal of interpretative emotion has been lavished on the unfinished portrait of Queen Elizabeth I which he painted near the end of her reign. It has been claimed to rake her soul with remorseless insight, and to have been perforce left unfinished because the queen could not abide its realistic reminder of her ageing appearance. Unfortunately for this interpretation, the miniature is a copy by Oliver from one of Hilliard's many representations of her. Hilliard had the monopoly of such portraits, and Oliver's was evidently made, not as the result of an *ad vivum* sitting, but from an existing work for repetition by foreign engravers such as Crispin van de Passe.

By 1603 there was sufficient difference between the styles of Hilliard and Oliver for the new court of James I to be able to decide between two marked alternatives. The king maintained the patronage for Hilliard which Elizabeth I had so consistently upheld. But Oliver's more up-to-date eclecticism appealed to Anne of Denmark, and she made him her 'painter for the art of limning' in 1605. His profile portrait of her in a masque

costume (Windsor Castle) reflects the love of magnificence which she set out to embody in the court entertainments. When her son Henry Frederick began to exercise his dominance over the artistic taste of the court, he too employed Oliver in preference to Hilliard. This patronage resulted in one of Oliver's finest portraits, the large rectangular miniature at Windsor Castle showing the Prince of Wales as the embodiment of chivalric virtue in the setting of a classical or medieval tournament (Fig. 11).

Oliver's first wife Elizabeth, the mother of Peter Oliver, died in 1599. When he married for the second time, in 1602, Isaac Oliver strengthened his links with the émigré artists who formed a compact community in London, and thereby reinforced the cosmopolitan sympathies already apparent in his travels and his productions. His second wife Sara was a daughter of Marcus Gheeraerts the elder and Susanna de Critz. By marrying her Isaac Oliver became connected by marriage with Marcus Gheeraerts the younger, the leading painter in oils in England at the end of the sixteenth century, with John de Critz, who became Serjeant Painter in 1605 and with his brother-in-law, Maximilian Colt, who became Master Sculptor in the reign of James I. Oliver maintained his associations with this powerful set of artists of immigrant descent when Sara died after three years of marriage in 1605. His third wife, Elizabeth, whom he married in 1606, becoming a denizen in the same year, was a daughter of James Harding, a court musician of French birth.

Since none of his historical drawings are dated, the extent to which this closer association with a cosmopolitan group of artists encouraged Oliver's ambitions to create compositions in the mainstream of European art is a matter of speculation. Such evidence as there is suggests that his main effort was concentrated in the last years of his life.

The importance he placed upon his figurative limnings and drawings of equally complex composition is made clear by his making special reference to them in the will he drew up during his final illness in 1617. He specifies his 'drawings already finished and unfinished' and 'Limning pictures, be they histories, stories' or any limning of whatever nature which was unfinished. These were all bequeathed to Peter Oliver provided that he was himself practising the same art, as of course he was. The most conspicuous unfinished limning was his *Entombment* or *Burial of Christ* (Fig. 12). Charles I instructed Peter Oliver to finish this piece, and when Van der Doort came to catalogue the king's collection of limnings he placed it first of all, with a detailed account of the actions of the twenty-six figures of which it is composed. This remarkable invention was for long believed to be lost, but recently it has been rediscovered in the Musée d'Angers, where it has been since at least 1801. It closely follows the elaborately finished ink and black chalk drawing in the British Museum, assigned to the last year or so of Oliver's life. Most of his other surviving drawings of 'histories or stories' have considerable affinity with this complex exercise which suggests that Oliver's powers as a creator of religious or mythological pictures in little were maturing just before his relatively early death. The impulse he gave to original interpretation on this scale was not sufficient to overcome the irresistible demand for portrait miniatures. In England a few later attempts were made, for example, by Nicholas Dixon and Bernard Lens; on the Continent rather more, by such artists as Friedrich Brentel, Philip Fruytiers, Richard

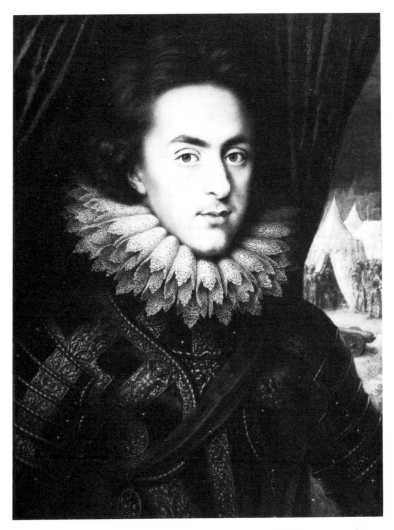

11 Isaac Oliver, *Henry Frederick, Prince of Wales*

van Orley, culminating in the mid-eighteenth century in the snuff-box erotica of Jacques Charlier and the minuscule landscapes of the Van Blarenberghes.

Hints of the potential decay of historical limning in England are already evident in Isaac Oliver's practice. Charles I's collection possessed a copy by him of Holbein's *Death and the Prelate*, still in the Royal Collection. This was the forerunner of a type of limning which the king and other noble patrons were more willing to support than the creation of original historical compositions: that is, small limned copies of prized Old Master oil paintings. Peter Oliver's career was to be conditioned by this movement in taste, as we shall see in the next chapter.

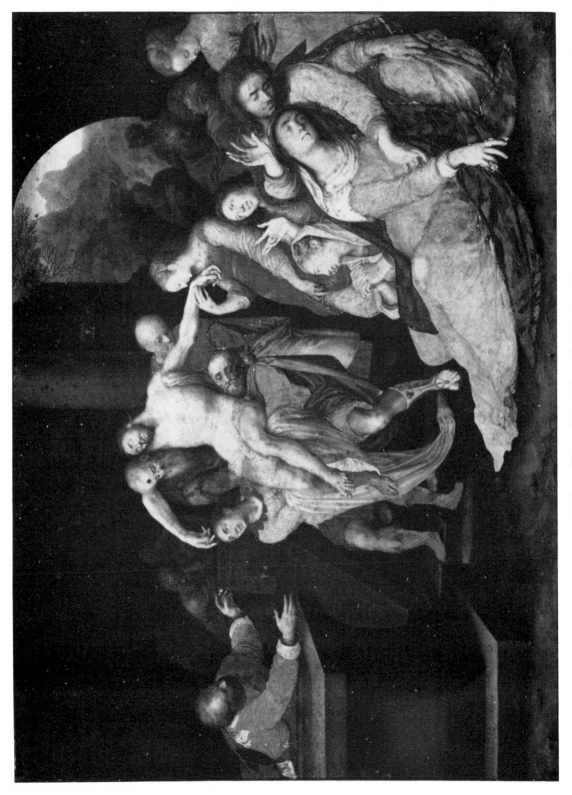

12 Isaac Oliver and Peter Oliver, *The Entombment*

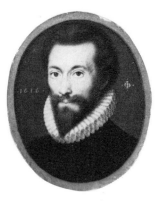

14 Isaac Oliver,
John Donne, 1616

13 Isaac Oliver, *Alice, Countess of Derby*

Meanwhile Isaac Oliver continued with his main occupation of portrait miniature painter (Fig. 13). Much of his employment consisted in work for the court. In the year of his death, 1617, he was paid for four pictures of Prince Charles. Such repetitions are well-executed routine portraits, not all that dissimilar from those he made of Prince Henry Frederick, in which he no doubt had the assistance of Peter Oliver. Individual commissions were more calculated to bring out his full powers. His miniature of Dr Donne, signed and dated 1616 (Royal Collection, Windsor Castle; Fig. 14), is an intensely observed portrait executed in the fine *sfumato* stippling which characterises his later manner. The sitter was quite aware of his good looks, but has not exacted from the artist one of those moralising portraits which he had painted when Dean of St Paul's, clothed in his shroud and ready for the grave. This miniature was painted in the year Donne was presented to the living of Sevenoaks, and the commission may have come through his connections with the Sackvilles. In the same year Oliver painted his full-length *tour-de-force* of Richard Sackville, 3rd Earl of Dorset (Victoria and Albert Museum). This large miniature has so close an affinity with the 'Jacobethan' oil paintings in which sitters are posed full-length in curtained interiors on Turkey carpets that they have led to speculation that Oliver himself painted the oils most akin in design. However there is no direct evidence to connect him with large-scale painting in oils. Oliver is known to have made a miniature copy of a portrait by William Larkin, and the suggestion that some of the oil full-lengths are by Larkin has a certain plausibility.

The somewhat archaic treatment of this Sackville portrait shows that Oliver was eclectic enough to adopt the style required by his patron. In another large miniature, of Lord Herbert of Cherbury (Earl of Powis), he reverts to the *imprese*-ridden world of Hilliard in the 1580s and 1590s. This shows the flamboyant courtier lying on the

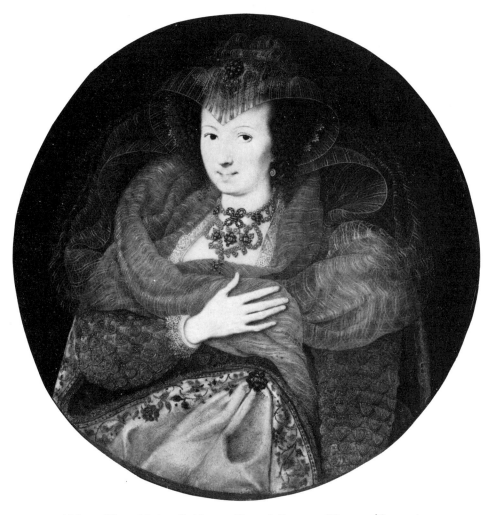

15 Isaac Oliver, *A lady, called Frances Howard, Countess of Essex and Somerset*

ground with a shield bearing the emblem of sympathetic magic, about which he wrote in his philosophical treatise *De Veritate*.

The place in Oliver's development of his two largest female portraits is more difficult to determine because there is no complete certainty about either their sitters or their dates. These are the 'Lady, called Frances Howard, Countess of Essex and Somerset' (Victoria and Albert Museum; Fig. 15) and the 'Lady, called Lucy Harington, Countess of Bedford' (Fitzwilliam Museum). Both show their sitters in highly decorated, perhaps masquing costume, and both are circular, their diameters of 5 inches being large in relation to the usual vertical axis of about 2½ inches. Criticism has veered between acceptance and total rejection of the traditional identifications of the sitters, and the

dates proposed have varied between 1595 and 1615. It would be comfortable, though not necessarily correct, to accept the view put forward by Finsten, that both were painted at the same time showing sitters in the costumes designed for the masque *Hymenaei* produced for the marriage of Frances Howard to the 3rd Earl of Essex in 1606.

Isaac Oliver was acclaimed for his historical limnings, such as 'The Entombment', in the seventeenth century. Admirers of these works applied to him Vasari's praise of Giulio Clovio as a Michelangelo in little, and it is certainly true that the basic influence behind his most ambitious works was that of Michelangelo. This may well have been transmitted to him by a knowledge of Clovio's work, which he may have seen in Venice or could have encountered through engravings. Another source for such a connection might have been Joris Hoefnagel, who had been deeply impressed by Clovio's limnings. But in the field of portrait miniature painting Oliver's name is, during the seventeenth century, consistently placed second to that of Hilliard as the 'well-profiting' pupil of the most eminent master. Horace Walpole reversed this trend by claiming that our greatest obligation to Hilliard is because he contributed to form Oliver, whose work he rated far more highly. Since then it has become customary for writers to take sides and weigh one against the other in terms of comparative value. Whilst a preference for one or the other as the greater miniaturist is a matter of individual taste, it has to be pointed out that it is not a case of comparing like with like. Hilliard was a late mannerist who adapted the Continental influences which he had experienced in the 1560s into a totally personal and English style. Oliver was his junior by virtually twenty years, that is by a full generation. His assimilation of the Continental examples he studied in the 1580s and 1590s had naturally a modish look to the more progressive tastes of the Jacobean court, even though it had a less emphatically national feeling about it.

Both Hilliard and Oliver were supreme in their own way. The gifted artists who succeeded them in the seventeenth century had to develop the art of limning against a background of changing pictorial taste and into new directions.

Peter Oliver, Laurence Hilliard and other early seventeenth-century miniaturists

Isaac Oliver made his bequest of unfinished works to his son Peter Oliver conditional upon his being ready to 'exercise that art or science which he and I now do'. This shows that Peter had been working with his father for a time before 1617. Even without this confirmation, it might have been deduced from a number of the routine repetitions of the standard head-and-shoulders miniatures of Prince Henry and Prince Charles which were produced from Isaac Oliver's original conception. These were evidently in much demand after the untimely death of the heir to the throne, Henry Frederick, Prince of Wales, in 1612. In the Royal Collection at Windsor there is a miniature of the young Prince Charles considered to have been painted around 1612 which is signed with Isaac Oliver's monogram; the same collection has a very similar one, slightly modified with the addition of an incipient moustache, signed with Peter Oliver's monogram, and probably made shortly after his father's death.

Peter Oliver continued in favour with the younger members of the royal family. He produced his own portrait type of Charles, Prince of Wales in 1621, and another, close to a portrait by Mytens, of the sitter as king around 1626. He also made a number of repetitions of his portraits of the exiled Frederick, King of Bohemia and Elizabeth, Queen of Bohemia (Fig. 16). Besides these official commissions he painted a number of individual portraits in which he can be seen to have developed his father's later style in the direction of a softer and more *sfumato* stippling stroke. He had an original sense of colour; the portrait of Sir Francis Nethersole in the Victoria and Albert Museum, which is dated 1619, is carried out in warm tones of grey and brown relieved with gold and against a luminous grey background (Plate VIII). Nethersole was Secretary to Elizabeth of Bohemia, and this portrait, painted in the year in which she became queen, indicates that she had maintained her connections with the English court and its most prominent miniature painter.

Peter Oliver was the only child of Isaac Oliver's first marriage, and the only one of his children to pursue the art of miniature painting. The date of his birth is not recorded and has recently been the subject of debate. For it is known that Peter Oliver married his aunt, Anne Harding, his father's third wife's younger sister, and that she was born in 1593. However, there seems no reason to suppose that he could not have been younger than her, and there is some corroborative evidence for the date of 1594 which has been accepted in the past. Peter Oliver is an artist who has been plentifully

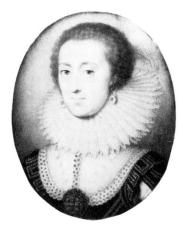

16 Peter Oliver,
Elizabeth of Bohemia

portrayed: in a self-portrait drawing in the National Portrait Gallery, in an oil by Hanneman in the Royal Collection, and in a drawing in the Fitzwilliam Museum, Cambridge. With this wealth of evidence it is possible to identify a Hilliard-school miniature in the Fondation Custodia, Paris, as another portrait of him. It is inscribed *Ars mea Patrimonia. Ætatis suae. 27. 1621.* The legend, identifying the sitter as the son of an artist and himself an artist, fits Peter Oliver's circumstances, and the birth date of 1594 established by it is that which had been deduced from the study of his emergence as his father's understudy in the early 1610s.

In view of the terms of his father's will it is not surprising to find that Peter Oliver did in fact complete his father's most ambitious concept, the large historical limning, *The Entombment*, which was unfinished at Isaac Oliver's death. But this seems to have been less due to filial piety than to the commands of King Charles I. When compiling his catalogue of the Royal Collection around 1639, Van der Doort wrote about the completed limning 'Which peece was begun by the old Oliver and since by yo^r Ma^{ts} appointm^t. finished by his son Peter Oliver.' It is possible to read into this statement the implication that the command to finish the work was given after Charles I's accession in 1625. This would be consistent with the fact that the long series of copies in little from Old Master paintings which occupied Peter Oliver's energies during the latter years of his life begins in 1628. *The Entombment* was certainly completed by 1636 when the king granted the artist an annuity for this and other pieces. There is an odd sequel to this well-documented episode in the history of British miniature painting. When Sir William Sanderson published his *Graphicê* in 1658 he referred to a limning begun by Isaac and finished by Peter Oliver, which he describes as a 'History of the Buriall of a Gretian Monarch'. He had seen it in the hands of Endymion Porter, well known for his activities in forming Charles I's collection. Sanderson's book is intended as a plain man's guide to the appreciation of art, and is riddled with errors. It can hardly

be doubted that he too is referring to *The Entombment* as one of the best known examples of its kind in the mid-seventeenth century.

In recording the discovery of this key work in the Musée d'Angers, Dominique Cordellier quotes the observations of Joseph Marchand, who first described it when it appeared – how, it is not known – in his collections in 1800 or 1801. He was not aware of Peter Oliver's collaboration, but detected two hands in its execution, forming the hypothesis that the miniature had been damaged and restored by an artist with considerably less talent than Isaac Oliver. However that may be, Peter Oliver had inspired Charles I with sufficient confidence to employ him on copying a number of his oils. At least fifteen limned subject miniatures by Peter Oliver are recorded: of these only one, of *St Paul and the viper, after his shipwreck*, is not known to be copied from an existing painting and may be an original invention. But the preference of the king and other collectors was for small portable copies of their treasured pictures, and Peter Oliver was latterly engaged in making them almost to the exclusion of direct *ad vivum* portraiture. Much of the emphasis in British collections, those of the king, the Earl of Arundel and the Earl of Pembroke, was on Venetian painting, and seven of Peter Oliver's limned copies are after pictures by, or then thought to be by, Titian.

Of the copies by Peter Oliver from pictures in the English collections, eight remain in the Royal Collection at Windsor Castle and two are in the Victoria and Albert Museum, namely, *The Flight into Egypt* and the *Rape of Lucrece*, both after Titian. They are faithful and colourful renderings of their originals, and the whole group helps to recall the dispersed splendours of one of the finest princely collections assembled in the seventeenth century. For, of the original pictures from which Peter Oliver made his copies, *St George and the Dragon* by Raphael is in the National Gallery of Art, Washington, D.C.; the so-called *Marquis del Guasto with his mistress*, by Titian, and the *Antiope*, by Correggio, are both in the Louvre; the *Rape of Lucrece* by Titian is in the Kunsthistorisches Museum, Vienna and the *Venus and Mercury teaching Cupid* by Correggio is in the National Gallery, London. That the copies were much prized by Charles I is indicated by the care with which they were provided with shutting cases and keys. Such a case can be seen at Ham House, containing Hoskins' large portrait of Katherine Bruce, Countess of Dysart. Similar protection against fading was unfortunately not usually accorded to the portrait miniatures in the Royal Collection. The high estimation in which such copies of great paintings were held is also evidenced by the similar works in the output of other seventeenth-century miniaturists. The copy by Flatman of Feti's *David with the head of Goliath* is now in the Victoria and Albert Museum; the copy of David Des Granges of the *Marquis del Guasto with his mistress* by Titian is at Ham House, and also at Ham House is a series of monochrome copies in indian ink on vellum by Paton, many of the same subjects as Peter Oliver's historical limnings. But, interesting historically as this phase of British miniature painting may be, it is difficult to avoid the conclusion that its practice was not beneficial to the progress of the art of miniature painting, or at least to the development of those who followed it most assiduously. Excellent though the copy may be, it remains but a copy, and original work, whether in portraiture or historical limning, must take precedence over it. There did not emerge from all this activity a series of original history pieces of small scale; Oliver's *Entomb-*

ment of Christ seems to have been the last major attempt at creation in that genre, and the English school produced no Clovio, Elsheimer, Brill or Rottenhammer in answer to the stimulus of the Italian masters in Charles I's collections. More dispiritingly, portrait miniature painting became for a while a matter of copying oil portraits in little. Most of Peter Oliver's time seems to have been taken up by his work as a copyist in miniature. The greater number of his original portraits are assignable to the 1620s – the period differentiated in costume by the falling band. His first dated limned copies are of the year 1628, and they continue till after 1639, the date of Van der Doort's catalogue of Charles I's collection.

Peter Oliver's copies were much admired, both in his own time and later. His relative Edward Norgate wrote: 'Histories in limning were strangers in England till of late years it pleased a most excellent King to command the copying of some of his own pieces, of Titian, to be translated into English limning, which indeed were admirably performed by his servant, Mr Peter Oliver.' His copying extended beyond histories into portraiture, and he was much employed by Sir Kenelm Digby in that way. Horace Walpole regarded as one of his greatest strokes of fortune as a collector his discovery of a large group of these Digby portraits in the house of a Welsh descendant of Sir Kenelm. He wrote: 'The capital work is a large miniature copied from Van Dyck, of Sir Kenelm, his wife and two sons, the most beautiful piece of the size that I believe exists.' A copy of the complete group by Van Dyck, with Sir Kenelm and Lady Digby and their two sons in the Nationalmuseum, Stockholm, is dated 1635; separate portraits of Sir Kenelm and of Lady Digby copied from the same group and dated 1632 are at Sherborne Castle.

Peter Oliver was inclined to experiment in his use of materials. He is said to have been the first miniature painter to use a gessoed card to replace the playing card as a support for the vellum. He also tried out new colours. Norgate in his *Miniatura* records how Peter Oliver tried some of Sir Nathaniel Bacon's pink and that he 'did highly commend it and used none other to his dying day. Wherewith and with Indian lake he made such expressions of those deep and glowing shadows in those histories he copied after Titian, that no oil painting could appear more warm and fleshly than those of his hand.' Norgate also records that Peter Oliver painted landscapes with the point of the brush, as a new genre in English art. But though Peter Oliver expunged any hint of archaism and a Gothic past from his style, a certain loss of intimacy was the result. As a technical exponent of the skills of miniature painting Peter Oliver was the equal if not the superior of his father. Although Alexander Cooper was under the care of John Hoskins, he found it instructive to study under Peter Oliver. But this technical competence was not fuelled by the creative drive of the Jacobean age, and Peter Oliver's work is unduly composed of copies rather than original invention. He died in 1647, leaving all his goods to his wife, Anne.

A tragi-comic conclusion to his story is related by Vertue on the authority of Anthony Russell, whose grandfather had been a close friend of the Olivers and their circle. It appears that on his restoration Charles II enquired after Peter Oliver and was told that he was dead, but that his widow was alive and had many of his miniatures, including duplicates of some he had made for Charles I. The king visited her and chose many of

the pictures, for which he granted her a pension of £300 a year for life. Some years afterwards Anne Oliver heard that the King had given some of these pictures to his mistresses; whereupon she said, with more vigour than tact, that if she had thought that the King would have given them 'to such whores, bastards or strumpets, the King should never have had them'. This speech got back to the king's ears and her pension was never paid again.

Nicholas Hilliard characterised the 'good workman' as 'having commonly many childeren if they be maryed', and we know that he himself had seven born between 1578 and 1588, of whom three were sons and four daughters. Of these offspring only one, Laurence, who was baptized, and therefore presumably born, in 1582, followed his father's calling, and he did so with much less success than Peter Oliver.

Certainly Nicholas took as many pains as possible over the training of his son and in providing for his livelihood. More than one of his letters to Sir Robert Cecil, later Earl of Salisbury, contains references to these matters. When Laurence was nineteen years of age, his father suggested that he might be taken into Cecil's service: 'He hath the Spanish tongue and an entrance into well writing and drawing.' The request occurs in the midst of one of Nicholas Hilliard's complaints about his own financial straits, and he goes on to say that because of the falling-off of work he cannot keep his son continually employed. In 1606 we learn that this plea had been granted, and that subsequently Laurence Hilliard had been making miniatures and gold medals for King James I. Nicholas asked the Earl of Salisbury to let Laurence wait on him in livery at the feast of St George. Laurence had been made free of the Goldsmiths' Company in 1605 by patrimony – that is by virtue of his father's freedom. It was decided in 1608 that after his father's death Laurence should succeed him as His Majesty's limner, beginning at £40 a year. The grant of this reversion stated that Laurence, 'having been trained up and instructed by his said father, hath attayned so good perfeccōn and skill in the said art of lymning'. He duly succeeded his father in this office in 1619 and kept the post until his death in 1648. His successor, curiously enough, was Sir Peter Lely, for we learn from an act of the Lord Chamberlain's for February 1663 that he was granted 20 oz of gilt plate for New Year's Gifts, the same as for Laurence Hilliard 'formerly in that place'.

It is reasonable to assume from his long connection with the court that Laurence Hilliard was responsible for a number of those stock miniatures of King James I, Queen Anne of Denmark and their family which, though produced during the lifetime of Nicholas Hilliard and reflecting his style, are mechanical and crabbed in effect. About half-a-dozen original miniatures which bear his initials LH in Roman capitals and are dated between 1621 and 1644 are known. In them his lack of real flair is only too apparent. The stamp of style remains his father's and he carried it on till the 1640s; but he had none of the calligraphic bravura of Nicholas Hilliard, and his vision was modest and timid. It is only in the drawing of the eyes that he in any way emulates his father's skill of hand. He gives all faces the same unmeaning roundness, is apt to suggest an effect of baldness about all his sitters, male or female, and obviously has difficulty in drawing the hair of moustaches or beard. He imitated also his father's style of italic inscription in gold lettering on the ground of the miniature, but again with less certainty of hand. One of the works which represents him most favourably is that of a man, dated

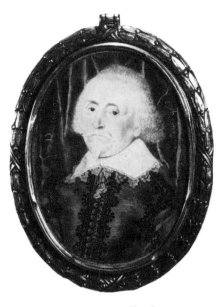

17 Laurence Hilliard,
An unknown man, 1640

1640, at the Fitzwilliam Museum, Cambridge (Fig. 17), but apart from the date and costume it could easily be taken for a work of sixty years earlier. Perhaps Laurence Hilliard's greatest interest is as the probable author of the miniature known as the 'Somerville Shakespeare'. The portrait does not, in all probability, represent Shakespeare, and it can no longer be accepted as the work of Nicholas Hilliard, under which doubly deceptive guise it acquired some reputation and currency, even to the extent of being engraved as the frontispiece to a nineteenth-century edition of Shakespeare's works. These potential associations would be even more interesting if the original from which the Droeshout engraving of Shakespeare was made were ever to come to light. So far as it is possible to judge, the print shows the formal qualities to be expected if it had been derived from a miniature by Laurence Hilliard.

Laurence Hilliard married in 1611 Jane Farmer, a well-to-do widow. But insecurity and mischance appears to have afflicted his children. In July 1660 Brandon Hilliard, son of Laurence Hilliard, petitioned King Charles II

> for one of the places of King's Waiter in the Custom House, London. His father and grandfather served the late King as limners, for which £600 is still due; [he] bore arms himself in the war and was menial servant to the Princess Henrietta at Exeter; on its surrender [he] was persecuted by the enemy and by creditors from whom he purchased goods for her, and [was] forced to shelter in France and the West Indies, till the Restoration.

In *Il Cortegiano* Castiglione says that the courtier should not neglect the arts of painting and drawing. He brushes aside the objection that these are mechanical pursuits by quoting examples from antiquity of illustrious and well-born men who practised them

as liberal arts. Nicholas Hilliard enthusiastically embraced this view and considered that, in particular, limning was 'fittest for gentlemen'. He bases this assessment on the facts that it can be carried on in secret, that it is 'sweet and cleanly to use' and 'tendeth not to common men's use'. The number of manuscript guides to limning which circulated in the seventeenth century show that this art was indeed regarded, like gardening or the pursuit of science, as a hobby which might be indulged without any loss of gentility. Three gentlemen in particular qualify for discussion beside the professional limners: Edward Norgate, Sir James Palmer and Sir Balthasar Gerbier.

Norgate, the son of a Master of Corpus Christi College, Cambridge, was versatile in his occupations. He was tuner of the king's virginals, organs and other instruments, illuminator of initial letters on Royal Patents, Clerk of the Signet, heraldic draughtsman, and Windsor Herald. He compiled a technical treatise on miniature painting which exists in two versions. The earlier, of *c.* 1620, was prefixed to the only known copy of Hilliard's *Arte of Limning*. The extent to which it was circulated in manuscript caused him to write an enlarged and revised version shortly before his death in 1650. He specifically states that he had practised limning as a recreation as far as his other duties gave him opportunity. A group of four miniatures, two of members of the Harrison family, is attributed to him with some plausibility. The key piece is a version in this group of his first wife's miniature. A second version, in the Victoria and Albert Museum, was the first work to be associated with Norgate. The sitter was Judith Lanier, a member of a prominent family of musicians, whom he married in 1613. She died in 1618, and her bereaved husband wrote a salute to her virtues on the back of the portrait. Once regarded as Norgate's own work, the latter version is now regarded as probably by Isaac or Peter Oliver, and the other version to be Norgate's copy. The Harrison portraits reveal Norgate as a follower of the Hilliard and Oliver tradition, without much originality; perhaps always a copyist of other men's inventions. He imitates Oliver in the meticulous drawing of hair and lace, Hilliard in the general presentment and the English appearance of his sitters.

A similar blend of Hilliard's and Oliver's manners is to be discerned in the miniatures of Sir James Palmer (1584–1657) which have been identified by a fairly coherent chain of circumstantial evidence. Palmer was a friend of Charles I and had sufficient credit with him as a connoisseur to advise on the formation of the magnificent Royal Collection of paintings. He was long known to have practised in miniature through a reference in Van der Doort's catalogue of Charles I's collections. It was not, however, possible to ascribe any known miniatures to him till three portraits with the monogram JP (deceptively like Isaac Oliver's monogram) were found in different collections, and proved to be by the same hand as family portraits of Sir James Palmer's wife, and father and mother-in-law, still in the possession of his descendants. One of Palmer's mannerisms is to write the date of his miniature horizontally across the background; and he uses a rather scratchy stroke for the shadows under the chin.

The third courtier to combine limning with wider interests was Sir Balthasar Gerbier (1592–1667). Even for the versatile seventeenth century he had many accomplishments; he was adventurer, painter, architect, musician, author, courtier, lecturer and diplomatist. He was born at Middelburg of French parentage but came to England in

1616 and entered the service of the Duke of Buckingham. He played an important role in the world in which art and politics were commingled by Charles I's ruling tastes: Gerbier was fairly prolific in drawing small pen-and-ink portraits in the manner of Goltzius, whose pupil he may have been, but miniatures by him are rare. That of Charles I as a young man in the Victoria and Albert Museum shows a respectable amateur competence; a larger full-length equestrian portrait of his patron, George Villiers, Duke of Buckingham, in the collection of the Duke of Northumberland, is more ambitious in conception. He was not admired by Sanderson, who wrote that he 'had little of Art, or merit; a common Pen-man who Pensil'd the *Dialogue* in the Dutch Church LONDON'.

These gentlemen-limners, who carried out the precepts of Castiglione and Hilliard, were all closely connected with the growth in interest in art in early seventeenth-century England. Norgate taught the art of heraldic illumination to the sons of the great collector Thomas, Earl of Arundel; and his brother-in-law, Nicholas Lanier, a musician and amateur painter, bought pictures in Italy for Charles I. Palmer, who was closely connected with the formation of the Royal Collection, may have compiled a catalogue of it. Gerbier was the principal adviser to the Duke of Buckingham in the speedy assembly of a remarkable group of Venetian and other paintings, and acted as host to Rubens when he was in England in 1629. The fact that they dabbled in limning confirms that miniature painting had become an established branch of the fine arts, and enhanced its standing in England.

John Hoskins

The miniatures gathered together under the name of John Hoskins were the finest produced in the period between the death of Nicholas Hilliard and the supremacy of Samuel Cooper. Their excellence may account for the relative eclipse of Laurence Hilliard and the extent to which Peter Oliver switched to copying Old Masters in the 1620s and 1630s. The precise definition of the personality of John Hoskins is however a formidable problem. Quite apart from the notorious difficulty that there was a younger John Hoskins, also a limner, we are faced from the outset with a set of signed works of such variety of style that it would normally be judged that more than one hand was at work. The historian is in the position of the early Greek philosophers trying to determine between the One and the Many.

An eighteenth-century account of John Hoskins states that 'he was bred a Face-Painter in Oil, but afterwards taking to Miniature, far exceeded what he had done'. As yet no oil painting by him has been discovered. His beginnings have to be reconstructed from his early, signed miniatures. One or two of the earliest, including that of an unknown lady in the Royal Collection which shows the sitter in a low-cut lace-edged décolletage, appear from their costume to have been painted *c.* 1615. That is, he may have been under the instruction of either Nicholas Hilliard or Isaac Oliver. Jim Murrell has made the interesting suggestion that the so-called Gyles manuscript, which contains instruction on limning and shows a first-hand knowledge of Hilliard's practice, may have been written by Hoskins. The author of the manuscript says that he has also been a painter in oils, which is a point in favour of the identification. On the other hand, the portrait of a lady at Windsor and other early works by Hoskins suggest the influence of Oliver as much as of Hilliard. Like so much about Hoskins, the evidence is tantalisingly incomplete.

The few known facts about the family of John Hoskins show that he was born before 1600. His father John Hoskins died as a prisoner in the Fleet in 1610, and his sister Barbara, who became the mother of Samuel and Alexander Cooper, was married in 1607. We do not know whether she was older or younger than her brother, but she may have been born in or before 1590. If the earliest known miniatures by John Hoskins are of *c.* 1615 (Fig. 18) he was presumably already out of his apprenticeship and aged at least twenty-one, which accords with the usual supposition that he was born around 1595. But there seems no reason to deny that his career may have been yet longer than

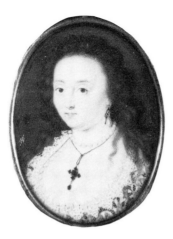

18 John Hoskins, *An unknown lady*

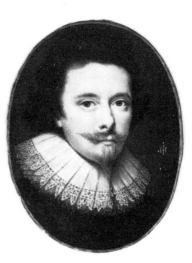

19 John Hoskins,
A man called Henry Cary, Lord Falkland

generally assumed and that he could have been born around 1590 and emerged, after an experience of painting in oils, as a miniaturist soon after 1610.

After the few miniatures of the 1610s the next certain landmark is a small signed miniature, also in the Royal Collection, depicting Robert Carr, Earl of Somerset. In this Carr is shown in the falling band worn in the 1620s, and it was possibly painted at about the time of his release from the Tower in 1622. Unlike Hoskins' earlier portraits with their overtones of Oliver this is painted in a style reminiscent of Laurence Hilliard. The slightly later *Man called Henry Cary, 1st Viscount Falkland* presents a more forceful example of this transitional style (Fig. 19).

Specific documentary references confirm that Hoskins was becoming well known in the early 1620s. Constantine Huygens, the Dutch poet and statesman who was keenly interested in the arts, knew him during his early visits to London, which took place between 1618 and 1624. An invoice in the Portland Collection refers to payment for two small pictures by John Holles, 1st Earl of Clare, in 1626. Even earlier, there is the evidence of Aubrey's piquant gossip about Bishop Overall's wife:

> the greatest beautie of her time in England. That it was so I have it attested from the famous limner Mr. Hoskins, and other old painters, besides old Courtiers. She was not more beautiful than she was obliging and kind and was so tenderhearted that (truly) she could scarce denie any one. She had (they told me) the loveliest Eies that ever were seen, but wondrous wanton.

Now Dr Overall, who 'notwithstanding he knew well enough that he was horned, loved her infinitely', died in 1619 and had married his too obliging wife in about 1607, so these reminiscences, like the names of her lovers, belong to the England of King James I, and during the lifetimes of Hilliard and Oliver.

Shortly after the accession of Charles I the signed miniatures of John Hoskins display a marked leap forward into a more contemporary style. This is seen in elegant portraits

of Charles I, Henrietta Maria and George Villiers, Duke of Buckingham. Their new-found sophistication derives from the official portraits of Daniel Mytens, who was encouraged by the new court.

The numerous repetitions of these miniatures have led John Murdoch to surmise that Hoskins was already employing studio assistants to help with the production of replicas. He goes on to suggest that one of these assistants may be Alexander Cooper. It is an accepted fact about Hoskins that he undertook the role of guardian of his sister's children, Samuel and Alexander Cooper. Other early accounts say that Alexander Cooper was trained by Peter Oliver. It is certainly true that it has often been found difficult to distinguish between these miniatures of Charles I and Buckingham, when unsigned, and the work of Peter Oliver. Murdoch's hypothesis would imply that Alexander Cooper, emerging from instruction from Peter Oliver in his 'teens, went back to his uncle's studio as an assistant around 1625. If so, it was not for an extensive period, since he is in all probability found working on his own in 1629, the date of the miniature of John Digby, 1st Earl of Bristol, in the Victoria and Albert Museum, which is on stylistic grounds almost certainly by him.

The earliest account of John Hoskins taking on the responsibility for his sister's presumably orphaned children was given by Richard Graham in the notes he added to Dryden's translation of Du Fresnoy's *Art of Painting* published in 1695. He says that Samuel and Alexander Cooper were 'bred up . . . under the Care and Discipline of Mr. Hoskins'. This implies both that they were his wards, and that they were his pupils in the art of limning. As we have seen, the period during which Alexander Cooper was in that position was relatively short, and is reported to have been diversified by a time as the pupil of Peter Oliver. Samuel Cooper's association with his uncle was of far longer duration. He was presumably put under formal instruction at the age of fourteen or so, that is, around 1622. When Sir Theodore Turquet de Mayerne, the physician who took such a keen interest in artists and their materials, visited Hoskins in 1634 he found Samuel Cooper still working with his uncle. By then he may have been the formal partner of Hoskins. In any case his continued presence in the studio may throw some light on the next shift in the style of miniatures bearing the Hoskins signature.

For in 1632 Van Dyck came to work in England for the best part of ten years, and his success made it impossible for any portrait painter, whether in big or in little, to ignore the revolution in his patrons' taste. The immediate response from Hoskins was to increase the size of his miniatures and to make in that larger, but still reduced, format faithful copies of Van Dyck portraits. The large circular portrait of Henrietta Maria in the Rijksmuseum, dated 1632, and the *Frances Cranfield, Countess of Dorset* in the Buccleuch Collection are attractive examples of this phase.

Although these admirably reproduce the elegance of their originals they are curiously impersonal, unlike the virtually contemporary *ad vivum* miniatures by Hoskins such as that of Sir George Heron in the Victoria and Albert Museum, which has a personal and individual charm. There is a more dramatic response to the challenge posed by Van Dyck in the miniature of Edward Sackville, 4th Earl of Dorset, in the Victoria and Albert Museum (Fig. 20). A signed work by Hoskins, his attempt to emulate the force and tonality of Van Dyck has resulted in a brash and unpleasing variation on the older

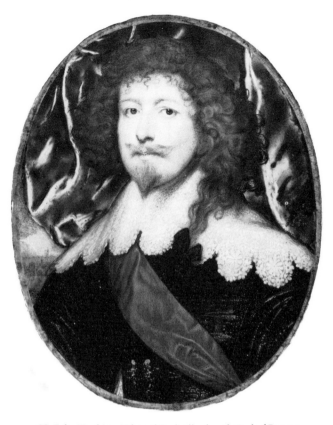

20 John Hoskins, *Edward Sackville, fourth Earl of Dorset*

styles of miniature portraiture. It is possible that in such a miniature we can see the apprentice hand of Samuel Cooper bringing his admiration of the new master into his uncle's studio practice. The same possibility arises with the much more forceful limning of Henry Rich, 1st Earl of Holland, at Ham House. Although listed in an inventory of 1679 as a work by 'old Hoskins' it anticipates the mature style of Samuel Cooper in its breadth of treatment and reddish-brown tonality.

The profound effect of Van Dyck's arrival on a limner's patronage and practice is graphically illustrated by a letter of the Earl of Strafford writing from Ireland in 1636 to his agent in England, bidding him to get pictures from Van Dyck 'as cheap as you can', and adding, 'I pray get Hauskins to take my picture in little from my original that is at length, and to make it something like those he last drew, and desire Sir Anthony [van Dyck] from me to help him with his direction.'

But the benefit of contemporary comparison was not always on Van Dyck's side. Sir Kenelm Digby caused many pictures of his lovely wife Venetia Digby to be painted by Van Dyck, some of which, as we have seen, were copied in miniature by Peter Oliver. He wrote to Sir Tobie Matthew from Liège in 1641:

Methinkes, the different kindes of Idoles, made by these two different senses, may aptly enough be compared to the two kindes of painting; the one, of oyle colours, in great; the other of illumining, in little. The first giveth you pictures, so like, as some people think them even the worse for it. The best faces, are seldom satisfyed with van Dyck; whereas, not the very worst, even complained of Hoskins . . . And this peradventure is the reason why Cavaliers (who desire to have cause of believing that nature spent her utmost store of blessings in framing her whom they love best; so carefull are we to contribute to our own mischiefe) are ever more earnest to have their Mistresses picture in limning than in a large draught with oyle colours.

This judgment shows that, a century after the introduction of portrait miniature painting, it had become equal to, or more highly prized than, painting in oil, through the delicacy and intimacy of its portrayal.

The king showed his appreciation of portrait miniature painting by his substantial patronage of John Hoskins, as Van der Doort's catalogue of his collection, drawn up in 1639, reveals. At that time Charles I had eight limnings by Hoskins. A large circular miniature of the king had been copied by Hoskins from his own original, which Charles I had had exchanged with the Lord Chamberlain. Two somewhat smaller portraits of Queen Henrietta Maria were also 'done by the life'. The remainder were copies; those of the king and queen together, and two of the queen alone were after Van Dyck. More usually the king commissioned Hoskins to make copies of old portraits to complete the miniature gallery of his ancestors when contemporary limnings were not available: for instance those of Elizabeth of York, Henry VII's queen, and Anne Boleyn. The most remarkable was the miniature of James I copied from the portrait by Paul van Somer. This is still in the Royal Collection, and in it Hoskins can be seen to have subdued his own individuality in the interests of making a deceptive copy. The resulting miniature would never be assigned to Hoskins were there not this inescapable evidence to show that it is by him. When an artist has so chameleon-like a style it is evidently hard to tell whether variations in his practice are due to his own shift of interest or to the presence of a new studio assistant.

Van der Doort's marginal notes also show that the king wanted Hoskins, like Peter Oliver, to embark on a number of miniature copies of Old Master paintings. At one time he had five paintings in his care, for copying, including 'the great flower pot out of Nonsuch gallery' and two paintings of roses. But he was either uninterested or overworked, since Van der Doort indignantly records of a Holy Family by Palma Vecchio, 'mister hasckins had it 9 jar tu kopi in timing [?tiny] but als it not don'.

The next events which had a marked effect on the conduct of Hoskins's practice occurred on the eve of, and during, the Civil War, during which he appears to have maintained his loyalty to the king (Fig. 21). On 20 April 1640 Charles I granted him, as His Majesty's Limner, a life annuity of £200. Like many royal salaries this was no certain security against penury. Hoskins is known to have received only one instalment of £50, and in 1660 he petitioned for the payment of £4,150 arrears. Another reference in Aubrey's *Lives* probably refers to the elder Hoskins and to the years of the Great Rebellion. It concerns a visit to Robert Hooke, the future experimental physicist, during his boyhood at Freshwater, Isle of Wight. Hooke was born in 1635 and left Freshwater in 1648, so the visit was probably of the early forties:

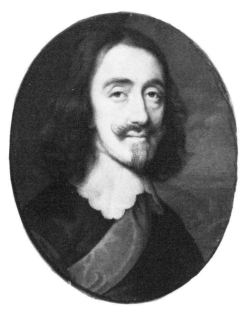

21 John Hoskins, *Charles I*

> John Hoskyns, the painter, being at Freshwater to drawe pictures, Mr Hooke observed what he did, and, thought he 'why cannot I doe so too?' So he gets him chalke, and ruddle [i.e. red ochre] and coale, and grinds them, and puts them on a trencher, got a pencil, and to worke he went, and made a picture: then he copied (as they hung up in the parlour) the pictures there, which he made like.

From which it appears that Hoskins worked also as a pastellist.

Samuel Cooper left Hoskins in either 1641 or 1642 to set up in his own house in King Street, and to embark on that independent practice which dominated miniature painting till his death in 1672. Competition with his acknowledged supremacy was now a constant factor for Hoskins.

It is at this stage that the possible activity of the younger John Hoskins has to be considered. It has long been known that there was a second John Hoskins, the son of John Hoskins senior, and that he worked as a limner. He was first recorded by W. Sanderson, who in his treatise *Graphicê*, published in 1658, wrote: 'For Miniture or Limning, in watercolours, Hoskins and his son, the next modern since the Hilliards, father and son; these Pieces of the father (if my judgment faile not) incomparable.' His activity has been confirmed by documents recently published by Mary Edmond, relating to legal proceedings in York in 1658. The papers bear the signatures of Samuel Cooper, Alexander Cooper and of the younger John Hoskins. Hoskins is described as a limner and picture-drawer, with an address different from that of his father, who lived in Bedford Street, Covent Garden. John Hoskins junior had been in Durham Yard for three years, that is, from 1655 or 1656; he stayed there till 1669. His age is given in these documents as

about forty-one years. Too much weight cannot be placed on this estimate, since the clerk was reckless in his conjectures; he says that Samuel Cooper was about forty-three, when in fact he was forty-nine, and that Alexander Cooper was about forty, when he was forty-eight years old.

There all certain knowledge about young Hoskins ends at present. It is believed that the elder John Hoskins married twice. The name of his first wife is not recorded, nor the date of that marriage. A miniature and a drawing which are believed to represent John Hoskins junior show him as a young man in the 1640s or 1650s, and suggest that the date of his birth may have been around 1620–30. If the earlier of these dates is likely (as the York document may suggest), we should expect him to be emerging as an artist with a personal style in the mid-1640s. It is certainly the case that there is a uniform stream of signed Hoskins miniatures from this period in which the impact of Van Dyck has been fully absorbed and become a recognisable and sensitive idiom. There is less ruggedness and insistence on force of character than in the contemporary miniatures of Samuel Cooper. The miniaturist draws the hair with a finer touch in place of the broad impressionistic mass which Cooper gives this feature. The difference in approach to detail is also found in the drawing of the eyes. Following Hilliard's advice, the Hoskins miniatures show the pupil round and clear, with light reflected in the eye; whereas in Samuel Cooper the eye is large and heavy and seems to be pressed down upon by the eyelids. In the later Hoskins miniatures we can discern a greenish colour in the pointilliste dotting with which the complexion is rendered.

The fact that these miniatures exhibit a steady and delicately refined style has suggested to John Murdoch that they are all the work of John Hoskins junior. He has listed twenty-two miniatures mostly signed and dated between 1645 and 1658 which he assigns to the younger man. This is a simple and attractive theory which implies that John Hoskins senior went into virtual retirement around 1645, apart from the production of a few works of inferior quality. There is nothing inherently improbable in this supposition. The elder John Hoskins would have been well over fifty years old in 1645 if we take the most likely estimate of his birth date as *c.* 1590.

But a number of difficulties need to be overcome before the theory can be given full credence. The portrait miniature of a young man in the Buccleuch Collection, which is signed and dated 1656 and inscribed *Ipse* is one of the two existing pieces of evidence for the estimated age of John Hoskins the younger (Fig. 22). Although not in good condition it can be seen to be painted in a far bolder and more direct manner than the general run of portraits we have been considering, typified by the Sir John Wildman of 1647 (Victoria and Albert Museum) (Plate IX). I am told by Mr Bayne-Powell that there are inscriptions on the reverse of miniatures of Sir John and Lady Danvers, giving the sitters' names with signatures and the date 1653. These belong stylistically with the group of twenty-two ascribed to John Hoskins junior, but the inscription is not in his hand as we know it from the York legal document.

There are other worrying circumstances. On stylistic grounds it would be maintained that the miniature of Katherine Howard, Lady d'Aubigny, of *c.* 1640 (Victoria and Albert Museum; Fig. 23) is by the same hand as that of Sir John Wildman. Yet the former is assigned to the father and the latter to the son under this theory. Of course this

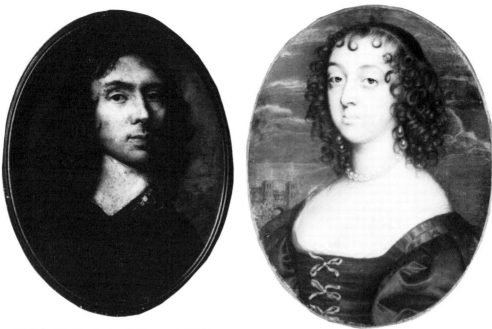

22 John Hoskins junior, *Self-portrait*, 1656

23 John Hoskins, *Katherine Howard, Lady d'Aubigny*

problem could be surmounted if we could place the birth of John Hoskins junior near to that of the Cooper brothers. But then he would probably be too old to fit the supposed miniature self-portrait of 1656 inscribed *Ipse* in the Buccleuch Collection. There are other facts about the elder Hoskins which are hard to reconcile with the view that he gave up entirely in the 1640s. His grant of a pension from the King was on condition 'that he work not for any other without his Majesty's licence'. Since he petitioned Charles II for over twenty years' arrears of the grant in 1660 he ought to have been able to claim that he had worked to deserve it during that time. Furthermore the last Hoskins miniature is dated before the death of the elder in 1665. The younger Hoskins lived at least until 1693. There appears to be no reason why he should have abandoned his profession so soon after embarking on a lively and diligent practice.

It is therefore far from certain that we are yet able to isolate the work of John Hoskins junior from that of his father. The nearest to a documented piece which is available is the alleged miniature self-portrait, and it has proved difficult to assemble a corpus of works around that as a stylistic guide. But though his work is obscure a little more is known about his personality. The self-portrait and the drawing by Samuel Cooper believed to represent him reveal a flamboyant character. He is said to be the 'cousin Jacke' who was at a dinner party given by Samuel Pepys on 19 July 1668. The other guests were Samuel Cooper, then painting Pepys's wife, John Hayls, the oil painter, Henry Harris the actor and Samuel Butler, a company described by the diarist as 'all

eminent men in their way'. In 1670 he married Grace Beaumont, who came from a sub-stantial family in Wells, Somerset. This was in the year after he left his house in Durham Yard, perhaps signalling the end of his career as a limner.

The elder Hoskins made his will on 30 December 1662, when he was 'weak in body but of good and perfect memory'. His main beneficiary was his widow Sarah, pre-sumably his second wife, and he left John Hoskins junior £20. He died a poor man, and was buried in St Paul's, Covent Garden, on 22 February 1665. Whether we regard it as a composite production added to by pupil, partners and apprentices, or as an *œuvre* dominated by the developing taste of one man, the body of signed Hoskins miniatures is the pivot round which seventeenth-century limning revolves. It reflects in its pro-gression the cross-currents of fashion in the large-scale English portraiture of those decades. Until about 1630 it represents the continuation and mature working-out of the tradition of Hilliard and, to some extent, Oliver. If anything could make one regret the advent of Van Dyck it would be the interruption of this slow unfolding of Hoskins' early style, so completely natural in its shy unrhetorical rendering of character, its gravity and its quaint but technically accomplished charm. There are no more intimate and touching portraits in our native art than some of these delicately painted works of yellowish tone. These early works run side by side with those of Cornelius Johnson, who was a friend of Hoskins, and faithfully mirror the same moods. They are in effect the end of the specifically Elizabethan tradition of portraiture. The major cause for its close was the influence of the court, with its understandable preference for the cosmo-politan skills of Rubens and Van Dyck. The patronage for the later Hoskins miniatures, in which there was direct competition with the accepted supremacy of Samuel Cooper, came from a wide and sophisticated group of people. It included the radical republicans Wildman and the Lord Conway who had to wait for his miniature by Samuel Cooper, but Charles II is conspicuously absent. These later miniatures speak a more inter-national language than the English – almost the Anglo-Saxon – of Hoskins's first style, but in both groups is to be heard the note of romantic melancholy which is never far distant from the portraiture of our countrymen. As it is with Hilliard in his earlier style, so it is only with Samuel Cooper that the later work of Hoskins can be compared; he forms a bridge between our two greatest miniaturists.

Chapter 6

Samuel Cooper

The first half of Samuel Cooper's career has already been outlined in the previous chapter. It is a singular fact about this remarkable man that over thirty of his sixty-five years of life were spent under the shadow of John Hoskins. As has been recorded, he and his brother Alexander (who is discussed in the next chapter) were the children of John Hoskins's sister Barbara. It was till recently believed that Samuel Cooper was the younger of the two brothers, but Mary Edmond has shown that in all probability he was born in 1608, a year before Alexander. Both boys were put under the protection of their uncle John Hoskins. It is not known when or why this happened, but we may assume that they had been orphaned. Alexander Cooper is reported to have been taught by Peter Oliver; he had established himself as an independent miniature painter by 1629, when he was twenty years old. Samuel Cooper, on the other hand, stayed on with his uncle. As we have seen, Theodore Turquet de Mayerne found him in the Hoskins studio in 1634; on that occasion he obtained a formula for Cooper's method of making white lead which is the only surviving manuscript by the artist known to exist. At the same time the doctor made an interesting record of Hoskins' method of painting and his use of little, turned ivory dishes for his colours. This device may have played a part in suggesting the use of ivory as a ground for miniature-painting which took hold in the eighteenth century.

When B. Buckeridge appended his short biography of Samuel Cooper to the 1706 edition of de Piles' *Art of Painting* he accounted for his long association with Hoskins, and its break-up:

> He so far exceeded his Master, and Uncle, Mr. Hoskins, that he became jealous of him, and finding that the Court were better pleased with his Nephew's Performance than with his, he took him in Partner with him; but still seeing Mr. Cooper's Pictures were more relished, he was pleased to dismiss the Partnership, and so our Artist set up for himself, carrying most part of the Business of that time with him.

It is now known, in partial corroboration of this record, that Cooper moved to his own house in King Street, Covent Garden, between May 1641 and April 1642. Mary Edmond surmises that this step may have coincided with his marriage to Christiana Turner, of a staunch royalist family of Yorkshire.

The removal marks the establishment of Samuel Cooper's reputation as the leading miniature painter of his age. But he had already made some progress toward recog-

nition as an artist independent of his uncle's studio. Even if it were plausible to discern the hand of Samuel Cooper in the earliest miniatures in which the influence of Van Dyck is apparent, such as the Edward Sackville, 4th Earl of Dorset (Victoria and Albert Museum; Fig. 20) or the Henry Rich, 1st Earl of Holland (Ham House) the fact remains that the former is signed with the Hoskins monogram, and the latter was ascribed to Hoskins in an inventory of 1679.

However there is a certain and acknowledged early work by Samuel Cooper: the miniature of Margaret Lemon in the Fondation Custodia (Lugt Collection, Paris; Fig. 24). This is signed S.C. in monogram and inscribed by the artist with the sitter's name in full, in intertwined letters on the face of the miniature. Margaret Lemon was Van Dyck's mistress and model and the historical circumstances show that this *ad vivum* portrait must have been produced between 1632, when he came to England, and 1639, when his marriage to Mary Ruthven was arranged by Charles I, to the fury of his discarded friend. The sitter's costume is a riding habit and may be dated *c.* 1635.

Richard Graham, one of the few early sources for the events of Cooper's life, wrote in 1695 that he derived great advantage from 'the *Observations* which he made of the *Works* of *Van Dyck*', and he may have been a neighbour of the painter in Blackfriars before Hoskins moved to Bedford Street, Covent Garden in or before 1634. The fact that he was called on to paint this impressive portrait establishes that there was a strong personal link between the two artists, over and above the flattery of imitation which Cooper pays to Van Dyck's style. Van Dyck was not a possessive lover. That he did not resent his friend Porter's interest in her is shown by the contemporary note: ' 'Twas wondered by some that knew him, that haveing been in Italy he woud keep a mistres of his in his house Mrs. Leman & suffer Porter to keep her company.' His indulgent disposition was not shared by Margaret Lemon. Hollar describes her as a demon of jealousy who created the most horrible scenes when society women sat to Van Dyck for his portraits. He says that she 'on one occasion in a fit of hysterics had tried to bite Van Dyck's thumb off so as to prevent him ever from painting again'. In a different version of the story she is said to have tried to bite off his thumb on hearing of his forthcoming marriage to Mary Ruthven.

It is obvious that this imposing half-length portrait painted for the leading artist of the court has a special importance in Cooper's development. It demonstrates that, at the age of about twenty-seven, he was fully equipped to set up on his own, and possessed a style in which the most recent developments in large-scale oil portraiture had been assimilated. That he did not immediately become independent may be accounted for by his acceptance of partnership with Hoskins.

But there are a few other signed miniatures produced before his definite break with his uncle's studio in the early 1640s. One is in the Royal Collection at Windsor and shows a courtier in resplendent costume; although somewhat damaged on the face it bears an authentic signature, and the lace-edged falling collar which the sitter wears shows that it is a product of the 1630s. A miniature of the royalist George Gordon, second Marquess of Huntley, in the Mauritshuis is signed and indistinctly dated, probably to 1640. It bears some similarity to Van Dyck's portrait of the sitter, but appears to be an independent production. The signed miniature of Algernon Percy, 10th Earl of

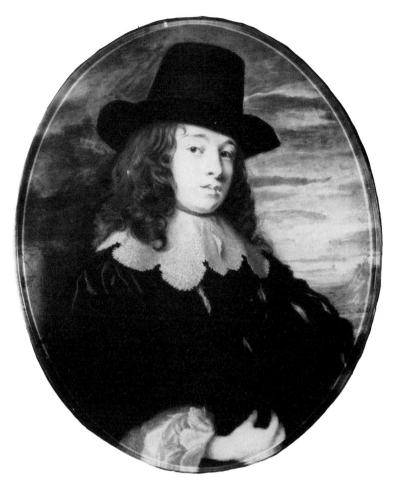

24 Samuel Cooper, *Margaret Lemon*

Northumberland, in the Victoria and Albert Museum is more directly related to the portrait of *c*. 1638 by Van Dyck.

Even when we add to these a handful of unsigned miniatures of the 1630s plausibly ascribed to Cooper it is a meagre tally for an artist in the full possession of his powers and approaching the age of thirty. One explanation may be that he was spending some of the time in Europe.

The wall monument which was placed in St Pancras Old Church after his widow's death in 1693 states that he was 'principibus Europae notus . . . ' and 'linguarum plurimarum peritiam'. It is not known what travels he undertook to meet those princes, nor when he learned his languages, but he may have been abroad some time between 1635 and 1640. This possibility may be strengthened by a discovery of Basil Long's. He found in a sale catalogue of 1895 a reference to two signed miniatures of a burgomaster of Hamburg and his wife. They are described as being painted on coins – perhaps the

two halves of a *schraubtaler* – one of which is dated from Hamburg 1636. Of course there is no necessary correlation between the origin of and date on the coin and that of the portrait on it, but the hypothesis that Cooper was in Germany at that period would help to account for his widespread reputation in Europe, his command of languages, and the relative scarcity of English miniatures during this period.

In any event from 1642 onwards there is a year-by-year tale of signed and dated miniatures, showing the artist in the full stride of a career which did not falter till his death in 1672. Documentary references also become more frequent; perhaps the earliest is that of Norgate in his *Miniatura*, about 1648. Norgate gives generous praise to the artist 'whose rare pencill' does 'equal if not exceed the very best of Europe', but is inclined to think that his portrait drawings may even excel his miniatures.

The family of Cooper's wife suffered for their loyalty to Charles I during the Great Rebellion. Alexander Pope, who was a nephew of Samuel Cooper, wrote that two of his mother's brothers suffered, presumably in the Yorkshire campaign of 1644, and a third followed the King's fortunes and became an officer in Spain. But the range of Cooper's sitters during the Civil War and the Commonwealth does not indicate that he took sides in the conflict. He shows the actors in this drama as determined soldiers, grave gentlemen in buff jerkins and breastplates. It would be hard to deduce from the miniatures of John, 1st Baron Belasyse, 1646 (Fitzwilliam Museum, Cambridge) and General George Fleetwood, 1647 (National Portrait Gallery) that the former was a royalist and the latter a regicide. Sometimes he does reveal more about his sitters. The miniature of Hugh May, 1653 (Royal Collection; Fig. 25) has a flamboyance which prepares us for his occupation, the architect who was to become Controller of the Works at Windsor Castle. That of John Carew (in the possession of his descendants) testifies to the resolution of a regicide who also fell out with Cromwell, a republican 'without guile and reproach'. To portray the Puritan Sir William Palmer in 1657 (Victoria and Albert Museum; Plate X) Cooper developed a subtler lighting and more refined touch. During these years he produced a remarkable series of portraits of women in which he emphasises a sober and serious demeanour in preference to more obviously feminine characteristics. That believed to be of Mrs Elizabeth Leigh, 1648 (Fitzwilliam Museum, Cambridge; Plate XI) is an outstanding example. Later, probably in 1653, Dorothy Osborne was writing to her suitor Sir William Temple in terms which show that Cooper was not thought to be above copying large paintings, though apparently in the end it was decided that he should paint a miniature from the life. There is a moving undertone to the correspondence, since she had been disfigured by the smallpox, but Temple had not been deterred by the loss of her beauty. The letters read (on 3 July 1653):

> Fod God's sake do not complain so that you do not see mee . . . If I had a picture that were fit for you, you should have it. I have but one that's anything like, and that's a great one, but I will send it some time or other to Cooper or Hoskins, and have a little one drawn by it, if I cannot be in town to sit myself.

And again, on 13 June 1654:

> I shall go out of town this week, and so cannot possibly get a picture drawn for you till I come up again which will be within these six weeks, but not to make any stay at all . . . I would have

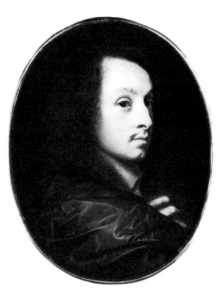

25 Samuel Cooper, *Hugh May*, 1653

had one drawn since I came, and consulted my glass every morning when to begin; and to speak freely to you that art my friend, I could never find my fact in a condition to admit on't, and when I was not satisfied with it myself, I had no reason to hope that anybody else should. But I am afraid, as you say, that time will not mend it, and therefore you shall have it as soon as Mr. Cooper will vouchsafe to take the pains to draw it for you. I have made him twenty courtesys, and promised him £15 to persuade him.

Regrettably, if Cooper did eventually paint the miniature it is not now identified. It is interesting to see that he is mentioned in the same phrase as Hoskins, though given priority. Furthermore, Dorothy Osborne does not distinguish between the older and the younger Hoskins, which might have been expected at this date. It looks as though 'old Hoskins' was still the artist who came to mind.

The fullest recognition of Cooper's pre-eminence as a miniaturist in the Commonwealth period was accorded by Cromwell himself. He gave him the kind of patronage which had been extended to Hilliard by Queen Elizabeth I, and to Hoskins by Charles I. The association began soon after the execution of the king in 1649.

In November 1650 Lord Conway's man of affairs in London was trying to arrange a sitting for his master with Cooper, which had to be postponed because of the work to be finished for Cromwell and his family. Three years later he was portrayed by Hoskins in a miniature now in the Wallace Collection, but it is not known whether he was still waiting upon Cooper's leisure.

References to Cooper in the diplomatic correspondence of the Commonwealth show that his portraits of Cromwell were in demand for the Dutch and French statesmen, and he was called on to provide one of these portraits as part of a present to the Swedish ambassador in 1656. It was presumably earlier than this that Cromwell had sent a

miniature of himself by Cooper to Queen Christina of Sweden with the verses by Milton:

Bellipotens Virgo, Septem regina trionum,
Christina, Arctoi lucida stella poli!

The most impressive of the versions of this much-repeated portrait of Cromwell is the sketch in the Duke of Buccleuch's Collection (Fig. 26). This is unfinished, a fact which gave rise to a persistent legend. The Falkland family, descendants of Cromwell from whom the miniature passed to the Duke of Buccleuch's Collection, declared that there was a tradition in the family that Cromwell, entering Cooper's house one day, had discovered the miniaturist making a surreptitious copy from it, and had confiscated it then and there, thus accounting for its unfinished state. Unfortunately for the credit of this story, Vertue records an earlier and more reliable sequence of events, whereby Richard Cromwell bought it from Samuel Cooper for £100 after Oliver Cromwell's death.

It is an early example of a practice Cooper adopted of retaining a sketch of portraits he knew he would be called upon to repeat. He would have regarded these sketches as necessary adjuncts to his work for Cromwell or, later, Charles II; now they are valued as the works in which his genius for revealing character through portraiture reaches its fullest expression. Cromwell's famous command that his painter should not flatter him, first recorded around 1721 by Vertue, was said to have been addressed to Lely. But it is not certain that Cromwell sat for Lely, and the evidence of the actual portraits suggests that he may well have been speaking to Cooper, who in any event did carry out the instruction to 'remark all these ruffness, pimples warts & everything as you see me'. With all his realism he does give a penetrating insight into the single-mindedness of purpose and the undeviating will of the man.

The close relations he had enjoyed with Cromwell did not cloud Cooper's reception at the restored court of Charles II. The king visited him for his portrait almost immediately on his return to England. Aubrey relates the circumstances in his *Life of Hobbes*:

> I then sent a letter to him [Hobbes] in the countrey to advertise him of the Advent of his master the king and desired him by all meanes to be in London before his arrivall; and knowing his majestie was a great lover of good painting I must needs presume he could not but suddenly see Mr. Cowper's curious pieces, of whose fame he had so much heard abroad and seene some of his worke, and likewise that he would sitt to him for his picture, at which place and time he would have the best convenience of renewing his majestie's graces to him. He returned me thankes for my friendly intimation and came to London in May following.
>
> It happened, about two or three dayes after his majestie's happy returne, that, as he was passing in his coach through the Strand, Mr. Hobbes was standing at Little Salisbury-house gate (where his lord then lived). The king espied him, putt of his hatt very kindly to him, and asked him how he did. About a weeke after he had orall conference with his majesty at Mr. S. Cowper's, where, as he sate for his picture, he was diverted by Mr. Hobbes's pleasant discourse.

During his remaining twelve years of life Samuel Cooper was confirmed in the recognition that he was the premier miniaturist. His appointment as King's Limner took place before 1663, and he was then receiving a salary of £200 per annum and privileges. The king's sittings at the outset of the reign were followed by others, notably one

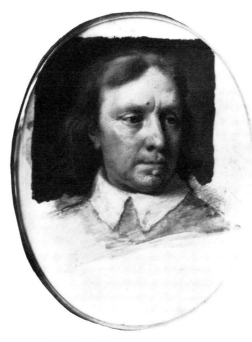

26 Samuel Cooper, *Oliver Cromwell*

attended in 1662 by Evelyn which is discussed later. They resulted in a sketch portrait, now somewhat retouched (Chiddingstone Castle Collection) from which Cooper made, amongst other repetitions, two large portrait miniatures in the full panoply of state robes and the Garter insignia. One of these, rectangular in shape, is in the Good-wood Collection (Fig. 29); the other, which is oval, is in the Mauritshuis. At the same time Cooper was employed in portraying the queen and the king's mistresses, though not in that order. He had already made a miniature of Barbara Villiers, later Duchess of Cleveland, in 1661, a date inscribed by the artist on the version in the Royal Collection (Fig. 27). The following year Catherine of Braganza arrived from Portugal for her marriage to Charles II. She sat to Cooper, presumably soon after; this resulted in a magnificent large-scale sketch in the Royal Collection, but no finished versions painted by Cooper from this model are at present known (Plate XII). A third member of the series of large sketch miniatures at Windsor, that of Frances Stuart, Duchess of Richmond, would have been painted soon after her arrival from France in 1663. Cooper was surprisingly successful in evoking dignity from the homely features of the King's brother, James, Duke of York; a particularly fine version painted early in the new reign, 1661, is in the Victoria and Albert Museum (Fig. 28).

His reputation brought to his studio sitters of renown from many different spheres of activity; statesmen such as John Maitland, 1st Duke of Lauderdale, ecclesiastics such as Gilbert Sheldon, Archbishop of Canterbury, sailors such as Sir Frescheville Holles, men of learning such as Noah Bridges, the mathematician and cryptographer. His fame

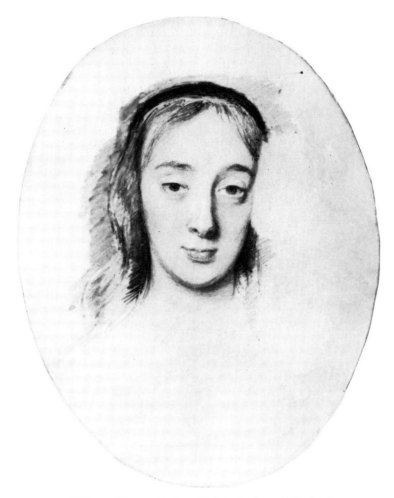

27 Samuel Cooper, *Barbara Villiers, Duchess of Cleveland*

on the Continent attracted the notice of Cosimo de' Medici, later to become Cosimo III of Tuscany. On his visit to England in 1669 he gave several sittings for his portrait in miniature. In the record of these visits discovered by Professor A. M. Crinò we find that Cooper was 'a tiny man, all wit and courtesy, as well housed as Lely, with his table covered with velvet'. The miniature, which cost the Grand Duke the large sum of £150, was completed and sent to Florence in the following year. It was deemed lost until Sir Oliver Millar located it in the Uffizi in 1965. Though damaged, it is an impressive example of Cooper's work on a big scale, and the pose, showing the Grand Duke in armour confronting the spectator from a balustrade in a landscape, is original even in Cooper's work.

There are more frequent references to Cooper's house in Pepys' diary. Their association began in 1668, when Pepys had decided to have his wife's miniature painted by

28 Samuel Cooper, *James II as Duke of York*, 1661

Cooper. On his first visit to Cooper's house Pepys saw portraits of Frances Stuart, Duchess of Richmond, and General Monk – perhaps the fine portrait of the Duchess of Richmond in man's costume and the large unfinished portrait of Monk in the Royal Collection at Windsor. The portrait of the duchess was the more poignant because she had just been disfigured by smallpox: five years before Pepys had described her 'with her sweet eye, little Roman nose and excellent taille' as 'the greatest beauty I ever saw, I think in my life'. Pepys' opinion of Cooper's limnings then was 'so excellent as, though I must confess I do think the colouring of the flesh to be a little forced, yet the painting is so extraordinary as I do never expect to see the like again'. Mrs Pepys appears to have had at least eight or nine sittings, and though Pepys was not satisfied with the likeness or the blue garment with which Cooper draped her, he paid out £38 3s. 4d. for the miniature gratefully enough. He had found Cooper good company and was delighted by his skill in music. During the course of the sittings, he gave the Sunday dinner-party, already mentioned in the context of John Hoskins, junior, among the guests at which were Samuel Cooper, John Hayls, the English rival to Lely, and Samuel Butler, the author of *Hudibras*. Hayls was a cousin of Cooper's, and a beneficiary under his will equally with members of the Hoskins family. Samuel Butler's interest in painting and music was the bond between him and Cooper: as Aubrey records, 'His love to and skill

in painting made a great friendship between him and Mr. Samuel Cooper (the prince of limners in this age).' It was, as Pepys says, 'a good dinner, and company that pleased me mightily, being all eminent men in their way'.

The constant demand for his services, and his conscientious determination not to skimp over the number of sittings, meant that he was in these days always under pressure. He was working till within a few days of his death on 5 May 1672. He was asked to hasten a portrait of Lady Exeter in April of that year, but was busy with commissions from Charles II and the Duke of York. On 4 May the letter-writer reported that Cooper had promised 'with all imaginable respect and kindeness' to finish it, but had fallen dangerously ill and would probably not live for three days. On the next day the miniature painter Charles Beale wrote in his diary, 'Mr. Samuel Cooper, the most famous limner of the world for a face, died.'

His reputation was indeed an international one. The 'Life' appended to de Piles' *Art of Painting*, 1706, says that he took one of his finest pieces, a portrait of Swingfield, to France, and it introduced him into the favour of the French court and was much admired there: also that the French king once offered £150 for his portrait of Cromwell but could not have it. The enamellist Petitot sent his son to study under him; but since the younger Petitot was dissatisfied with his tuition this was not an entirely satisfactory episode. Cooper's contacts with Holland are illustrated by the letters which passed between Constantine Huygens, junior, and Christian Huygens when the latter was in London in 1663. Constantine Huygens was a skilful amateur artist, at the time experimenting with miniature painting, and sent an example of his work to his brother with a request that he would seek the opinions of Lely and Cooper upon it. In acknowledging their criticisms he said: 'Under a master like Cooper one would soon have worked with assurance but here we are in an unlucky country.'

Further contemporary testimony of his fame on the Continent is provided by the correspondence of 1691 between Aubrey and John Ray the naturalist. Aubrey had written:

> When I was lately at Oxford I gave several things to the Musæum, which was lately robbed, since I wrote to you. Among other things my picture in miniature by Mr. S. Cowper, (which at an auction yields 20 guineas), and Archbishop Bancroft's, by Hillyard, the famous illuminer in Queen Elizabeth's time.

To this Ray, on 27 October 1691, replied:

> You write that the musæum at Oxford was rob'd, but doe not say whether your noble present was any part of the losse. Your picture done in miniature by Mr. Cowper is a thing of great value. I remember so long agoe as I was in Italy, and while he was yet living, any piece of his was highly esteemed there: for that kind of painting he was esteemed the best artist in Europe.

Ray was abroad between 1663 and 1666. Inasmuch as prices are a mark of contemporary appreciation it may be noted that in 1668 his price for the limning of Mrs Pepys was £30 (together with £8 3s. 4d. for the crystal and frame). Vertue knew of a miniature of Sir Peter Lely in the possession of his grandson on which the painter had recorded that he sat seven times for it and paid 30 guineas. In 1671 Charles Beale noted that Lely

raised his prices from £15 to £20 for a head and £25 to £30 for a half-length. It emerges that Samuel Cooper was for a time paid twice the rates which Lely commanded.

That his repute in Italy lasted after his death is shown by the concern felt by Cosimo III for acquisitions from his studio. His agents sent him lists of a score or so of miniatures left by the artist to his widow; most were unfinished, and some may have been by, or completed by, other hands. Although he had paid the highest recorded price for his own miniature by Cooper, the Grand Duke declined to pay £25 each for the works available, and the offer lapsed. Eventually the jewels of the collection, the five large miniature sketches of Queen Catherine of Braganza, the Duchess of Cleveland, the Duchess of Richmond, Monmouth and Monk, were acquired for the Royal Collection in return for a pension to the artist's widow, and are still in the Library at Windsor Castle.

Norgate remarked that in his judgment Cooper's portrait drawings were even more remarkable than his miniatures. In making such portraits Cooper was in the forefront of a movement which was to become fashionable in the late seventeenth century. The few surviving examples show that he had more considerable powers of interpretation than the specialists in the genre, such as Faithorne, Paton and White.

The description which Evelyn gives in his diary entry for January 1662 of Cooper drawing the king for the coinage (two of these drawings are at Windsor) helps to define the difference between Cooper's methods, both in drawing and limning, and those of his predecessors.

> Being called into his Majesty's closet when Mr. Cooper, the rare limner, was crayonning of the King's face and head, to make the stamps by for the new milled money now contriving, I had the honour to hold the candle while it was doing, he choosing the night and candle-light for the better finding out the shadows.

In short, Cooper applied the methods of the 'Tenebrosi' to his system of lighting, and this gives its distinctive appearance to his portraits. They are lit from high overhead, and to one side, so that the shadows of the eyelids fall upon the eyeballs, giving the half-ogling look which is almost like a signature by Cooper. This lighting brings out to the full the modelling of the opposed corner of the eye, emphasises the drawing of the nose, mouth and chin, and underlines all the marks of character, wrinkled cheeks and furrowed brows, common in that hard-living age. It also enables Cooper to observe the reflected lights cast upon the cheeks by the pendent sides of the periwig (Fig. 29). Nothing could be further removed from Hilliard's lighting 'in the open ally of a goodly garden, where no tree was near, nor any shadow at all', and the principle of a direct source of light from well in front of the sitter had been followed up to the time of Hoskins. The most apparent distinction between the later works of Hoskins and contemporary works by Cooper lies in the natural even illumination of the former, which casts but does not exaggerate the shadows, compared with Cooper's dramatic lighting.

In brush-work, too, Cooper was an innovator, because he abandoned the deliberate neat finish which had been bequeathed to his predecessors by the book-illuminators and took over from oil painting a breadth of stroke, which he does not necessarily fuse together. He generally renders his flesh tint in a warm reddish-brown tone, in place of

29 Samuel Cooper, *Charles II*, 1665

the pink over white hitherto usual in the English school of limners. Pepys, it will be recalled, thought the colouring of his flesh to be a little forced, but, either because it is less strange to our eyes or because fading has rendered the colouring less violent, Cooper's miniatures now seem to be models of harmoniously modulated light and shade.

But far in advance of any technical qualifications, the feature which marks Samuel Cooper out for the first rank among portrait miniaturists is his sense of character. In any definite historical epoch certain types of character preponderate over others and, at the time of the Civil War and the Puritan ascendancy in which Cooper was nurtured, force of personality and the more solemn values were favoured above frivolity and elegance. Samuel Cooper excels in portraying just those qualities. It would scarcely be necessary to labour the point were it not that the opinion has sprung up that Cooper was more successful in his portraits of men than of women. It is true that he does not reduce women to a formula of insipid flirtation, as does Lely in his series of Court Beauties: but when he set out to paint the portrait of a reigning court beauty, such as Barbara Villiers, Duchess of Cleveland, or Frances Stuart, Duchess of Richmond, he saw whatever there might be of solidity or worth in the beauty they presented to the microcosm of the court. He saw people *sub specie aeternitatis*, and therefore his portraits are as real today as when they were painted.

Portraits of Barbara Villiers, Duchess of Cleveland, must have been the most sought after images of the age. Cooper painted her full-face, as in the large unfinished sketch at Windsor, again turning to her left and looking to her front, as in a delicate sketch in the Victoria and Albert Museum and a completed version at Althorp, and with a covered head. These portraits were often copied both by him and by other limners; there is a copy of the last composition by Mrs Rosse. Cooper's portraits are quite consistent with other painters' view of 'the lady' but convey the impression of a beauty which is not always to be found in other renderings of her features. Whereas it was objected that Lely introduced Cleveland's melting eye into all his portraits of Court Beauties, Cooper confined himself to recording it in her case where it really existed, and looking afresh at the others. So when he came to paint Cleveland's most dangerous rival Frances Teresa Stuart, Duchess of Richmond, he evoked an entirely dissimilar image of her, with rounded, regular features, a more open and less lecherous gaze. Comparing the two portraits we can believe in the vast temperamental difference between the ambitious grasping Cleveland and the frivolous, good-hearted Richmond. His portrayal of the unfortunate Queen Catherine of Braganza steers a middle course between the contemporary reports which describe her as ugly – 'a bat, instead of a woman' – and those which call her 'lovely and agreeable'. Her swarthy complexion and projecting teeth are not too much concealed in the interests of court flattery.

Another criticism which has often been repeated by admirers of Cooper's portraits is that he was only able to draw a head. When he came to hands or bodies – so it runs since his first biographer, writing in 1695 – he lost his capacity. The legend takes force from a certain number of unfinished miniatures left by Cooper – many of them designedly unfinished, as studio sketches for repetition – and on to it has been grafted the hypothesis that the supposed inability to draw anything but heads arose from his

exclusive employment on that feature by his uncle, Hoskins. Now, in fact, the miniature of Margaret Lemon alone disproves any such claim. It is perfectly true that Cooper was dilatory, and sometimes perfunctory, in the purely mechanical finishing-off of drapery. Aubrey tells a tale which is to the point here in reference to the miniatures of Thomas Hobbes by Cooper. He relates that Cooper painted two such miniatures, 'the first the king haz, the other is yet in the custody, of his widowe; but he gave it, indeed, to me, and I promised I would give it to the archives at Oxon, with a short inscription on the back side, as a monument of his friendship to me and ours to Mr. Hobbes but I, like a foole, did not take possession of it, for something of the garment was not quite finished, and he dyed, I being then in the countrey – *sed hoc non ad rem*'.

Other than his deliberate sketches, such as the Cromwell and the large-scale group bought by Charles II, the majority of his unfinished works were those he did not have time to complete before his death. Towards the close of his life the artist was hard pressed, pursued even in spite of his high prices by more commissions than he knew how to fulfil. In 1668 the Grand Duke Cosimo III was told that Cooper would take four years to deliver any repetitions of the portraits of beautiful ladies ordered from him, since he had so much work on hand. Accordingly it is not surprising to read in the list sent to Tuscany of the miniatures left in Cooper's studio after his death the constant repetition of such phrases as 'faccia finita, et il resto abbozzato'. This shows only that Cooper followed the customary practice of painting the features of his sitters from life, leaving the drapery and background to be painted as he had leisure.

Alexander Cooper and other miniaturists of the first half of the seventeenth century

Until recently Alexander Cooper had been believed to be the elder brother of Samuel Cooper. In 1980 Mary Edmond published the record of his baptism in December 1609, thus demonstrating that he was the younger by about a year. Like Samuel, he was in the care of his uncle, John Hoskins, but even at this stage his career may have diverged from his elder brother's. For Joachim van Sandrart, whom he met in Holland in the 1640s, says that he was Peter Oliver's most celebrated pupil.

When we first meet his style it is a fully formed one, not noticeably more dependent on Peter Oliver than on John Hoskins, but his liking for lilac backgrounds, and those of even less usual colours, probably reflects the former's influence in his work. Reversing the usual trend of English art history, which was to import painters from the Continent in general and the Low Countries in particular, he went abroad as a skilled exponent of the specifically English art of miniature painting and found favour and employment in foreign courts, especially in Holland and Sweden. For that reason the student who wishes to see his output has to visit Amsterdam, The Hague, Stockholm, Gothenburg and Copenhagen.

His earliest known independent miniature is probably that described as a portrait of John Digby, 1st Earl of Bristol in the Victoria and Albert Museum. It is dated 1629 and, although not signed, it can hardly be doubted that it is by the same hand as the round portrait of an unknown man in a *schraubtaler* in the same collection, which is signed (Fig. 30). More conclusive evidence that Alexander Cooper was working on his own while his elder and yet more gifted brother was still either an assistant or a partner of John Hoskins is provided by his employment by the exiled King and Queen of Bohemia and their court. He seems to have already been abroad in Holland in 1631; he was certainly there in 1632. The evidence for the earlier date of 1631 is the inscription engraved on the back of the miniature by him in the collection of the Countess of Craven, representing the King and Queen of Bohemia and William, Lord Craven, who fought in their cause. In 1632 and 1633 he painted a remarkable series of portraits of the King and Queen of Bohemia and seven of their children; this series, framed together in a chain, was in the Kaiser Friedrich Museum, Berlin. While he was certainly on the move for the remainder of his life, the records of his journeys are tantalisingly incomplete. If it is true that he met Sandrart in Amsterdam, this meeting must have taken place before 1642, when that painter left the city. He then showed Sandrart portraits of many lead-

ing members of the English court, which suggests the strong possibility that he returned to England and worked there some time between 1633 and the early 1640s. He is definitely recorded in residence in The Hague from 1644 till 1646. Then in 1647 he was invited to work at the court of Queen Christina of Sweden. The invitation was probably conveyed by the Queen's favourite Count Magnus De la Gardie, whose miniature by Alexander Cooper is among the substantial number of his works in the National-museum, Stockholm (Fig. 31). He was one of the artists chosen by the queen to encourage the fine arts in her Court; the enamellist Pierre Signac, who was influenced by Cooper's portraits, was appointed in the same year. Alexander Cooper's name occurs in the accounts of the Swedish court from 1647 till 1657. As with painters attached to the English court, the payment of his salary was erratic. In 1652 he petitioned for eighteen months' arrears; this request appears to have failed, and in 1654 he approached King Charles Gustavus in great need, not having been paid for his works for six and a half years, and his pension then being two years in arrears. It appears that in addition to a liberal yearly salary he had the right to be paid for each miniature he painted.

The number of miniatures that Alexander Cooper painted of Queen Christina and her courtiers and, after her abdication in 1654, of King Charles Gustavus, shows that he was actively employed during those years in Sweden. But, possibly because he found it difficult to collect the payments due to him, this was not his exclusive occupation or place of work. The report of the lawsuit of 1658 in York to which he was a signatory states that he had been with his brother Samuel for three years past. It has already been noted that the clerk's report is not entirely reliable; for instance, he gives Alexander's age as about forty, when he was in fact forty-eight or forty-nine, but it provides good reason for believing that Alexander Cooper spent at least part of the years 1655 to 1658 in England. It is also certain that he accepted an invitation to Denmark in 1656. The resulting miniatures of King Frederick III, his Queen Sophie Amalie and their children are preserved in Rosenborg Castle. According to Dr G. C. Williamson he died in Stock-holm in 1660. He states that the death certificate recorded that the event took place 'at his rooms, alone, and with his brush in his hand'; but subsequent attempts to find the certificate and verify these facts have failed.

Alexander Cooper is an artist of so much talent and acclaim that it is unfortunate that the information about him is so sketchy. The recognised specimens of his miniature painting are found in a number of small clusters rather than a continuous series from which a logical development of his style could be charted. At the outset we may discern a fine and broad manner; and they seem to run side by side, for the miniature of Lord Craven in the Countess of Craven's possession is in the broad style and that of Charles Louis, Count Palatine, in the Victoria and Albert Museum, is in the fine manner. On the principle that members of the same family tend to have a common style in their formative years, we may plausibly discern in Alexander Cooper's broad manner a derivation from Samuel Cooper's development. With a freshness of vision and a bold-ness which is already emancipated from the strict tutelage of Peter Oliver and John Hoskins goes a slight tendency to chalkiness in the colour which is also to be seen at times in Samuel Cooper's work. The finer manner of Alexander Cooper is exquisite in

30 Alexander Cooper,
An unknown man

31 Alexander Cooper,
Magnus Gabriel De la Gardie

its delicacy of finish; though it had lost some of the strength of characterisation thereby. A point of particular excellence in his miniatures lies in his management of the lighting of the hair, which he makes to shine with the sheen of silk; the highlights in the costume are also drawn with the same delicate brilliance.

During the last years of his career, in Sweden, Alexander produced a number of miniatures of private citizens as well as the royal portraits for which he was allocated his pension. His acquaintanceship was varied, and among his cosmopolitan acquaintances was the philosopher Descartes. Aubrey retails Alexander Cooper's story of Descartes' mathematical instruments which, contrary to the usual elaboration in those days, consisted merely in a pair of compasses with one leg broken and, for his ruler, a sheet of paper folded double. According to this account the friendship occurred in Sweden, and Descartes was in that country from September 1649 till his death in February 1650.

His miniature of Count Magnus Gabriel De la Gardie, in the Nationalmuseum, Stockholm, is invested with a splendid degree of bravura which approaches that of Samuel Cooper, though the drawing of the hair is softer and the penetration into character less revealing. Similar qualities were evidently apparent in his portrait of Seved Bååth, which now we only know from the engraving by Jeremias Falck. These and many other of his miniatures were painted from the life; but he was also called on to copy the work of other artists, particularly in the case of the miniatures of King Charles Gustavus required in quantity after his accession in 1654, which were copied from the oil portrait by the court painter David Beck. This illustrates the rather more limited attitude of Continental courts toward portrait miniature painting which was at this time in England highly regarded as an art in its own right rather than a method of multiplying official images.

All the artists so far discussed painted their miniatures in the established medium of water-colour. Fairly soon after the establishment of the genre by Clouet and Horne-bolte some painters adopted the small size of the miniature for portraits in oil on a metal support, such as copper. Some of these had a merit above the ordinary run. An oil miniature was correctly catalogued by Van der Doort as the work of Hans Eworth, whose practice was generally in large-scale portraiture. It is a portrait of such quality that Charles I altered the attribution to Antonio Mor in a manuscript emendation to Van der Doort's catalogue. Misattributions of miniatures are common enough, but they rarely occur at this exalted level.

Cornelius Johnson, a member of the group of immigrant artists in London which included the Oliver, De Critz, Gheeraerts and Russel families was, in the main, a painter of half-length portraits, but made something of a speciality of oil miniatures. It will be sufficient to say here all that needs to be said about this poor relation of mainstream limning. Speaking generally, oil miniatures do not form so aesthetically satisfying a genre as miniatures painted in water-colours on vellum or ivory. Whether it is the greater opacity of the medium or the more obvious resemblance to reduced copies of oil paintings which gives rise to this lack of satisfying quality is hard to say. The type was overworked abroad in the production of stereotyped images of court notables, and these oil miniatures were then arrayed in bewildering numbers. The miniature room at the Uffizi was an example of such a courtly arrangement. Oil miniatures are also dif-ficult to classify and study satisfactorily because they are rarely signed, and all attempts to make much progress with their identification have been frustrated by this barrier. It is therefore in the main an anonymous branch of the art. There are exceptions, both to the general poverty of quality in oil miniatures and to their unidentifiability. A miniaturist who signed himself *F S* is thought to have been the Pole Smiadecki, who is said on flimsy evidence to have been taught by Samuel or Alexander Cooper in Stock-holm. Cornelius Johnson's few oil miniatures preserve in great measure the qualities of his work in a larger scale. A type for them is provided by the Duke of Portland's miniature, which is signed at the back – *C. Johnson Fecit 1639.*

Other miniatures attributed to him through their stylistic resemblance to this signed piece show that he was in demand for portraits of wealthy city merchants. For instance, in 1637 he painted the marriage portraits of the immensely rich Peter Vanderput and his bride Jane Hoste. His oil miniature of the slave-trader, tax farmer and Royalist Sir Nicholas Crispe (in the Fondation Custodia, Paris; Fig. 32) descended through his daughter to James Sotheby, who assembled a notable collection of miniatures in the last decade of the seventeenth century.

Cornelius Johnson was born in England in about 1593 and worked here till 1643. His work is first clearly identifiable from about 1619 onwards, so he is nearly contem-porary with John Hoskins, who among the miniaturists in water-colours most nearly recalls Johnson's reticent, shy interpretation of character. Indeed the two artists were probably acquainted, for a miniature is known on the back of which is inscribed 'Hoskins drawn by himself and by him given to Old Johnson ye painter, of whose son I bought it at Utrecht, 1700. F. St. J.'

Another and generally more pleasing parallel to limning is provided by miniature

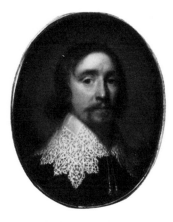

32 Cornelius Johnson,
Sir Nicholas Crispe

painting in enamel. This craft was new to Britain when Jean Petitot brought his great skill in it over from France. Enamel miniatures may be briefly described as miniatures in which the colours are fused with vitreous ground on being baked in a furnace. The colours thus obtained are permanent and have brilliance imparted to them by the glaze. The Frenchmen Henri and Jean Toutin seem to have taken the decisive step forward in applying the existing technique of ornamental enamelling to portrait miniatures in the early years of the seventeenth century, and Jean Petitot was probably their pupil. Petitot was occupied for the greater part of his long life in working for the Court of Louis XIV. We are here, however, only concerned with his English period, which comprises the earliest enamels known to be by him and forms a separate and interesting episode in his career, as well as an individual contribution to the miniature painting of these years. Petitot came to England in about 1637, perhaps earlier. He was employed by Charles I, whose cabinet contained a box-wood carving of Lucretia by him. It is not clear when Petitot returned to France; he was certainly there by 1650, but in all probability the troubles of the court in England had induced him to return many years before then. During his English period, but scarcely ever afterwards, Petitot was accustomed to sign his enamel miniatures on the back. Such signatures occur between the dates 1638 and 1643, and these probably express within a year or two the limits of his activity here. Iconographically, these enamels run parallel with one side of Hoskins' work, since they are copied from paintings by Van Dyck and other court painters, and their differences are mainly those imposed by the different medium and method of production. The Duke of Portland had in his collection five fine examples, representing Charles I, 1638; Henrietta Maria, 1639, after Van Dyck; Charles II as Prince of Wales, 1639, after Van Dyck; the Duke of Buckingham, 1640, after Honthorst; and the Duchess of Buckingham, 1640. Two in other collections, of a larger size, are dated 1643: the Duchess of Richmond (Nationalmuseum, Stockholm); the Countess of Southampton (Duke of Devonshire's Collection). All of these enamels, which already exhibit Petitot's immaculate finesse and accuracy, are copied from paintings. It is singular however that

among the countless miniatures he made of Louis XIV during his subsequent career parallels with existing paintings are rarely recorded. It is said that the king used to give him one or two sittings to complete work begun from portraits in oil. And among his English enamels was one for which a larger scale original has not been found – his portrait of Mlle Kirk, 1639.

Sir Theodore Turquet de Mayerne discovered 'the purple colour necessary for the carnation tints in enamel painting' during his researches into artists' methods, and it may be supposed that he imparted this knowledge to Petitot. His return to France did not entirely sever his connections with English art (Fig. 33). He made some copies of miniatures by Samuel Cooper, and sent his son Jean Petitot junior, to study with that master before he had attained the age of nineteen. If Vertue's account be correct, the younger Petitot did not find this instruction helpful and soon returned to France. He was back in England five years later, apprenticed to another, unnamed miniaturist, and did some work for Charles II. The next important event in enamel miniature painting in England was the arrival of Charles Boit from Sweden in 1687, described in Chapter 10.

The last of the miniaturists working under the shadow of Van Dyck and in imitation of Hoskins to concern us here is David Des Granges. He was baptised as a Huguenot in London in 1611. In 1636 he married Judith Hoskins, presumably a relation of the miniaturist. In his loyalty to Charles II he followed him in his flight from the Parliamentary forces and was appointed His Majesty's Limner in Scotland in 1651. Twenty years later he petitioned the King for £72 still owing to him for thirteen miniatures of Charles II executed by him in or around 1651 in Scotland. In the petition he says that he is old and infirm and his sight and labour are failing him, he is disabled thereby from getting any subsistence or livelihood for himself and his impotent children, and forced to rely on charity. It seems probable that he did not long survive in this pitiable condition.

The first known artistic employment of Des Granges was as engraver; in 1628 he engraved the painting by Raphael of *St George and the Dragon*, of which a miniature copy was made by Peter Oliver. His name also appears on engraved title-pages. The earliest dated miniature by him is that at Windsor Castle, said to represent Catherine Manners, Duchess of Buckingham; it is signed in his usual way with the initials *DDG* arranged in a triangle, and dated 1639. A signed miniature in the Victoria and Albert Museum, however, shows a man in the costume of not later than 1630 (Fig. 34). In 1640 he carried out his most ambitious limning – a miniature copy of Titian's *Marquis del Guasto with his Mistress* at Ham House. Were this not signed with his name in full, it would in all probability be accepted as a work by Peter Oliver, who had copied the same original in the Royal Collection.

The quality of Des Granges' miniatures ranges from the modestly pleasing to the frankly ill-drawn. Probably he was at his most confident when he had an original by Van Dyck or Hoskins before him as a model. Iconographically his independent portraits of Charles II in Scotland are valuable, as they show the king's features in the period between his youth and the settled, dissipated face of his later years, and when he was out of the range of more illustrious portrait painters. Des Granges also shows some

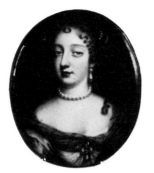

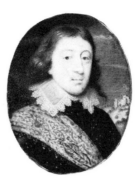

33 Jean Petitot,
Frances Teresa Stuart,
Duchess of Richmond, 1669

34 David Des Granges,
An unknown man

originality in his sense of colour. He often gives to his miniatures light-brown or dark-grey backgrounds which make a subdued harmony of tone with the colour of the sitter's costume and complexion. His work in oils is less well known than his miniature painting but potentially of more interest. After some hesitation the traditional attribution to him of the large canvas *The Saltonstall family* in the Tate Gallery is now upheld. Though the composition is naive the painting has an intimate sensitivity unusual in Stuart portraiture. Although Des Granges is really a minor artist Sanderson published in 1658 the opinion that he was a 'rare Artisan', linking his name with those of Soest, Lely, Walker and Wright.

Chapter 8

Thomas Flatman, R. Gibson and other mid-seventeenth-century miniaturists

Of the disciples of Samuel Cooper, Thomas Flatman was at once the closest and the most successful. There is no documentary record of Flatman having been taught by Cooper, but his work gives unmistakable testimony for the supposition that if he did not actually receive verbal and practical instruction, he had a succession of Cooper's miniatures to draw on and copy, and assimilated a considerable part of their spirit as well as their technical method.

We are always inclined to suspect the man who practises more than one profession as a Jack of all trades and master of none, and it is probable that this feeling has unjustly depreciated the esteem in which Flatman's miniatures are held. For Flatman was in his own day accounted as, in the main, a successful poet, and he was also called to the Bar. These facts may have spread the idea that he was a gentleman dilettante, and amateur, in the craft of limning; but both in quantity of output and in quality he was of professional standing. As the history of seventeenth-century miniature painting becomes clearer, the more exact does Vertue's judgment seem: 'He may well deserve the Title of a Master in the Art of Limning and indeed equal to Hoskins, senior or junior, and next in imitation of Samuel Cooper.'

This versatile man was born in 1635; he was educated at Winchester and New College, Oxford. He entered the Inner Temple in 1655, eventually being called to the Bar in 1662. He was already becoming known as a poet by 1658. In that year he wrote some satirical verses on the absurdly conceited Samuel Austin the Younger which were published in 'Naps upon Parnassus'. Among his fellow contributors to this volume were Thomas Sprat and Samuel Woodford, both of whom played an influential role in his future life. Sprat, later bishop of Rochester, was to become the historian of the Royal Society, and it was presumably through his encouragement that both Woodford and Flatman became Fellows of that institution. Flatman shared rooms in the Inner Temple with Woodford, and the portrait he painted of him in 1661 is one of his earliest known works (Fitzwilliam Museum, Cambridge). His interest in this art is heralded by other verses by him also printed in 1658 and prefixed to Sanderson's treatise *Graphicê*. In this he wrote about the sun that

> The blushing fruits, the gloss of flowers so pure
> Owe their varieties to his miniature.

In 1661 he is referred to in the diaries of Charles Beale, senior, as the painter of miniatures of himself, his wife Mary Beale, and their two children. This marks the progress of a lifelong friendship, one consequence of which was that Samuel Woodford, who had met the Beales' daughter Alice through Flatman's introduction in 1659, married her in 1661.

The dominant living English poet at the Restoration was Abraham Cowley. Flatman's attempts to imitate his Pindaric verses were hardly successful and Rochester castigated them, saying that he 'rides a jaded muse whipt with loose reins'. As the tally of his friends amongst the clergy – Tillotson, Sancroft, Sprat, Woodford – shows, Flatman was of an earnestly religious disposition, and his more admired verses were composed in a spiritual vein.

Professor Saintsbury has justly described his autobiographical poem 'The Review' as a 'remarkable *Religio Laici* for the time'. This poem is dedicated to Sancroft, then Dean of St Paul's and later Archbishop of Canterbury, who was a relation of Flatman's. A number of letters from Flatman to Sancroft have been published, in which he writes with excessive deference and subscribes himself 'meanest kinsman' or 'poor kinsman'.

Other letters addressed to Charles Beale in the Bodleian Library, Oxford, are written in an effusive spirit of friendship and an exaggerated alternation of spirits which at one stage prompts Flatman to suggest his suicide by drowning to avoid his worries – prominent among which was a small debt which he owed to Charles Beale. A morbid preoccupation with the thought of death was a constantly recurring theme in Flatman's life, as his poems, with their succession of genuinely felt funerary odes, bear witness.

Flatman was appointed a Fellow of the Royal Society in 1668, the year after Cowley's death. We must suppose that this was due as much to his repute as a poet and his friendship with Sprat as to his fame as a limner. There is no evidence that he took any marked interest in experimental science: and if the aim was simply to carry out the Society's intention of promoting 'the perfection of Graving, Statuary, Limning, Coining' Cooper, then at the height of his powers, would have been a more obvious choice.

Amongst Flatman's satirical pieces is a Bachelor's Song against marriage. He kept to this precept till he was thirty-seven but was then, as Anthony à Wood puts it, 'smitten with a fair virgin; and more with her fortune'. He died in 1688; and it has been suggested, though on slender grounds, that à Wood's enigmatic description of the event, 'at length he gave way to fate', implies that he committed suicide. His son had died before him, and both were buried in St Bride, Fleet Street. His sitters were drawn from a wide range of Restoration society including statesmen and learned men. Among his friends, apart from the clergy and members of the Royal Society, were the musicians Purcell, Blow and Pelham Humfrey and the writers Izaac Walton and Charles Cotton. His tribute to the engraver William Faithorne has survived the general neglect into which his verse has fallen:

> A Faithorne Sculpsit is a charm can save
> From dull oblivion, and a gaping grave.

Two phases may be discerned in Flatman's style of portraiture. The earlier phase

copies with extreme literalness the characteristics of the duller type of Cooper portrait, and in the process loses most of the power of the original. This phase is typified by such signed and dated works as the portraits of an unknown lady, 1661, and of Charles Beale, senior, 1664 (both in the Victoria and Albert Museum; Figs. 35 and 36). These are all good, painstaking likenesses, which show that their maker had a genuine flair for portraiture, but they are timid in touch, unpleasing in the brown flesh colour and rather gloomy in mood. A useful point to notice for the identification of other examples is the prevalence in them of sky backgrounds characterised by a harsh blue, not found in Samuel Cooper's works. Afterwards Flatman's style becomes broad, self-confident, both more original and more intelligently dependent on Cooper's. To this later phase belong the majority of Flatman's extant miniatures; notably the brilliant self-portrait of 1673 (Fig. 37) and the portrait said to be of Abraham Cowley (both Victoria and Albert Museum: the latter Alan Evans Collection; Plate XIII). The study of old master painting indicated by the magnificent miniature copy of *David and Goliath* from the original in the Royal Collection by D. Feti (Flatman's copy is dated 1667 and is in the Victoria and Albert Museum) may partly explain the origins of his later manner. Whatever the reason, his use of generalised drapery in the form of a toga, and the way in which the features of his sitters fill out the oval in which they are portrayed, give his later miniatures a classical, Roman presence which is his totally individual contribution to mid-seventeenth-century portraiture.

The extent to which these mature works of Flatman have been mistaken, or passed off, for those of Samuel Cooper is sufficient evidence for their quality and their affinities of style. When, as has happened more than once, the signature of Samuel Cooper has been fraudulently added to Flatman's miniatures the resulting confusion is understandable, but they have an entirely distinct spirit and style of their own. The coarseness, the *gran maniera* of Cooper, is carried to an extreme in them, and little or no attempt is made to fuse the distinct, broad brush strokes into the semblance of a rounded surface. The originality of Flatman's interpretation of character resides in a certain susceptibility to the expansive, the temperamental and the heroic in his sitters. Sometimes this tends merely to a sense of braggadocio, but when Flatman is concerned with his own circle of friends, as for instance with Samuel Woodford and Charles Beale, senior, he produces a penetrating and sympathetic portrait.

The links between Flatman and the Beale family were firm and long-lasting. Charles Beale, senior, a civil servant who became Deputy Clerk of the Patents Office, acted as Mary Beale's studio assistant and as a colourman. He was content to squander the proceeds of his wife's hectic activity as a professional portrait painter, which he chronicled in great and valuable detail. However Mary Beale found time to compose a fifteen-page manuscript on Friendship beginning 'Friendship is the nearest union which distinct souls are capable of.' We get the impression in the Beales' circle of a rather 'Bloomsbury' group of young intellectuals, somewhat introspective, and self-consciously trying their hand at more than one art; or, to be less anachronistic and more geographically correct, a 'Bury St Edmunds' group. The west Suffolk connection begins with Richard Cradock, rector of the parish of Barrow, near Bury St Edmunds, in the early seventeenth century. His daughter Priscilla married Richard Thach and became

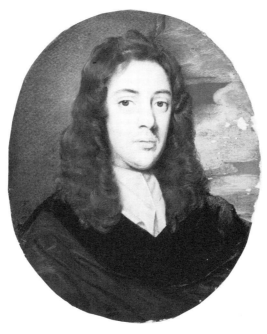

35 Thomas Flatman, *Charles Beale*, 1664

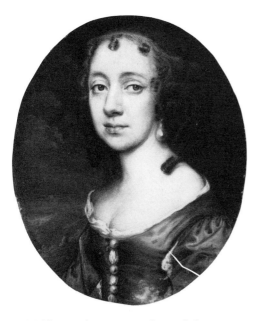

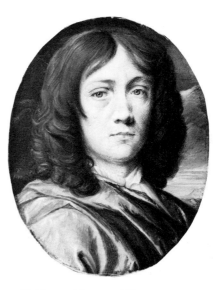

37 Thomas Flatman, *Self-portrait*, 1673

36 Thomas Flatman, *An unknown lady*, 1661

the mother of Nathaniel Thach, also of Barrow. Richard Cradock was something of an amateur painter and left his prepared cards to Nathaniel Thach, who became a miniaturist of considerable accomplishment. The few works by him which have recently been disinterred indicate that he took over Alexander Cooper's role as miniaturist to the Palatinate family in the mid-1640s at the period when his predecessor was leaving Holland for Sweden (Fig. 38). He left so little trace of himself in England that the indefatigable archivist George Vertue had never heard of him; possibly his entire professional career was spent on the Continent.

Matthew Snelling, another minor miniaturist, was a near-contemporary of Thach. He was baptised in King's Lynn, in 1621, but was taken at the age of four to Horringer when his mother remarried in 1625. There he was in a parish near to Barrow, under the shadow of the Hervey family of Ickworth who were among his early patrons. Snelling's career can be traced from the 1640s till the 1670s in a succession of dull miniatures, though he could occasionally improve on his dry, brown scratchy style, as in the portrait of an unknown man signed and dated 1663 in the Victoria and Albert Museum (Alan Evans Collection; Fig. 39). Whatever his reputation may have been in his own time, by the early eighteenth century it had sunk to that of a dilettante. Vertue, apparently relying on gossip from the husband of Susan Penelope Rosse, wrote 'This Mr. Snelling was a gentleman and seldom painted unless for Ladies with whom he was a mighty favourite and a gallant'; he also believed him to have acted as pander to the Duke of Norfolk's second marriage. In fact the known works by Snelling are fairly equally divided between portraits of men and of women. Snelling supplied colours to Charles Beale, and once was accused by him of offering too low a price for a painting by Rottenhammer, which was for sale.

Richard Cradock was succeeded as rector of Barrow by his son John Cradock in 1630. His daughter Mary was baptised there in 1633 and married in the same church in 1652 to Charles Beale. In addition to her extensive practice as a portrait painter in oils Mary Beale is said to have painted some miniatures. A miniature said to represent Henry Somerset, Duke of Beaufort (Beauchamp Collection) is inscribed with the monogram MB, and therefore believed to be by her, but little progress has been made in establishing an *œuvre* for her on this basis. More is known about her son Charles Beale, junior, who was put to study limning with Flatman in 1677; before then he had been given a taste of the artistic world through being shown Lely's collection when he was twelve and being painted by Lely when he was fourteen. His father's account-books record how he paid £3 when Charles was attached to Flatman, a sum he was to work out. The same note-books record the purchase of 'abortive skins' for his work and the expenditure of £1 15s. on a desk for him.

Vertue alleged that Charles Beale practised as a miniature painter for four or five years only and then gave it up because his sight would not stand the strain. The dated miniatures by him have, however, a span twice as long as this account implies: two in the Victoria and Albert Museum are dated 1679, and one of a man, in the Duke of Buccleuch's Collection, is signed and dated 1688. He may well, however, have given up the profession long before his death, which is believed to have taken place in 1726; he continued to paint in oils, and a number of works in his studio were impounded for debt

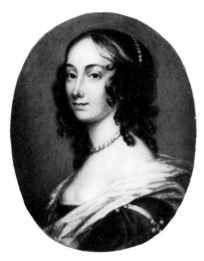

38 Nathaniel Thach,
Louisa Hollandina, Princess Palatine

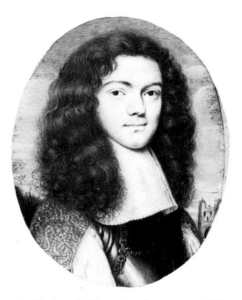

39 Matthew Snelling, *An unknown man*, 1663

on his death. His most original work consists of his intimate studies in red chalk of his family and friends, of which there is a large collection in the British Museum.

Little of the merit and not much more of the style of Flatman is to be seen in Charles Beale's miniatures. At most the influence seems to have come from the earlier and less broad of Flatman's manners. He is at his best when copying oil paintings in little, as in the agreeable copies in the Victoria and Albert Museum after Lely's self-portrait and Van Dyck's portrait of the Archbishop of Ghent. Beale's miniature of Archbishop Tillotson at Windsor is a copy of his mother's oil painting (Fig. 40). The companion miniatures of the Earl and Countess of Lauderdale painted by him in 1688 and now in the Victoria and Albert Museum show the weaknesses of his drawing; the scratchy hatching, especially in the background, and the flabbiness of the hands, confirm Vertue's statement that 'his sight would not bear the practice'.

The main interest of such mediocre talents as the monogrammist DM (probably Daniel Myers) and William Claret (d. 1706), both of whom worked in the early days of the Restoration, is to show that there was a growing demand for miniature portraits, not all of which was satisfied by the leading artists. This may partly have been due to the cost involved: Norgate, in his *Miniatura*, writes that the art is 'soe profitable (Noe painting in the world soe well paid for as Lymning)'.

The somewhat higher standards required by the court are exemplified by the long career of Richard Gibson, who was a dwarf. The early statement that he died in 1690 in his seventy-fifth year suggests that he was born *c.* 1615, and although this has been questioned there seems no good reason to doubt it. He is further said to have become page to a lady in Mortlake, and to have received some instruction from Francis Cleyn, then director of the Mortlake tapestry works. He entered the service of Philip Herbert,

Earl of Pembroke, the Lord Chamberlain, and by this means attracted the attention of the king. The first record we have of his activity as a limner occurs in 1639, when Charles I instructed him to make a copy from Peter Oliver's limning of Titian's *Venus and Adonis*. The note about this, in Van der Doort's idiosyncratic phonetic spelling, reads 'tis pis auff ardonis Was te noffember 1639 bij me diliffert tu da kings hands inde kabint and bij his M agen diliffert tu dick melort chamberlings dwarff vor tu kopit and den tu restorit agn vorda kings us tu de kabnt'. Or in modern spelling. 'This piece of Adonis was the November 1639 by me delivered to the King's hands in the cabinet and by his M[ajesty] again delivered to Dick my Lord Chamberlain's dwarf for to copy it and then to restore it again for the King's use to the cabinet.' A further note indicates that the Duke of Lennox, Mr Trevor and Endymion Porter were present at this vividly described scene in the Cabinet Room at Whitehall, which evidently impressed Van der Doort with a keen sense of the king's gracious condescension. The copy made by Gibson is now in the collection of the Marquess of Exeter at Burghley House. Gibson's miniature copy of Titian's *Marquess del Guasto with his Mistress*, now in the Portland Collection, is dated 1640, and may well have been made from Peter Oliver's limned copy of 1629, rather than from the original then in the King's Collection. The copy of the same composition by David Des Granges, already mentioned as now being at Ham House, is also dated 1640.

There was a tragic sequel to Gibson's activity for the king. Van der Doort hanged himself in the summer of 1640, according to Sanderson because he could not find a miniature by Gibson, *The Parable of the Lost Sheep*, which had been entrusted to him. The episode is poignant for any who may now have miniatures under their charge, but they may take courage from the sequel, since after Van der Doort's death this piece was found in his estate and returned to Charles I. Nothing further is known of it, and it is not clear whether it was an original composition or a copy from an oil painting.

The king had found wives for Van der Doort and Van Dyck, and steps were taken to choose one for Richard Gibson. A bride was found for him of the same height – 3 feet 10 inches – as himself, and the marriage of this picturesquely matched pair inevitably intrigued the courtiers. The poet Waller wrote upon this occasion his verses:

> *Of the Marriage of the Dwarfs*
> Design or Chance make others wive,
> But Nature did this match contrive:
> Eve might as well have Adam fled,
> As she deny'd her little bed
> To him, for whom Heav'n seem'd to frame,
> And measure out this only dame . . .

and so on for another sixteen witty lines. The marriage took place on St Valentine's Day, 1641.

Richard Gibson is said to have painted miniatures of Cromwell, but none are known at the present time. After the Restoration there is a reference to him in a letter in the Earl of Halifax's possession; this letter is addressed to the first Viscount Ingram by his man of affairs in London, John Booth, and dated 7 December 1664. The relevant extract runs:

40 Charles Beale, junior,
Dr John Tillotson, Archbishop of Canterbury

I cannot possibly prevail with Gibson the Painter to finish my Ladies Picture by express from the King he is so taken up in copying out 2 of the Countess of Castle Main that he will not intermeddle these 10 days with any other, and the great Picture must also waite his leisure without which he cannot worke. Mr. ffranklin saith he will take care to send them as soon as the little one is finished.

Here is evidently a proposal for a miniature to be copied from an existing oil painting. A miniature of the Countess, Barbara Villiers, who was subsequently made Duchess of Cleveland, in the Wallace Collection, may well be one of those referred to in Booth's letter, since it is copied from an oil painting of *c*. 1664 by Lely, and appears to be by Gibson. The association between Lely and Gibson was of long standing. Lely's double portrait of the dwarf and his wife Anna is in the Kimbell Art Museum, Fort Worth, Texas. Another painting by Lely, variously known as 'A sleeping shepherd' or 'A sleeping dwarf', of the late 1640s, is thought almost certainly to represent Richard Gibson. Much later, in 1672, there is a record of Gibson accompanying Lely on a visit to watch Mary Beale at work.

Richard and Anna Gibson had nine children, and the five who lived were of normal size. Susan Penelope Gibson will concern us later as a miniature painter in her own right under her married name of Rosse. Gibson was appointed drawing-master to the daughters of James II, Mary and Anne, both subsequently to become Queens of England, and his association with Mary was so close that he accompanied her to

41 Richard Gibson, *Elizabeth Dormer, Countess of Carnarvon*

Holland on her marriage with William of Orange in 1677. He resided at The Hague on and off till 1688. While he was there his other daughter, Anna, became involved in matrimonial difficulties which attracted the attention of local gossip and the law. Marinus van Vrijbergen, the young son of a statesman, had become intimate with Anna, and after plighting his troth to her secretly in front of a Roman priest in November 1679, lived with her as his wife. When she became pregnant he urged her to return to England to await her child. A girl was born in 1681 and named Elizabeth after Anna's mother-in-law. In the meantime Marinus declared, in January 1681, that he had resolved to marry another girl, a young widow without means, by whom he had a child. Susanna Huygens, writing to Christian Huygens about this affair at the time, says of the family of the dwarfs, 'ces deux créatures ont mis aux monde deux fort belles filles, dont l'une a touché la cœur de ce jeune Blondin'. Richard Gibson brought a case before the court in September 1681 to defend the rights of his daughter, and secured a judgment that the two were to be married openly. In December 1682 Anna promised not to seek legal means to force her husband to live with her; but it appears that the episode ended well, for Marinus van Vrijbergen was sent as envoy extraordinary to England in 1702 and married Anna Gibson openly in London. She had continued to use her married name since the earlier ceremony in 1679.

Richard Gibson himself seems to have returned from Holland to England on the accession of William III and Mary in 1688, and he died in 1690.

Apart from the copy after Titian of 1640 in the Portland Collection the miniatures by

42 Richard Gibson, *Louise, Duchess of Portsmouth*, 1673

Richard Gibson which are firmly documented under that name were produced later in his career. A limning of Elizabeth Dormer, Countess of Carnarvon, in the Yale Center for British Art bears a contemporary attribution to him and may be dated *c.* 1665 (Fig. 41). His pencil portrait drawing of a girl in the British Museum is signed and dated 1669. The miniature of Lady Isabella Dormer is signed and dated 1671, and the miniature of Louise de Kerouaille, Duchess of Portsmouth in the Uffizi is signed and dated on the back *R Gibson fecit, 1673* (Fig. 42). The study of the Gibson *œuvre* has been complicated by the existence of a series of miniatures, closely similar in style, which are signed *DG*. For about half a century it has been believed that these are the work of another, probably related, miniaturist, D. Gibson, about whom nothing else was known. John Murdoch has recently put forward a powerful argument for regarding the works signed *DG* and those signed *RG* as by one and the same hand. On this hypothesis the earlier signature *DG* would be interpreted, as Vertue recorded it, as the mark of Gibson the dwarf. This helps to account for a great deal which is otherwise mysterious. The works signed *DG* are clustered round the later 1650s; a miniature of Elizabeth Dormer, Countess of Carnarvon (formerly Lord Wharncliffe's), is dated 1657 and one of Lady Katherine Dormer in the Victoria and Albert Museum is dated 1659.

As Murdoch shows, this circle of patrons comes from the lineage of the former Lord Chamberlain, Philip Herbert, Earl of Pembroke, and his Carnarvon descendants, who were strong patrons of Lely. In fact, Richard Gibson, who had entered the service of Pembroke in the late 1630s, was still receiving an annuity from that connection in 1677. The case for identifying D. Gibson with Richard Gibson is strengthened by the fact that there is no independent evidence for the separate existence of the former in the contemporary archives.

We might be tempted to keep the options open by the consideration that it is highly unusual for an artist to change the initial letter of his signature in mid-career. We may also reflect on the fact that Vertue is not always accurate even when he has access to well-attested information. Although he met Peter Cross, his mistake in naming him Laurence or Luke Cross has only recently been rectified. If he was right about Gibson, and he certainly got his information from his son-in-law Michael Rosse, I would expect the 'D' of the earlier signature to stand for 'Dick' rather than 'Dwarf'. The notorious pride of dwarves makes the latter unlikely, and Van der Doort's account of the scene in the King's Cabinet Room which so impressed him shows that Gibson was called 'Dick' by his associates in the court.

It might also be possible to maintain that there is a stylistic distinction to be made between the works signed D. Gibson, which have very pronounced parallel striations and those signed Richard Gibson, which are softer in modelling. But these are probably the natural variations to be expected in a long career, and on balance it is reasonable to assign the whole group to Richard Gibson alone.

Susan (or, to be more exact, Susannah) Penelope Rosse, the daughter who followed the profession of her father Richard Gibson in miniature painting, was born about 1655. She married a rich jeweller, Michael Rosse, and all her known signed miniatures were painted after her marriage, being signed either *SPR* or *SR*. She died in 1700, but her husband was living at least as late as 1734 and was the source of George Vertue's information about Gibson the dwarf. It was in Rosse's collection (Vertue spells the name Rose) that Vertue also saw the portrait by Lely of Gibson, Gibson's bow (for he was an enthusiastic archer) and other portraits of him and his wife. Vertue also says, no doubt relying on Rosse's statements, that 'her first manner she learnt of her Father, but being inamoured with Cooper's limnings she studied and copied them to perfection'. This was a sufficiently natural course of affairs, and is borne out by her extant miniatures.

One of the largest groups of her work is in the Victoria and Albert Museum. These were part of the contents of a wallet traditionally known as 'Samuel Cooper's Pocket-Book', in the erroneous belief that all fourteen miniatures which it contained were by that artist. Closer examination has revealed that four unfinished portrait sketches are indeed by Cooper, including one of the much portrayed Duchess of Cleveland. Nine of those remaining are by Mrs Rosse. They are mainly portraits of her family, including two probable self-portraits, and miniatures of her father-in-law Christopher Rosse, his daughter Mary, who became Mrs Priestman, and the artist's sister Anna Gibson, whose marital difficulties with Marinus van Vrijbergen have been described (Fig. 43). It is an unusually interesting set of portraits of a circle of people, painted *c.* 1690, who were

43 Mrs Susan Penelope Rosse,
Mrs Marinus van Vrijbergen

linked by their family ties and their common district of residence in Covent Garden, rather than through prominence in politics or at court. The circumstance that four of Cooper's sketches were grouped with these intimately personal portraits of Mrs Rosse's family reinforces the belief that she had close contacts with him. Whether this association amounted to receiving tuition from him is not known, though there is nothing improbable in the suggestion; they were near neighbours and if the estimated date of her birth is correct she will have been about seventeen years old when he died. Another link between the families has been established by the discovery that her father-in-law Christopher Rosse probably moved into Samuel Cooper's house after his death in 1672. He left this property to his daughter Mary and her husband Henry Priestman, who had bought all the contents of Samuel Cooper's house from his widow.

An even larger number of miniatures by Mrs Rosse remained in the possession of her husband Michael Rosse after her death. They were included in a sale of his entire collection held at his house in Cecil Street. The dispersal was to continue till everything was sold, since Mr Rosse intended 'to retire into the Country for the Recovery of his Health'. The miniatures included at least eleven by Richard Gibson, ten by Samuel Cooper and thirty-two by Mrs Rosse. They were something of a drug on the market, or had too high reserves placed upon them at the outset, since almost everything included in the first week of the sale was offered again in the second series of sales three weeks later. Among those by Mrs Rosse were some religious pieces after Palma Vecchio and Van Dyck and her copy of Correggio's *Venus and Mercury*. No subject limnings of this nature by her are at present known. Then there are some *ad vivum* portraits, including one of the Moroccan Ambassador which attracted the attention of Vertue, who noted that it was a rectangular half-length measuring eight inches by six, and dated 1682; an

44 Mrs Susan Penelope Rosse,
Mary of Modena, Queen of James II

exceptionally large size in her work. The sale also included her copies after Cooper's portrait of the Countess of Sunderland, and from some at least of the five portrait sketches at Windsor. One of these, of the Duke of Monmouth, is now in the Buccleuch Collection. Comparison with the original shows that Mrs Rosse tried hard to emulate Cooper, but succeeded only in producing a weaker version of his style with a thinner brush-stroke and less effective balance of light and shade. Almost her most attractive works are those of very small compass, such as that, just over an inch high, of a lady, in the Victoria and Albert Museum and one of similar dimensions, of Mary of Modena, in the Royal Collection at Windsor Castle (Fig. 44).

Nicholas Dixon and P. Cross

The career of Nicholas Dixon began at the same time as or shortly after that of Thomas Flatman; but to show that the style of Samuel Cooper did not completely dominate post-Restoration miniature painting in England, it is necessary only to compare the contemporary work of these two artists. From the evidence of his earliest works we may conclude that Dixon was a pupil of Hoskins. His miniature of Sir Henry Blount in the Beauchamp Collection at Madresfield Court is datable from the costume to the early 1660s and is closely allied to the style of Hoskins at the same time. Other miniatures signed by Dixon and bearing dates in the 1660s are known, and tell the same tale – for instance, that of Frances Brooke, formerly in the Pierpont Morgan Collection, dated 1667, and that of a man dated 1668, formerly in the Pfungst Collection. Though his style became fully individual, and then deteriorated, Dixon never seems to have felt the inclination to copy the differentiating characteristics of Cooper's lighting and *gran maniera*. This fact is the more significant since he was well enough established by 1673 to be appointed limner to Charles II in direct succession to Samuel Cooper. He also received the appointment of Keeper of the King's Picture Closet and was supposed to receive a yearly payment of £200 for these official positions.

The chief technical evidence of Dixon's dependence on Hoskins is to be found in his soft, undramatic modelling of the face. In spirit also he has inherited as much of Hoskins' shy intimacy as could reasonably be carried over into the court circle of Charles II. His original characteristics are a rather scratchy line and a reddish-brown flesh colour which he applies fairly indiscriminately to all casts of complexion and, most conspicuous of all, the 'Dixon eyes'; although he had avoided the impact of Cooper's manner, Dixon had fallen heavily for Lely's mannerisms as seen as their most idiosyncratic in the 'Beauties of Hampton Court'. From these he has borrowed, in addition to derivations of pose, the half-closed elongated eyes which convey languorous lasciviousness (Fig. 45).

It is instructive to compare 'Dixon eyes' with 'Cooper eyes', for the differences between them provide a measure of the different calibre of the two miniaturists. 'Cooper eyes' are formed by a violent cast shadow, but the course of the shadow seems to be studied afresh in each case, and does not deform the natural shape of the eye. The hollow between the temple and the edge of the eye is picked out by the lighting, and the shadow inside the top lid and on the eyeball is graduated. Dixon does not use such

violent lighting as Cooper but, relying apparently more on a formula than on obser-
vation, he draws a shadow of uniform thickness under the top lid, modifies the shape
of the eye into a long almond-like oval and produces a slightly goitre-like protuberance.

Setting aside these tricks, which become more pronounced in his later works, and
eschewing invidious comparison with Cooper, Dixon made an impressive contribution
to the portraiture in miniature of the late seventeenth century. The quiet good manners
of tone which he took over from Hoskins make his work less immediately effective than
Flatman's, but he had as much insight into the characters of his sitters. From about
1680 onwards his work fell off. The colour becomes more straw-like, the drawing less
careful. The causes may have lain partly in his financial difficulties, partly in the time
he was spending on making miniature copies of oil paintings.

Dixon had begun to work on a relatively large scale as early as 1668, when he painted
a rectangular miniature of Anne, Countess of Exeter, her brother William and their
page (Burghley House). This is a composition of three half-lengths in a landscape, and
derives from the example of Van Dyck and Lely. In forming a series of limnings after
Old Masters he was not, it seems, working for a commission but forming the collection
as a speculation. This approach is different from that originally adopted by Peter Oliver
who, like Richard Gibson, was commanded by the king to make his copies from works
in the Royal Collection. But, as we have seen, Peter Oliver also made second copies for
his own use; so, to judge by their presence in Michael Rosse's sale, did Susan Penelope
Rosse. Dixon adopted a new and more active approach to the marketing of his
limnings. In 1685 he held a lottery of 'excellent miniature paintings'. We do not at
present know whether this was a success, but in 1698 he promoted another lottery
consisting both of cash and limnings which Vertue described:

> The hopefull Adventure, a Lottery sett up in 1698, to be drawn at Mr. Dixon painter in St.
> Martins lane principal contriver – and at his house was a collection of pictures to be seen which
> was to have been one of the prizes. The whole summ £40,000 divided into 1214 prizes, the
> highest prize in money £3000 and the lowest £20 amounting to £37000 pounds besides one
> prize of a collection of Pictures in limning not to be equalled anywhere if this collection falls into
> the hands of any person that don't understand them or will part with them they shall receive for
> them £2000 in Money of the Proposer, the purchase of one Ticket 20 shillings Her Royal
> Highness Anne Princess was an adventurer.

The hopeful adventure miscarried so far as Dixon was concerned, for in 1700 he was
fain to mortgage a collection of seventy miniature paintings, doubtless the lottery prize
specified. This collection was transferred in 1708 to the Duke of Newcastle for the sum
of £430; they descended through Lord Oxford to the Duke of Portland's cabinet at
Welbeck Abbey. Only thirty of the seventy remain, yet they cover a wide field of paint-
ing. There are among them copies, mostly about ten inches by eight inches or more in
size, of pictures by Dou, Poelenburgh, Cornelisz van Haarlem (*The Miracle of
Haarlem*), L. Carracci (*Cleopatra* – the picture at Hampton Court), Guido Reni,
Elsheimer (*Ceres in Search of Proserpine*), as well as portraits of James II, William III
and other notabilities. The only repetition of a subject in Peter Oliver's repertoire of
copies is that after *Mercury Instructing Cupid in the Presence of Venus* by Correggio,
and Dixon's copy in this instance is reversed. If the two landscapes, one a *Landscape*

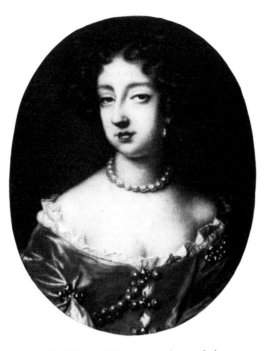

45 Nicholas Dixon, *An unknown lady*

representing Spring, in this collection are Dixon's own invention, as, for all we know to the contrary, they may be, they entitle him to a place among the followers of the medieval illuminators and one of the few miniaturists of the time to have taken to his heart Norgate's recommendation in *Miniatura* of landscape as a subject for the limner.

There is nothing to show what led Dixon into so ambitious a project. The titles of the forty miniatures which are no longer at Welbeck Abbey have survived and show that these seventy miniature subjects comprised a fairly comprehensive anthology of mythological and religious pieces. They are far greater in number than those made by Peter Oliver for Charles I. If Dixon, as Keeper of the King's Picture Closet, hoped that some might fill a similar position in the collection of Charles II it seems that the only acceptable subject was that described in the 1687 catalogue of the Royal Collection as 'An immodest piece, a limning'.

His signature of 1708 agreeing to the transfer of his seventy limnings to the Duke of Newcastle is the last dated reference to Dixon. Vertue says that he died in the King's Bench Walks, where he was avoiding prosecution, presumably for debts incurred over his lottery bubble. Neither the date of his birth nor that of his death is as yet known. His usual signature was *ND* in a monogram, the right-hand stroke of the *N* forming the left-hand stroke of the *D*. There is a representative group of works by him in the Victoria and Albert Museum; the Duke of Portland had three signed portrait miniatures by him, and among other private collections the Duke of Buccleuch's is again outstanding in the

number of works by him that it can show (Fig. 46). Vertue thought that Dixon 'by his workes seemed to decline much before he died', a view which has not been challenged. It was accordingly left for Peter Cross to carry in to the eighteenth century the traditions of the art he had practised in its heyday during the lifetime of Samuel Cooper and Thomas Flatman.

Vertue came to know Peter Cross shortly before his death in 1724. He saw the contents of his sale in 1722, and heard from the old man some interesting gossip about the great days of seventeenth-century limning. For instance Cross told him the history of Cooper's sketch portrait of Cromwell, and that he had been employed by one of the Protector's relatives to cut it into an oval. Vertue also records that the Duke of Hamilton gave Cross a miniature, supposed to be the portrait of Mary, Queen of Scots, and instructed him to make it as beautiful as he could. This was the source of many copies by B. Lens and others which set in circulation a popular but spurious image of the Queen, for whom at that time especially a cult had sprung up.

Valuable as these notes are, Vertue combined with them a mistaken account of Cross's name which has only recently been corrected. He gives his initial, with one exception, as L., and translates this as 'Luke' or 'Laurence'. There was a good reason for this confusion, since the monogram on Cross's later work does look exactly like an *L* entwined with a *C*. It was only when the back of a miniature of Sir James Ogilby, 1698, belonging to Daphne Foskett was examined that it was discovered that the cursive letter read as *L* was in fact the first letter of the full signature *Peeter Cross*: and a simpler signature in the same writing *P Cross* has been found on the reverse of the miniature of Lady Katherine Tufton, 1707, in the Victoria and Albert Museum (Alan Evans Collection, Fig. 47). Before these discoveries, which are confirmed by contemporary documents, a list of works had been drawn up for an artist Peter Cross, supposed then to be distinct from Laurence Cross. The primary Peter Cross signature, with initials clearly reading *PC*, begins *c*. 1665 and occurs till 1691 and again in 1715. Drawings or miniatures with the interlaced monogram which looks like *LC*, but which we must now read as *PC*, run from 1678 until 1716. These two groups can now be regarded as the work of one diligent and long-lived artist. It involves stretching the meaning of Vertue's remark that in 1723 he was 'upward of seventy' to imply that he was in fact approaching eighty in that year. If he were born *c*. 1645 he would have been capable of the assurance seen in his earliest known miniatures of *c*. 1665. During his first years of practice his style varied considerably and his signature occurs in Roman initials as well as in a cursive script. By 1670, when he painted the portrait of William Gore and signed it in full on the back *P. Cross* he had achieved the individual style which persists, though it develops, throughout nearly fifty years remaining of his career (Fig. 48). The hair is exquisitely drawn with an effect of glossy sheen which rivals Cooper and is carried out with thin brush strokes; the lace cravat is as fine, and in the modelling of the face the thin brush strokes are beginning to pass into the dot-like stippling which was the main deviation of Peter Cross from normal English practice.

Technically, Cross carried stippling further than it had yet advanced in England, and he formed his flesh tints by juxtapositions of tiny dots of colour, sometimes red, blue and green side by side. The effect is to give at times a powdery appearance to his

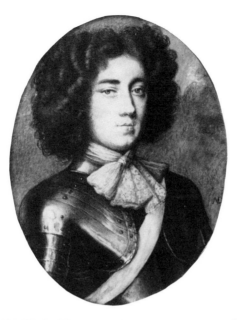

46 Nicholas Dixon, *James Scott, Duke of Monmouth*

48 Peter Cross,
William Gore, 1670

47 Peter Cross, *Lady Katherine Tufton*, 1707

portraits, but he never loses the sense of his general presentation or the strength of his portrayal of character. It has been suggested that his addiction to stippling points to a Continental origin for his style. It is far more probable that it is an extension of methods initiated by John Hoskins. If we examine the hair and the face of Hoskins' large portrait of the Countess of Dysart at Ham House, or a number of his smaller miniatures of the 1640s and 1650s, we shall find that green, blue or yellow dots are juxtaposed with the flesh tint, and this, rather than anything in contemporary Continental practice, seems the true ancestor of Cross's 'pointillisme'.

Another integral element in the general effect of Cross's later miniatures is the large proportion of white or lightly toned ground which is left untouched in them. This is partly a consequence of the stippling method, because when the colour is built up from separate dots, the little unpainted areas between them add luminosity to the whole – a principle understood and exploited by Turner in the water-colours of his middle years. This is another characteristic in which Cross looks forward to the eighteenth century; when ivory replaced vellum as the material for miniatures, as it began to do during his lifetime, all the more light and luminosity was attained by not covering the whole of it with the pigment. Indeed it comes as something of a surprise to find that Cross never painted on ivory, so closely would his style have lent itself to that material.

Cross was a collector as well as a painter and restorer of miniatures. The sale of his collection included twelve miniatures by Samuel Cooper. At least two of these were bought by Edward Lord Harley (later the second Earl of Oxford) for his collection, and are now at Welbeck – they are the portrait of Sir Frescheville Holles and the unfinished portrait of Cooper's wife – and their presence in the limner's collection show that if he pursued a different path from Cooper's it was not for want of knowledge and appreciation of some of his best works. Unavoidably, the manner (though not the mannerism) of Lely is to be seen in the miniatures of Peter Cross, but it is more a parallelism of mood and method than a direct process of copying. Miniature painting was not, at this time any more than hitherto, subordinate to full-scale portrait painting in the hands of its foremost practitioners. Nor do we need to remind ourselves, in looking through his impressively uniform body of work, that Kneller came to England in about 1676 and dominated its large-scale portrait painting till 1723. If any exchange of ideas took place between the two artists it was not Cross who borrowed from Kneller. None the less, a change of mood is discernible between his earlier and his later works. A typical Peter Cross miniature of 1680 reflects at once the confidence and the cynicism which we associate with the late seventeenth-century court. Even the size, which is larger than passed current in the middle of the century, reflects his intention to impress the personality of the sitter upon the spectator. But in the first decade of the eighteenth century a change has taken place. The naivety, the modesty and the unself-assertiveness of the national character are beginning to reappear, and were to be the theme of the British-born artists of the next generation.

Chapter 10

Foreigners in England at the turn of the century: Boit, Richter and B. Arlaud

Throughout the seventeenth century English miniature painting had played a conspicuous role in Western art. It was admired on the Continent by Louis XIV, Cosimo III and Constantine Huygens; Petitot sent his son to study in England, and some English miniaturists, such as Nathaniel Thach and Alexander Cooper, were recruited by overseas Courts. But by 1700, a year marked by the death of Mrs Rosse and the debility of Nicholas Dixon, the native vein of talent in limning was temporarily exhausted. As with oil painting, skilful artists from Europe were attracted to England to satisfy the continuing demand for portraits in miniature. Up to a point the limners who responded to this need were bringing back a tradition which had been transplanted from this country, and helped to restore it here. A decisive link in the chain was the decision of Queen Christina of Sweden to promote the art of miniature painting, and her consequent invitation to Alexander Cooper and Pierre Signac. Signac had been trained in the French method of enamel miniature painting, having been apprenticed to the Toutin family from whose craft and example stemmed the brilliant achievements of Petitot and Bordier. But in Sweden he was sufficiently influenced by Alexander Cooper to take up the practice of miniature painting in water-colour as well. In this branch of the art he achieved so close a resemblance to Cooper's work that it can be difficult to distinguish their routine royal portraits. Signac continued this style of portraiture for over twenty years after Alexander Cooper's death, and transmitted the tradition to a number of followers, one of whom was Charles Boit. Boit's father had gained his position of tennis instructor to the court as payment for a claim he had on Signac.

Boit, who was born in 1662, was apprenticed to a goldsmith and jeweller. As in the case of Hilliard, there can be a close connection between these callings and that of the limner. In particular, decorative enamelling is an important feature in the embellishment given to jewellery, and Boit was one of those who made the transition from decorative enamelling to painting miniature portraits in enamel. Having been discharged from his apprenticeship in 1682 he went to Paris, where he may be supposed to have studied the enamels of Petitot and Bordier. He came to England in 1687. Vertue records that this was at the invitation of a merchant, Mr Souters or Sowters, who had encouraged another Swede, Michael Dahl, to come to England five years earlier. The two fellow countrymen were to become close associates, but in the year Boit arrived Dahl was studying in Italy. Boit did not confine his earlier English activities to London.

49 Charles Boit, *Queen Anne and Prince George of Denmark*, 1706

Two of his first known enamels – apparently *ad vivum* portraits of Captain Gervase Scrope and his wife – are signed and dated from Lincoln in 1693. He made another enamel portrait in the same year at Coventry, where also he gave instruction to Humfrey Wanley. Wanley did not make a name as a miniaturist but was able to display his connoisseurship of the art when he became Librarian to the Earls of Oxford. In that capacity he watched over the formation of one of the outstanding collections of seventeenth-century miniatures, now the Portland Collection.

For many years after Boit's arrival in England court patronage, in the hands of the House of Orange and of the Hanoverians, was disposed to favour enamel painting. With this preference went a readiness to commission enamel copies of existing oil portraits, and Boit showed himself willing to make these as well as *ad vivum* portraits. Vertue hints at a certain rivalry in this field between Kneller and Dahl, who between them dominated large-scale portraiture at the time; he suggests that Kneller promoted Zincke to offset the natural affinity between the two Swedes, Boit and Dahl. But in fact, quite a number of Boit's enamels are copied from Kneller. In 1696 Boit's abilities were recognised by William III, who appointed him Court Enamellist. It was the first time such an appointment had been made in England. Whether Nicholas Dixon continued to hold the post of Court Limner at the same time is not known, but when Bernard Lens received the Court apointment he also was styled His Majesty's Enameller, although he did not in fact work in that medium.

Boit worked for over ten years in England on his first visit to this country, and then started on a short tour of various Continental courts, being in Holland in 1699, at the Elector's court in Düsseldorf in 1700 and during the same year at Vienna. He had received the patronage of Peter the Great during his visit to London in 1698; many fine enamels of the Czar resulted from this meeting and their subsequent encounter in Paris in 1717. Boit was already beginning to work on a larger scale than the conventional enamel portrait which, like the usual miniature in watercolours, could be held in the palm of a hand. In Vienna he was given full scope for this ambition, being commissioned to paint an oval enamel measuring 15 × 18 inches. This is designed in the form of an elaborate political allegory of twelve full-length figures showing the Emperor Leopold I surrounded by his family and mastering the world. It is an astonishing technical achievement, though his rather more modest double portrait of Queen Anne and Prince George of Denmark in the Royal Collection, which is dated 1706 and measures 10 × 7¼ inches, is now in better condition (Fig. 49). He had already embarked upon an even more ambitious project, the Blenheim enamel, which became a kind of South Sea Bubble of the miniature world. Vertue's account of this remarkable episode is one of the liveliest narratives in his Notebooks and, since he got his information from Otto Frederick Peterson, who worked on the project with Boit, it can be relied upon, bizarre though the proceedings were. The plan was to enamel on to a rectangular plate measuring 24 × 16 inches (or 22 × 18 inches – accounts vary) an allegorical design by Laguerre commemorating the battle of Blenheim. The original design showed the Duke of Marlborough being presented to Queen Anne by Victory, accompanied by Prince Eugene. The queen was attended by her Council of State and by her court ladies. Queen Anne's husband, Prince George of Denmark, was an active

patron of the proposal and procured an advance of £1000 so that Boit might build a special furnace of the necessary size and intensity of heat. Early on in the proceedings Boit realised that the project was too ambitious to succeed, but he allowed it to run on for ten years, having raised more than another £1000 from the Treasury, on which he lived extravagantly. When curiosity about the progress of the enamel became too pressing he drew the design in unfired water-colours upon the surface of the plate, and his visitors were none the wiser. Although the project was supposedly being continued after the death of Prince George of Denmark in 1708, the changing political climate had its effect upon the proposed composition. Sarah, Duchess of Marlborough, was losing her influence with the queen, and all the court ladies were to be omitted. The Duke of Ormond, who succeeded Marlborough as commander in Flanders in 1712, was to be given a prominent role. As a result Prince Eugene refused to have anything more to do with the plan. Upon the death of Queen Anne in 1714 the Treasury required a return for their expenditure, and Boit fled to France in the same year, never to return, though his career on the Continent continued successfully but insecure financially. There he was much patronised by the Prince Regent, the Duke of Orleans. He died in Paris in 1726.

It is not entirely clear why Boit decided at an early stage that the technical difficulties of the Blenheim enamel could not be overcome. It would have covered a surface less than twice that of the enamel of Leopold I which he had achieved in Vienna. But though the effort came to nothing, it was not all wasted labour. For one thing, it brought Boit much custom; Peterson told Vertue that 'this made a prodigious noise about the Court and Quality, that brought in a multitude of business to him'. For another it induced Boit to recruit assistants who carried on his methods of enamel painting. One of these pupils was Peterson himself, whose considerable talents are known only by two or three works, one of them being a portrait of the poet John Gay in the Nationalmuseum, Stockholm. Another of the pupils who worked with Boit ostensibly on the large enamel was C. F. Zincke, who was soon to come into prominence as the leading enamellist in England.

Technically considered, Boit's enamels are excellent; they show almost as controlled a mastery of the craft as do Petitot's (Fig. 50). His pre-eminence as a craftsman encouraged an admiration for enamel paintings in the taste of English patrons, a taste which during the half century for which it lasted helped to depress the more authentic national school of miniature painting in water-colours. For, admirable though its products often are, enamel painting is one remove away from the intimacy and actuality of miniature painting; the mechanical difficulties of its production interpose a barrier between the subject and the viewer, and this loss of immediacy is increased if, as is so often the case, the enamel is itself a reduced copy of an oil painting. Against these inherent defects may be set the practical advantage that enamels do not fade and so retain their high glossy colour; also the blending of the glazes under heat often produces in them an attractive *sfumato* effect. But, excellent though the work of Boit, Zincke and their followers usually is, and invaluable in the iconography of an otherwise sparse period, it is difficult not to regret that we have not for that period the work of a number of water-colour miniaturists of equal ability. The wheel came full circle when Jeremiah

50 Charles Boit,
Admiral George Churchill

Meyer, a pupil of Zincke who was himself a pupil of Boit, became one of the leaders of the new *floraison* of miniature painting on ivory in the second half of the eighteenth century.

Signac established a school of water-colour miniaturists in Sweden, as well as of enamellists. He was succeeded as court miniature painter first by Elias Brenner, and then by David Richter the younger, both practitioners in water-colour. David Richter spent some years in Italy and the remainder of his career in Sweden. But his younger brother Christian Richter came to England in 1702 at the age of twenty-four and spent the rest of his life here. He may have been encouraged to do so by his compatriots Hysing and Dahl, as well as by Boit (Hysing and Richter had been friends during their youth in Stockholm); these painters certainly made him welcome on his arrival. He too had been apprenticed as a goldsmith and he had studied medal engraving, another craft closely allied to that of the miniaturist. It is said that he painted in enamels, but only miniatures in water-colour by him are known. Again, they are predominantly copies after portraits by other artists, but in his case the necessities of disease rather than personal choice forced this course upon him. As Vertue expresses it:

> His nose fallen by some accident in ye Gardens of Venus made him looked on with a suspicious eye and did much prevent his public appearance and at the same time in the reaping such advantage by his Art suitable to his merit, his face being no agreeable prospect for fine ladies to see. Those scars were rather a motive of compassion than to inspire their graces and charms, such as always they expect should be represented by ye painter.

The illness eventually caused his death in 1732. Setting aside this misfortune, Vertue says that Richter drew better from the life than any of his contemporaries, and certainly this may well be true, in so far as it is possible to judge from his miniature copies. These have a finesse and an ability to reinterpret character which can scarcely be paralleled in the miniatures of the time. Richter's ability to think himself back into the character he

is rendering is amply evinced by his numerous copies of Cooper's portrait of Cromwell, which are faithful without being in any sense fakes. One of these copies, in the Wallace Collection, London, is inscribed by the artist on the back 'Sum possessor C Richter 1708', indicating that the artist owned a version by Cooper from which he made his repetitions.

He does not attempt to disguise the difference between his technique and that of Cooper – he proceeds by way of a minute stippling, which is reminiscent of Turner's later water-colour technique and productive of his brilliant colouring. One of his most colourful and pleasing works is the portrait of Lady Margaret Bagot, signed and dated 1710, in the Victoria and Albert Museum (Fig. 51). A replica, also by Richter, is known, but the oil painting from which it may have been copied has not yet been identified. This may, therefore, be one of his *ad vivum* portraits, but whether it is or not, it is certainly in itself one of the most captivating and natural portraits of an Englishwoman of the early eighteenth century, a version in miniature of the gentleness of Dahl.

A revealing instance of the difference in style between the fashionable portraiture of France and England, and of the dominant influence of large-scale painting over the art of the miniaturists at this time, is provided by the work of the brothers Benjamin Arlaud and Jacques-Antoine Arlaud. They were born in Geneva, and seem to have been fairly equally endowed with talent, but the former spent much of his productive career in England, the latter in France, with the result that they reflect, overriding their initial gifts and native training, the stamp of the prevailing modes of portrait painting at the courts of their adoption. Benjamin Arlaud is homely, bourgeois and matter-of-fact, cast in the mould of Kneller and Dahl, but Jacques-Antoine Arlaud, who was the friend of Rigaud and Largillière, shares their tendency to smooth and flatter the subject and to catch him, or her, in a mood of Baroque attitudinising.

Little is known about Benjamin Arlaud apart from what may be inferred from his surviving works. He painted William III in 1701, but it is not known whether this was done in England or abroad. He shared in the general enthusiasm for portraits of the leading allied military commanders of those victorious years, painting a number of versions of his miniatures of Marlborough and of Prince Eugene. He was also patronised by Lord Oxford and the Duke of Portland. These works, many of which are in notably well-preserved condition, reveal him to be an excellent miniaturist, who worked with fine touches in water-colour and achieved a strong effect of modelling and an authentic air of contact with his sitters. He merits as high a reputation as his brother, whose easy French elegance of approach has gained him the reputation of being the foremost miniaturist of his age. One of his most representative pieces is the miniature of John Christopher Pepusch (Royal Library, Windsor Castle; Fig. 52). The sitter, who was born in Berlin, had settled in London by 1700 and was the composer of the overture for *The Beggar's Opera*, for which he also arranged the tunes. Benjamin Arlaud's career was a relatively short one; no dated work after 1717 by him is recorded and he was certainly dead by 1721.

In that year Jacques-Antoine Arlaud was in London, and painted a miniature of Benjamin's widow (in the collection of the Queen of the Netherlands). She was Jeanne Marie Walker, who had been born in the Palatinate. Jacques-Antoine Arlaud had gone

51 Christian Richter,
Lady Margaret Bagot, 1710

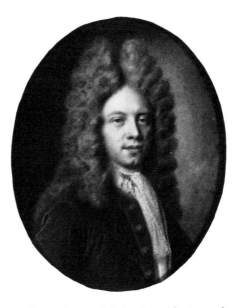

52 Benjamin Arlaud, *John Christopher Pepusch*

to Paris in 1688. There in due course he was encouraged by Philippe, Duke of Orleans, later the Regent, and he was called on for many miniature portraits of the 'Old Pretender', James Francis Edward Stuart. On his visit to England he had letters of introduction to the Court and was treated with considerable favour. The only English portrait at present known by him is that of his sister-in-law, but he did bring with him a limning of *Leda and the Swan* after either Michelangelo or Correggio, and is said to have sold a copy of this in England for the vast sum of £600. A miniature by Arlaud of this subject was included in the Duke of Chandos' sale in 1747, presumably the version of which Vertue recorded the purchase. After spending some forty years in Paris, Arlaud returned to Geneva in 1729, and he died there in 1746.

Bernard Lens and his sons;
C. F. Zincke and his pupils

At the opening of the eighteenth century, when foreign artists and new methods were being introduced into England the responsibility for providing a native contribution to miniature painting and for accepting the need of fresh technical developments was shouldered by Bernard Lens. He came of an artistic dynasty which provided in all four generations to the practice of art in England. His grandfather Bernard Lens is unknown except from one or two fragmentary documents. Vertue, quoting from a genealogical tree of the family, says that he was born in about 1631 and died in 1708: 'There was 4 or 5 books written in English by him – pretty large being collections – &c (Scriptural matters).' Another account has it that he was a painter in enamel who did not attain any excellence. His son, of the same name, is referred to as Bernard Lens, senior, or Bernard Lens II (born 1659, died 1725), to distinguish him from his father and the miniaturist. He was a draughtsman, mezzotint engraver and drawing-master, and with J. Sturt opened a drawing school in London in 1697. The British Museum has topographical drawings by him, and drawings from life by him are extant which show that he had a good command of the current Baroque manner. His portraiture from life may be judged from an Indian ink portrait of R. Newcourt in the Victoria and Albert Museum. This is a typical mezzotinter's drawing in broad patches of wash, and displays a rather literal rendering of the Kneller idiom.

It is his son, Bernard Lens, junior, or Bernard Lens III, with whom we now have to deal. He was born in London in 1682 and died in 1740; thus he began to work soon after 1700 and Vertue saw drawings by him dated 1703 and 1704 in the sale held after his death. His earliest known miniature is of the Reverend Dr Harris in the Yale Center for British Art. It is inscribed 'B. Lens ad vivum pinxit 1707' and breaks all native precedent by being painted not on vellum or on card but on ivory. There are no less than three miniatures on ivory by Lens bearing the date 1708 in the Marquess of Bristol's Collection at Ickworth, and from this time forward he painted on this new material habitually, though not exclusively. Bernard Lens is thus the first English artist to have made frequent use of ivory and may fairly be said to have introduced this revolutionary practice into the country in the decade after Boit had reintroduced the vogue for enamel miniature portraits. Overriding priority in the innovation, which swept through Europe, is claimed for Rosalba Carriera, the Venetian pastellist and miniaturist, who appears from a document written two years before her death to have been painting

ivory miniatures as early as 1696. A certain resemblance in technique between Lens and Carriera has led to the suggestion that the English artist copied her lead. He is not known to have travelled abroad, but one of the numerous English amateurs who had been to Venice may well have brought back one of these novelties, which soon became all the rage on the Continent; there is, however, no certain evidence on the point.

Although he painted on a new material, Lens used it in an old-fashioned way. The advantage which ivory has over vellum is its greater luminosity, its power of glowing through water-colours; but for this power to be apparent the colours to be used must be transparent ones. In the miniature painting of the sixteenth and seventeenth centuries the use of transparent water-colour was virtually confined to the face. Bernard Lens faithfully copied this practice in his miniature portraits on ivory. He models the face, and the flesh of the bosom left exposed by the décolletage of the time, with large and comparatively few touches of transparent colour, but the eyes, the hair, the costume and the background are in opaque body colour. Jim Murrell has emphasised the difficulties faced by the pioneers of this newly introduced surface, which does not take kindly to the application of water-colour. It was left for the miniaturists of the second half of the century to exploit to the full the delicacy and transparency possible in the new medium. None the less the miniatures of Bernard Lens must have seemed strikingly fresh to his contemporaries even beside the better drawing of Peter Cross and Benjamin Arlaud on vellum, and he received a flattering degree of patronage. That his method did not oust the other for some time is shown by the note Vertue wrote as late as 1735 on the little-known miniaturist, Zurich: 'Most of his limnings are a neat soft tender colouring – and painted on ivory, a manner much used of later years among the limners.'

Lens' career was a successful and apparently a prosperous one. He was no doubt indebted to his father for the instruction which set him out as an artist, for the Academy of Painting in Great Queen Street at which he is said to have studied was not founded till 1711. He became in due course miniature painter (under the style of enameller) to the Kings George I and George II, though without salary. He continued to practise his father's profession of drawing-master, and taught many fashionable pupils, among them the Duke of Cumberland, the Princesses Mary and Louisa, and the Duchess of Portland. Horace Walpole, another of his pupils, pays tribute to his excellence as a man and illustrates his integrity by the story of a lady whom he was painting in the costume of Mary, Queen of Scots: when she protested 'You have not made me like the Queen of Scots', Lens replied, 'No, Madam: if God Almighty had made your ladyship like her, I would.' Presumably the standard by which he was judging her was set by Peter Cross's beautified version of an old miniature, but the story shows how general the fashion for being painted in historic costume had become in the early eighteenth century.

Lens made many topographical drawings, and seems to have formed the practice of going on a yearly sketching tour, much in the manner of the masters of English water-colour painting half a century later. The dates of many of these itineraries, which were mainly into the West Country, are given in the notes Vertue made at the sale after Lens' death in June 1741. Further evidence of his far-reaching activity is provided by his drill book of Grenadier's Exercises (1735) and a *New and Compleat Drawing-Book*

(published posthumously). Nor did he confine his attention as a miniaturist solely to portraiture. He made copies of earlier miniatures of historical interest – for instance, there is a copy by him of a miniature by Hilliard of Queen Elizabeth, as well as of the unfinished portrait of Cromwell which Richter also had copied. He promulgated the type of false portrait of Mary, Queen of Scots, for which Peter Cross had been responsible. Copies of the 'Lens' type are often met with; they are often in a long oval (that is, broader than high) and inscribed in gold 'Maria Regina Scotorum'. Some are by his pupil, the Jewish artist Catherine da Costa.

Lens was also one of the last miniaturists to make miniature copies of classical mythological oil paintings. Among his productions in this sphere may be mentioned a copy of Poussin's *Hercules Choosing between Virtue and Vice*, of which the original is now at Stourhead, a copy of spandrel paintings by Solimena, and of a landscape with figures by Vandervaart. The last-named miniature, which is in a large format and which forms, as it were, an early eighteenth-century link between the medieval illuminators, the backgrounds of Elizabethan miniatures and the water-colours of the second half of the century, is preserved in the Victoria and Albert Museum. It is in a 'Bernard Lens frame', that is, a morticed rectangular frame of pear wood stained black, such as Lens himself made for many miniatures in the Duke of Portland's Collection. In addition, Lens often copied contemporary oil portraits in miniature.

There is no difficulty in forming an idea of Bernard Lens' somewhat John Bullish appearance, whose sanguine complexion and unrefined features accord well with the more pedestrian aspects of his style, for he made many self-portraits of himself, of which there are specimens in the collection of the Marquess of Bristol and in the National Portrait Gallery. Indeed he and his sons were much given to portraying the members of their family. There is a portrait by B. Lens of his wife Catherine at the age of fifty-two in 1733; he had married her in 1706. The Victoria and Albert Museum has the profile portrait of Bernard Lens by his son P. P. Lens and the portrait of another son, Andrew Benjamin Lens, at the age of about ten, by Bernard Lens.

In general, Lens followed closely the Kneller style of portraiture, in its reduction of the shape of the face to an uncomplicated ellipsoid suggestive of an attack of mumps, and the suppression of individual accidents of formation in the interests of Baroque theories. He even went so far as to imitate Kneller's far from natural flesh-colouring, and in place of the glowing carnations of a former age he uses greenish and greenish-brown flesh tones which, whatever their justification in oils, are of unpleasant effect on ivory. One of his most unusual achievements was to paint a series of fifteen miniatures of the family of William Whitmore, M.P. These were produced over a period of sixteen years between 1716 and 1731 and show his patron, his wife Elizabeth and twelve of their children at ages ranging from one month to six years. This family group has been dispersed; two are in the Victoria and Albert Museum (Fig. 53) and one in the Fondation Custodia, Paris; in it Lens maintained, during the many years of this commission, the unforced charm of the *naif* painter. In his more robust portraits, such as that of Lady Henrietta Harley and her daughter Margaret (Portland Collection), he is a foreruner of Highmore, Dandridge, Hudson and Ramsay, and it is those portraits which make him, during the years of the foreign occupation of miniature painting, the

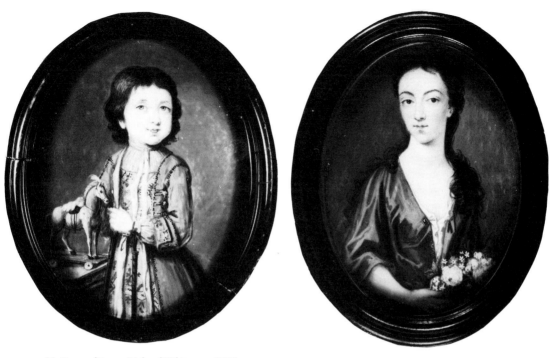

53 Bernard Lens, *Richard Whitmore*, 1718

54 Bernard Lens, *An unknown lady*

authentic link in England between the great periods of the seventeenth and eighteenth centuries (Fig. 54).

It is a remarkable thing to watch in a chronological survey of British portraiture the progress of this refinement in manners and revolution in taste – the rhetoric of Kneller insensibly gives way in the 1720s and 1730s to a new unselfconsciousness of approach, as though it were the first sign of spring. The process was observed by Vertue, who was especially the contemporary chronicler of this critical time, and he is constantly speaking of the new men in terms similar to those he applied to Highmore as early as 1726, 'a free judgment not vitiated by mannerists and a continual observation on Nature . . . he entirely set himself to imitate Nature in its just appearance in the portrait way and soon with great success and extreme likeness'. This process of gradual revolt from the domination of Kneller's influence is witnessed in another sphere in the miniatures of Bernard Lens' sons.

His eldest son had been called Bernard in accordance with family tradition, but failed to become the fourth in succession to pursue the profession of artist, becoming instead a clerk in the Exchequer Office, through the interest of Horace Walpole. But two younger brothers, Andrew Benjamin and Peter Paul, both became prominent miniaturists. Andrew Benjamin is believed to have been born in 1713 and Peter Paul in 1714.

Andrew Benjamin Lens lived well into the second half of the eighteenth century. His

collection of miniatures by his father and himself was sold by auction in 1777, and the years during which his portraits, mythological subjects and miniatures were exhibited at the Incorporated and the Free Society of Artists range from 1764 to 1779. No miniature of his which is certainly from the later period of his life is known. He is seen at his best in a miniature said to be of Peg Woffington dated 1744 in the Victoria and Albert Museum (Alan Evans Collection; Plate 55). By this time he had fully shaken off the direct imitation of his father's manner, and was responsive to the requirements of the time for natural, direct portraiture. This miniature bears his normal signature, formed of the letters *ABL* in a monogram shaped like his father's. An innovation rarely seen in his father's miniatures but common to him and his brother P. P. Lens is to be found in the stippled background shaded to give an area of light on the right of the sitter's head.

If we may judge by the number of extant works by him, Peter Paul Lens was a more prolific miniaturist than A. B. Lens, and a more original one. His earliest known work is a portrait of his mother done by him at the age of fifteen in 1729, possibly after an original by his father. The profile portrait of his father in the Victoria and Albert Museum done four years later is again not a typical work, but shows promise in the boy of nineteen. In the next year, 1734, he made a portrait of the young Sir Roger Newdigate which is characteristic of his fully formed style.

What we know of P. P. Lens' life marks him out as a young man fully abreast of the latest advanced thought and a confirmed rake-hell. In 1737 and 1738 he was in Dublin, and was a member of a hell-fire club called the 'Blasters'. A committee of the House of Lords reported in March 1738 that 'several loose and disorderly persons have of late erected themselves into a society or club under the name of Blasters, and have used means to draw into this impious society several of the youth of this Kingdom', and that 'Peter Lens, lately come into this Kingdom, professes himself a Blaster and a votary of the devil, and that he hath offered up prayers to him and publicly drunk to the devil's health, and that he hath several times uttered the most daring and execrable blasphemies'. He was forced to flee the country to avoid arrest, but returned to continue his career of miniature painter in England.

This episode makes it certain that the modern form of advertisement which so displeased Vertue when he noted it in 1741 was practised by P. P. and not B. or A. B. Lens, as he seems to suggest. He relates the system as follows:

> An Ingenious youth whose vile atheistical conversation and behaviour, publicly practised (for some such wicked blasphemous affair in Ireland he was forc'd to fly away) and known to distinguish him by. Another artful (perhaps new) stratagem was for some of his friends at the playhouse to show a picture in small watercolours to another in the opposite boxes, asks 'who did it', the other answers 'Mr. Lens' 'pray where does he live' thus in a full house 'I dont know, but if any person here can tell pray speak out that we may know where to find such an ingenious man'.

His rake-hell and anti-clerical views also make it probable that the story quoted by Long from an old newspaper cutting about a passage between Lens and a parson in Master Burrow's, an eating-house at Ivy Lane, refers rather to Peter Paul than Bernard. On this occasion he is said to have remarked that there was nothing he liked better than

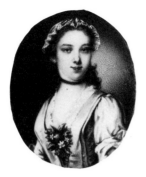

55 Andrew Benjamin Lens,
Peg Woffington, 1744

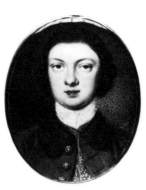

56 Peter Paul Lens,
An unknown youth

roasting a clergyman, to the surprise of his companions, who had seen that his neighbour was of the cloth. The parson turned the tables on his would-be tormentor by sampling his food as it was brought, to such effect that Lens had to leave in chagrin.

But there is no trace of pretentiousness or revolution about his miniatures. Their charm is rather that of the Maître Populaire de la Réalité and the innocent eye. If Kneller saw the Englishman of his day as permanently afflicted with mumps, P. P. Lens seems at times to have found that the outline of his face was a perfect circle; but this impression is fostered by his habit of drawing many of his sitters full face (Fig. 56). His sympathetic portrait of a little ragged boy, in the Victoria and Albert Museum, shows that he was responsive to the awakening interest of his times, symbolised by Hogarth, in scenes of low life. His portraits of children bring out to the full his naivety of temperament, but when he is drawing maturer features he shows that he is well able to delineate niceties of character. No miniatures by him after about 1750 appear to be recorded. Both he and his brother followed their father's practice of painting the sitter's dress in opaque body-colour and only the flesh in transparent water-colour.

Christian Friedrich Zincke began his spectacular career at about the same time as Bernard Lens and was active till near the middle of the century, though eyesight trouble prevented him working at full pressure for the later years of his life. The date of his birth is variously given as 1683, 1684 or 1685. He was the son of a Dresden goldsmith, and was first trained in that craft. However, he seems early to have had wider ambitions, and he had received painting lessons from the Dresden artist H. C. Fehling before he came to England at the invitation of C. Boit in 1704. (There is uncertainty whether he came in 1704 or 1706, but the former seems more concordant with the known facts.) As already recorded, Boit had enlisted his help in his project for the gargantuan enamel commemorating the victory of Blenheim. In this capacity he was learning the art of enamelling from the best available source and his earlier work shows how closely he absorbed his master's manner. Precisely when he set up on his own account is not known, but it was some time before 1714, as is evinced by Kneller's promotion of him in rivalry of Dahl's patronage of his fellow countryman Boit. There is a signed portrait of 1711 by him at Windsor.

By 1726 Zincke's position was so outstanding that Vertue could write that he was 'so fully employed that for some years he has had more persons of distinction daily sitting to him than any Painter living'. The accession of George II heralded fresh honours, for Zincke's portrait of the king found high favour with him. No doubt, as with Kneller, their common German origin made for a bond of taste as well as of language between the patron and the artist. He was given many commissions for portraits of the members of the royal family and replicas, and the king offered to employ all his time. This position of favour was not reached entirely without rivalry. In 1729 Mercier tried to jockey Zincke out of painting the portrait of Frederick, Prince of Wales, by telling him that the prince was so well pleased with the picture he had just finished that he wished the enamel to be made from that. Zincke had been considered successful with the Princesses Anne and Caroline, but not with Princess Amelia, and was accordingly all the more on his mettle to do justice to the prince. His insistence on making his enamels from the life is a feature which distinguishes him from most other enamellists.

Zincke eventually attained favour with Frederick and on the occasion of the Peace of Vienna on 29 March 1731 the prince found him work at court and said to him 'Won't you get drunk to-night! There is a peace made between Germany, Spain and England and Holland.' Zincke's answer was that he usually drank port wine, but upon this occasion he would regale himself and drink His Highness' health in French wine. Vertue continues:

> This is not to be taken for a customary practice in Mr. Zincke for of twenty years almost that I have been acquainted with him I never see him in that condition though I have often seen him take his bottle as others, and mostly he retired before others, and from his early and assiduous labours has gathered a pretty good Fortune (especially from the year 1720 when he began to save money by his works).

It was in 1731 that Zincke was steward of the St Luke's Club and in the following year Frederick made him his Cabinet Painter (Mercier already having the title of his principal Painter).

Part of Zincke's success at court was no doubt due to his compliance with the king's and queen's delicacy in respect of their consort's age. He told Vertue in 1732 that 'the Queen advised him to be sure to make the King's picture young, not above 25, and the King commended his works and admonished him not to make the Queen's picture above 28'. As both king and queen were forty-four on their accession, almost exactly the same age as Zincke, the chronicler might well comment, 'these courtesies to each other must be a mystery to posterity who sees them thus depicted without knowing partly the reason'.

Vertue is our main source for Zincke's life, and he has little to tell us but these crumbs of tittle-tattle from court sittings. In 1737 the artist visited Germany after an absence of twenty-five years. His eyesight had given trouble as early as 1725, and in 1742 he raised his price from 20 guineas to 30 guineas a head because he did not care to work so close and did not wish to undertake so many portraits. He moved from the artists' quarter in Covent Garden to South Lambeth in 1746, but appears still to have painted a few enamels, probably mainly for his own amusement. In 1757 and 1758 Jeremiah

58 Christian Frederick Zincke,
A lady, said to be Arabella Fermor, 1716

57 Christian Frederick Zincke,
An unknown youth

Meyer, then a young man of twenty-two, was his pupil, and thus Zincke passed on his Baroque craftsmanship to one of the leading miniaturists of the Rococo phase.

The extent to which Zincke, Lens and Richter monopolised the miniature painting of their day is well illustrated by the career of Zurich, whose use of ivory around 1735 was noted by Vertue as a novelty. Like Zincke he was born in Dresden and came to England to practise as an enamellist in 1714 or 1715. Vertue had a high opinion of his ability, and said that he never got the reputation he deserved because all the artists in London were already engaged to the interest of one of these three. So, although he could make enamels for half Zincke's price, his name and work have so completely disappeared that scarcely a single specimen of limning or enamelling is even tentatively attributed to him.

Walpole regarded the enamel of a youth by Zincke in his own collection as his masterpiece. This fine miniature, now in the Fitzwilliam Museum, is signed and dated 1716 ·(Fig. 57). It is copied from a painting by Lely which has long been regarded erroneously as a portrait of the poet Cowley as a boy. Walpole wrote of it: 'The impassioned glow of sentiment, the eyes swimming with youth and tenderness, and the natural fall of the long ringlets that flow around the unbuttoned collar, are rendered with the most exquisite nature, and finished with elaborate care.' Indeed, as might be expected from the high favour shown to him, Zincke was a master of the mechanical aspects of his exacting calling. As a portrait painter *ad vivum* he is on a slightly less exalted level. The veil imposed by the medium comes between him and his sitters, for one thing, and for another, he, like Kneller, never entirely cast off the German accent in his English career (Fig. 58). He moved with the times, though a little slowly; for whereas the Windsor portrait, dated 1711, of Sarah Churchill, Duchess of Marlborough, is in the style of Kneller, at the other end of his working days, in the

portrait of the third Duke of Portland dated 1742 at Welbeck Abbey, he shares the climate of Vanderbank (dead three years since) and Highmore. To what extent his pupils were responsible for enamels which passed under his name is an undecided question: in his vast output much inferior work was included. His draperies often suggest the co-operation of a drapery painter who fulfilled the same functions as Vanaken for large-scale portrait painters. But the chief reproach made against Zincke even in his heyday was that his portraits, especially his female ones, were too much alike. The *Gentleman's Magazine* of 1740 makes this point amusingly by describing in verse a 'Visit to Zink' by Juno, Minerva and Venus. Encouraged by the prospect of their commissions he brings out a specimen of his art which each goddess recognises as herself; but it is in reality the portrait of the poet's mistress Cloe.

> Trembling Zink, with humble bow,
> Thus interposed 'I must allow
> Bright goddesses, what here I drew
> Resembles every one of you:
> And yet, O pardon me, I pray,
> That all your charms I here display;
> Nor let on me your anger fall;
> 'Tis Cloe's fault – who wears them all.'

(The poem is quoted in full in Long's *British Miniaturists*, pp. 472–3.)

The grace which did not come naturally to Zincke was inherent in the French-Swiss enamellist Jean André Rouquet. He was born in Geneva, in 1701, and came to England early in his career, though the precise date and details of his apprenticeship are not known. Rouquet himself stated that he had spent thirty years in England; and as he left the country for France in 1753 this, taken at its face value, puts the year of his arrival at 1723 or earlier. Another tradition, that he came to England in the reign of George II, would advance the date to 1727 or later.

The Beauchamp Collection has two signed Rouquets and two enamels plausibly attributed to him. One of the latter is dated 1745. One of the signed works is said to represent William Fermor, who was born in 1723, and the apparent age of the sitter and the style of the costume support a date of *c.* 1730–5 for this enamel. Only a small number of miniatures known through their cursive *R* signature to be by this artist are recorded, and they appear to range from this date to 1755 (when he was back in France). No doubt other, unsigned, specimens are subsumed under the title 'Style of Zincke'. Those known to us have a prettiness which announces the Rococo and a *sfumato* effect of glaze which is softer than Zincke's. The portrait of William Pitt, Earl of Chatham, in the Victoria and Albert Museum is a characteristic signed piece from which his individuality may be judged. He gives his sitters small, slightly protruding eyes and observes the moisture on their lower lips; the costume is done with great delicacy (Fig. 59).

Vertue does not notice Rouquet till 1739, when he mentions him as the best of Zincke's imitators, whose price is ten guineas a head, Zincke recently having raised his to fifteen guineas or even twenty guineas. His only other note is of a favourable press notice on Rouquet in August 1749.

59 Jean André Rouquet,
An unknown man

Rouquet's own sound sense is revealed in the essay he published at Paris in 1755, two years after his entrance into France, entitled *L'Etat des Arts en Angleterre*. This is a well-informed critique, equally without flattery and detraction, which provides an invaluable pendant to Vertue's labours concerning the same period. Of particular interest is his description of how a portrait painter became for a time the rage of the town, by whom everyone must be painted, as for instance by Vanloo. He also describes the fashionable habit of calling to see a painter's studio under the guidance of a lackey – a practice perhaps also followed in the case of miniaturists, if the visit of Venus, Minerva and Juno to Zincke is any criterion.

The story related by Ephraim Hardcastle (W. H. Pyne) about a practical joke played by Rouquet, Hogarth, and Garrick on one Oram – a story in which Rouquet is made to speak like the French master in the *Magnet* stories, e.g. 'Hist! let us have the little dust vif him, and give him von genteel raps of his knuckles, for his too much of vanities. Oh! mon Dieu! it is good for to put him in the passion, and he will valk all the way since the bottom of the hall till the top, to abuse us every one' – is certainly apocryphal, since this episode is supposed to have taken place at the coronation of George III in 1761, when Rouquet had been dead two years.

None the less he was a friend of Hogarth, Garrick and the wits of George II's reign,and his own lively spirit is evidenced by the title of another publication of his, satirically called *L'Art Nouveau de la peinture en fromage, inventé pour suivre le louable projet de trouver graduellement des façons de peindre inférieures à celles qui existent* – a counterblast to Diderot's *L'Art de peindre en cire*. Perhaps he had it in mind to condemn the use of ivory as well as wax or cheese among new painting materials. But his spirit overpowered him, and he died insane in 1759, four years after the two publications in question.

Of Zincke's pupils, the earliest to achieve any notable merit was William Prewett. He is known by less than half a dozen works, but appears to have practised between about 1735 and 1750. Two signed works by him are in the Victoria and Albert Museum; one, a large enamel group with three full-length figures, is copied from a painting by

60 William Prewett, *Mr Newsham*, 1736

Vanderbank. The other is a head-and-shoulders portrait of Mr Newsham, one of the sitters in the larger group; there is nothing to show whether it is from the life, but it, too, has much of the swagger of Vanderbank about it (Fig. 60).

Louis Goupy and his nephew Joseph helped to introduce a French note into a number of aspects of British art in the early years of the eighteenth century. Both are said to have been members of the Academy set up by Kneller in 1711, but it seems possible that the careers of the two men have been confused together. Walpole admired the miniatures of Joseph Goupy, pointing out that they were painted in a different style from that of Lens, by adopting a broad manner akin to oil painting rather than stippling.

Another versatile artist who emerges as a sporadic miniature painter in the 1730s was the Irishman Thomas Frye, who came to London before 1735. He is known by a good oil miniature of 1737 in the Victoria and Albert Museum and, from the other end of his career, two water-colour miniatures of 1761 and one of 1762. In the intervening years his energies were much taken up with the Bow porcelain factory, of which he was manager from about 1744 till 1759, and in practising as portrait painter in oils. But it was as the engraver in mezzotint of large, brooding portrait heads which fill the whole plate that he achieved his most original work, and found the medium most fitted to his powerful but somewhat sombre approach.

The modest school of miniaturists, c. 1740–70

As the ambition of Baroque lost its impetus towards the middle of the eighteenth century it was succeeded, in England, by a spirit of unpretentiousness and quiet naturalism. In the sphere of miniature painting this lack of ostentation is reflected not only in the presentment of the sitter's appearance and character, but even in the size of the miniature itself. Whereas at the beginning of the eighteenth century Peter Cross commonly painted on ovals 3½ inches high, and in his confident heyday at the end of the century Cosway also worked on that scale, the miniatures and enamels of N. Hone and other artists working *c.* 1750 were usually only 1½ or even 1¼ inches high. So widespread a practice augurs a definite predilection in the period which favours it, and the miniaturists who were prominent between about 1740 and 1770 may accordingly be labelled the 'modest' school; their works are modest in size no less than in spiritual content. The great masters of late eighteenth-century miniature themselves had their origins in the modest school, and their earliest works are to be found among them; but they exact fuller treatment in the light of their careers as a whole, and this chapter is confined to some of the more typical of the minor masters of these three decades.

Though they are minor artists, there is a pronounced and natural charm about their miniatures. We may think of them as the parallels of such artists as A. Devis and C. Philips in oil painting, but they move on the whole more gracefully within their narrow confines. In them the shyness and reticence of the English character receives a just reflection, and they are always sensitive to the fresh-complexioned beauty of young women. Something in the national portraiture which was last seen in the earliest works of Hoskins comes to light again in these *petits maîtres*.

In resorting to a small format they were encouraged by the growing custom of wearing a miniature portrait round the wrist on a band or bracelet. Accordingly many of their miniatures are set in gilt oval surrounds curved to fit the wrist and provided with slides for attachment to a wristband. To this fashionable inducement toward the smaller size was added the practical need to master the difficulties of the new technique of painting with watercolour pigments on ivory. By painting on a restricted scale they prepared the way for the greater bravura of their eminent successors such as Meyer and Cosway. After the middle of the century they had been so successful in their aims that ivory had virtually replaced vellum as the support for miniatures. In achieving so complete a transition they had profited from their knowledge of the size and chromatic

range of the portrait miniature in enamel. Indeed some of these mid-eighteenth-century painters, such as Gervase Spencer and Nathaniel Hone, practised both in enamel and on ivory.

The very smallness of their scale and modesty of their approach renders the discrimination between individual styles, in the case of unsigned work, inordinately complicated. Even in the case of signed miniatures it is not always possible to decide whether we are dealing with the *oeuvre* of two artists or only of one. Fortunately, a sufficient number of signed and dated works are known to clarify the main characteristics of the period and its leading miniaturists.

The careers of P. P. and A. B. Lens, and other miniaturists considered in the last chapter, enter into this period and conform to its qualities; but possibly the earliest to typify it entirely is Gervase Spencer, whose first known dated work is of 1740, and who died in 1763. He is virtually the last miniaturist to be recorded by Vertue, whose absence from now on as a guide to the artistic history of the time is severely felt. Vertue saw his miniatures first in 1749, and learned that he had been till fairly recently a footman to a Dr W. and that he was self-taught in limning. It is hardly to be supposed, however, that he can have taught himself the painting of enamels, which form a considerable proportion of his work. If we knew who instructed him in that craft we should know also the origin of his style of drawing; on purely internal evidence the guess may be hazarded that he learnt from Rouquet. Daphne Foskett has plausibly suggested that Spencer's unidentified master may have been Dr Wall, whose name is given to the mid-eighteenth-century production of the Worcester porcelain factory. Certainly he would have known where his talented footman might go for instruction in enamelling.

His works, generally signed G.S. and bearing dates between 1745 and 1761, are frequently met with. His alternation between enamel and water-colour reflects the alternation in the taste of patrons at this time. The balance of preference was slowly tipping over from enamels – which had born away the palm in the days of Zincke's prime – to the water-colour medium which was to be the vehicle of the achievements of Cosway and his great contemporaries. In enamels Spencer achieves a softness of effect, and in water-colour a clearness of definition, which shows that he knew how to vary his style to the capacities of the two mediums. He was noticeably susceptible to the appearance of his sitters, for whereas he has left some exceptionally slovenly portraits of middle-aged men, which scarcely conceal his distaste for the task of painting them, he is invariably at his best when drawing a pretty girl – as, for instance, in an early enamel miniature (Victoria and Albert Museum; Fig. 61). He was able to make full use of his delicate sense of colour when his sitters chose to be portrayed in exotic costume. His enamels of a lady, called *Lady Mary Wortley Montagu*, 1755, in the Victoria and Albert Museum and of Elizabeth Bradshaw, 1757, in the Yale Center for British Art (Fig. 62) show these ladies in Turkish costume, a fashion possibly encouraged by the Swiss pastellist and enamellist Jean-Antoine Liotard who first worked in England in 1753.

Not much is recorded of the prices ruling after those noted for Zincke and Rouquet, but the Earl of Halifax has a receipt from Gervase Spencer, dated 1756, which shows that he was paid sixteen guineas for the enamel portrait of Miss Shepheard. Three years

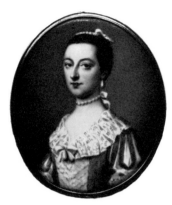

61 Gervase Spencer,
An unknown lady, 1756

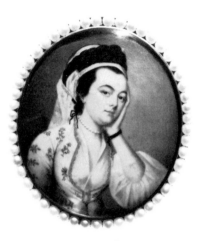

62 Gervase Spencer,
Elizabeth Bradshaw

before, G. Knapton had received twelve guineas for painting the same lady in oil on canvas.

Nathaniel Hone is one of a number of Irish artists who from this time forward make an important contribution to British miniature painting. He was born in Dublin in 1718, but appears early to have left for England, and spent some obscure years practising as an itinerant portrait painter. Pasquin gives a malicious account of the verbal and pictorial flattery used by Hone on his rounds, but this is no doubt invention. In 1742 we hear of him on the occasion of his marriage in York Minster to Mary Earle. Some mystery attaches to this lady. On her death in 1769 Hone addressed a letter, which is extant, to an unidentified nobleman from which it is evident that she had a personal claim on him and received an annuity. Presumably she was either the Lord's illegitimate daughter or discarded mistress. (*The Diary of Sylas Neville*, ed. B. Cozens-Hardy, Oxford, 1950, says, p. 84: 'He married some Lord's cast off mistress for £200 a year.') After his marriage, Hone is said to have settled in London; the earliest known miniature by him is one in private possession signed in full 'N. Hone' and dated 1747. It has more of a provincial, almost a Scotch, appearance than one of two years later which embodies the calm, modest good sense of his miniatures and enamels for the next twenty years.

The statement that Nathaniel Hone went to Italy to study *c*. 1750–2 has been made at least since the article on him by Lionel Cust in the *Dictionary of National Biography*. But Sir Brinsley Ford has told me that he has found no trace of Hone amongst the English artists in Rome. These doubts are reinforced by the charming enamel of a girl, Roosalia Drake, aged fifteen in 1751, in the Fondation Custodia, Paris (Fig. 63), which is inscribed with the sitter's name and age on the back and signed and dated by the artist in front. Again, there is no trace of this Drake family in Rome in 1751, when Hone was supposed to be there. In any case it is highly unlikely that he would have found the facilities for enamelling at his disposal on such a visit. It is probable, as Hilary Pyle has

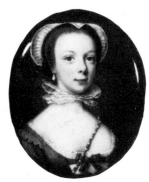

63 Nathaniel Hone,
Roosalia Drake, 1751

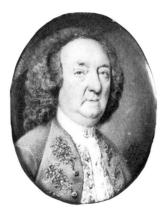

64 Nathaniel Hone, *Beau Nash*

deduced from a study of Hone's diaries, that he was never in Italy, and that the artist who became a member of the Florentine Academy was Nathaniel's brother Samuel.

None the less, Nathaniel Hone cherished an ambition to shine as a portrait painter in large. Amongst his works in oils are standard portraits of Wesley and Whitefield. In the earlier part of his career he was more employed as a miniature painter. His diary for 1752–3 shows that he had fifty sitters in rather less than two years, and that his average price for a miniature or enamel was ten guineas. He evidently lived as a man about town, for the same diary records visits to the masquerade and the purchase of buckles and silver lace for personal adornment.

Hone's miniatures, which are generally signed with a monogram *NH*, and dated, are common between 1750 and 1770; he lived till 1784, but appears to have given up miniature painting for the last fifteen years of his life. His sense of colour, which was impunged in his oil portraits, shows to advantage in his best miniatures. His sitters appear to be fuller blooded and of more sanguine temperament than those of Gervase Spencer, and the comparison can be made safely on the strength of their enamels, which cannot have faded. He did not entirely confine himself to portraits in miniatures, for the list of his works includes *A Fly, in enamel*, and *James Turner, a Beggar who Valued his Time at a Shilling an Hour*. With a natural talent for expressing female charm he combined an ability to express masculine character, as his penetrating enamel of 'Beau' Nash, 1750 (Holburne of Menstrie Museum, Bath; Fig. 64) demonstrates. Hone is described as a 'tall, upright, large man, with a broad brimmed hat and a lapelled coat buttoned up to his stock'. We have a personal note on the father as well as the son in Farington's entry concerning Horace Hone:

> I called on [Horace] Hone who shewed me drawings and miniatures. He derived from His Father [Nathaniel Hone] a habit of speaking of his own works in the same language that He wd. commend those of another person. He took up a drawing 'A pretty Head' said He, 'slight but clever'. – Of another 'That's a fine Miniature', – 'I expect it will be called for or I wd. send it to

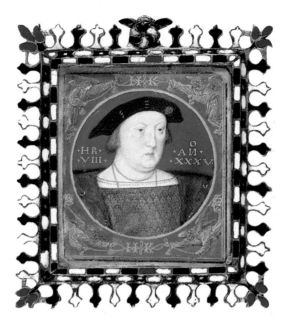

I Luke Hornebolte, *Henry VIII*

II Hans Holbein, *Mrs Pemberton*

III Hans Holbein, *Charles Brandon, Duke of Suffolk*

IV Nicholas Hilliard, *A man aged 24 in 1572*

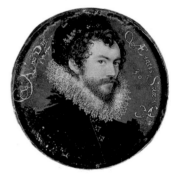

V Nicholas Hilliard,
Self-portrait, aged 30 in 1577

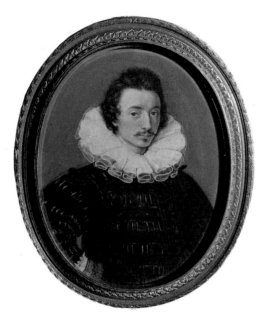

VI Isaac Oliver, *Self-portrait*

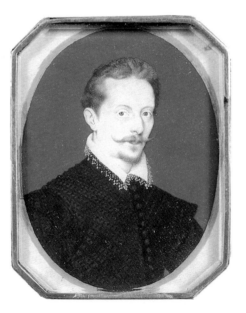

VII Isaac Oliver, *A man, called 'Sir Arundel Talbot'*, 1596

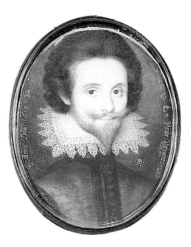

VIII Peter Oliver,
Sir Francis Nethersole, aged 32 in 1619

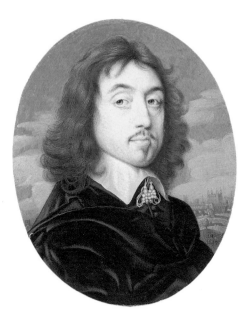

IX John Hoskins, *Sir John Wildman*, 1647

X Samuel Cooper,
Sir William Palmer, 1657

XI Samuel Cooper, *Mrs Leigh?*, 1648

XII Samuel Cooper, *Queen Catherine of Braganza*

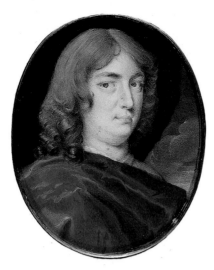

XIII Thomas Flatman,
A man, called Abraham Cowley

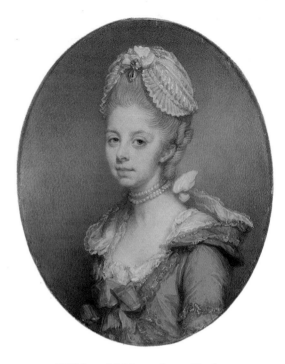

XIV Jeremiah Meyer, *Queen Charlotte*

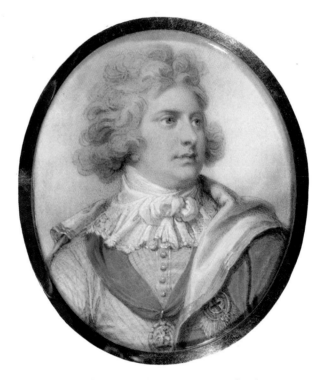

XV Richard Cosway, *George IV as Prince of Wales*

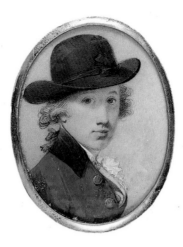

XVIII George Engleheart,
Sir Thomas Stepney

XVI John Smart, *Self-portrait*, 1797

XVII Ozias Humphry, *John Mealing*, 1766

XIX Sir William Charles Ross, *Princess Anna Feodore of Leiningen*, 1838

65 Samuel Collins,
A man, called Captain Bury, 1763

66 Samuel Cotes,
An unknown man, 1757

the Exhibition'. – This self praise is expressed in so natural a manner that though it is singular it is not offensive. (Farington's *Diary*, 2 April 1804)

Nathaniel Hone's large collection of prints and other works of art was auctioned in the year after his death. He had put his knowledge of them to devastating use in his painting 'The Conjuror', lampooning Reynolds's dependence on the Old Masters for the composition of his portraits. By copying many of the prints of Reynolds's sources he has carried out a scholarly survey of his more successful rival's methods. Angelica Kauffmann thought she was portrayed in it as a nude, and her successful request to have the painting rejected from the Academy exhibition of 1775 was based on the grounds that the academicians should take 'into consideration a respect to the sex which it is their glory to support'.

Equal interest is provided by the miniatures signed *S.C.*, which are uncertainly divided between Samuel Collins and Samuel Cotes. Collins is a forerunner of a growing number of miniaturists who practised in provincial centres from the mid-eighteenth century onwards. He worked in the remunerative atmosphere of Bath and had a good connection amongst the wealthy visitors to that spa till 1762, when he was forced to leave hurriedly for Ireland to escape his creditors. There he practised at Dublin, by now well established as a centre for the promotion of the arts, until his death in 1768. In Bath he taught Ozias Humphry, who succeeded to his connection there at the age of twenty. A miniature of Captain Bury in the Victoria and Albert Museum bears in front his signature 'Collins' in full and the date 1763; with a little imagination a foreshadowing of the style of O. Humphry can be discerned in it (Fig. 65). From this starting-point and a fully signed work of the following year in a private collection a few, but very few, miniatures of the 1760s which bear the initials *S.C.* may be attributed to Collins. Any miniature so signed and dated after 1768 is assignable to Samuel Cotes (though the work of the similarly initialled Sarah Coote, who exhibited from 1777 to 1784, is completely unknown), and by extension backwards from the considerable number of miniatures so assembled S. Cotes has been credited with other works signed *SC* back to 1757 (Fig. 66). In this there is nothing inconsistent with his biography. He was born in 1734, a younger brother of Francis Cotes, the eminent pastellist and portrait painter in

oils, from whom he had lessons. His obituary in the *Gentleman's Magazine* of October 1818 says, somewhat floridly:

> If he did not rival his fraternal master, it was because of the talents of the latter were of that superior character which Nature, husbanding her resources, refrains from putting forth more than once in the same age and country.

Francis Cotes is a notable member of the common-sense, honest bourgeois portrait painters who ran in rivalry with Reynolds and Gainsborough in their early days, and Samuel Cotes reflects the same temperament in his miniatures. The miniaturist lived till 1818, but ceased exhibiting in 1789, and the latest date noted on a miniature by him is 1786. Thus he lived well into the period of Cosway and Smart in their maturity, and his awareness of the greater virtuosity of these latter years is shown by his striving for more boldness of effect and his increasing the size of his ivories. S. Cotes invests his sitters with an air of sturdy self-confidence, and is one of those miniaturists who generally perceives in them an incipient smile. Technically, he customarily uses opaque colour in broken touches on the hair, as well as on the lace edging of costume and the cravat.

The course of his career gives an illustration of the changing demands which were being made on the miniature painter through the growth of exhibiting institutions. As well as producing the small and intimate portraits which could be worn as a piece of jewellery the limner had to compete, on the walls of an exhibition, with oils and water-colours. Some tried to counter this competition by painting more ambitiously and on a relatively large scale. Samuel Cotes was represented in the first exhibition of the Royal Academy, in 1769, by his *Mrs Yates in the Character of Electra* (Fig. 67). It is on a sub-stantial piece of ivory, six inches in height, and shows the celebrated tragic actress in the role, in Voltaire's *Orestes*, which she first performed in the month in which this was exhibited. It appealed sufficiently to the current vogue for representations of actors in character to be engraved two years later, and stands in line with a number of fairly grandiose theatrical portraits, such as Scouler's of Garrick and his wife, and Richard Crosse's even larger miniature of Mrs Siddons in 1783 (both in the Victoria and Albert Museum).

There are a number of miniatures painted between about 1750 and 1765 which are signed *P.C.* These initials were once believed to connote Penelope Cotes, as a possible alternative to Penelope Carwardine. Penelope Cotes was supposed to have been a sister of Francis and Samuel Cotes; but no trace of her existence has been discovered and she is now considered to be a figment of the imagination. There is no stylistic reason why we should not regard all the miniatures signed *P.C.* as the work of Penelope Carwardine. That this is justified in certain instances at least is established by the fact that the existing members of the Carwardine family have miniatures by their ancestress which closely resemble the other works of P.C. Penelope Carwardine is known to have been born about 1730, the eldest of six daughters of John Carwardine of Thinghills Court, Withington, Herefordshire. Her father having ruined the family estates, she took to miniature painting, and was practising by 1754. She married Mr Butler, organist of Ranelagh, St Margaret's and St Anne's, Westminster, though this took place before the accepted date of 1772, since Humphry portrayed her as Mrs Butler in 1767.

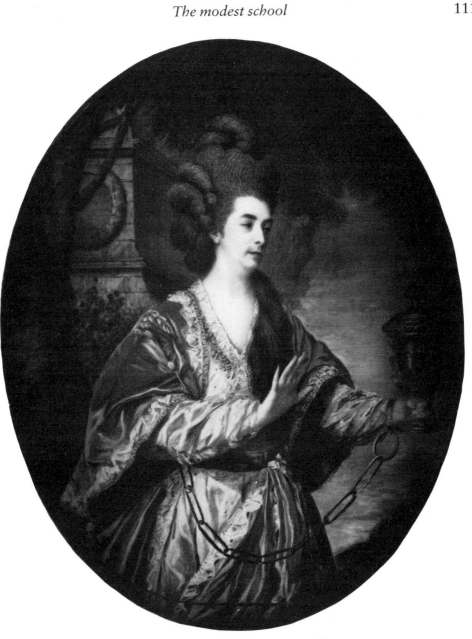

67 Samuel Cotes, *Mrs Yates as Electra*, 1769

68 Penelope Carwardine,
Maria Gunning, later Countess of Coventry, 1757

69 Luke Sullivan,
An unknown lady, 1760

She died in about 1800. If all mid-eighteenth-century miniatures signed *P.C.* are by her, it is necessary to make an amendment to the received account of Penelope Carwardine's career. It is stated in the *Dictionary of National Biography*, and repeated elsewhere, that she was instructed in miniature painting by Ozias Humphry. Humphry was born in 1742 and set up on his own by 1762, by which time P.C. had been at work for a number of years, and Penelope Carwardine also, by the same account. (There are references to her painting miniatures in Boswell's *London Journal*, 1762–3.) Humphry did paint a miniature portrait of her in 1767 (Fondation Custodia, Paris; Fig. 87), and she may well at this time, or earlier, have sought to improve her style from him, but he did not guide her earliest work. The earliest dated work of Penelope Carwardine is of 1753, and shows the formality of the Lens manner mingling with the greater interest in character and humanity of the newer fashion (Fig. 68).

Luke Sullivan was an engraver of Irish birth who took to miniature painting comparatively late in life and brought to it an original point of view. Born, it is said, in Louth in 1705 he soon left his home for England. His earliest engraving was a *View of the Battle of Culloden*, executed in 1746, and afterwards he was an assistant engraver to Hogarth. He is said in some accounts to have taken up miniature painting in 1759, though Long records a miniature by him which is signed and dated 1750. Certainly the majority of his uncommon works are dated between 1759 and 1770.

'Being much addicted to women', says a contemporary account of Sullivan, 'his chief practice lay among the girls of the town; and indeed he resided almost entirely at taverns and brothels.' His death, which occurred at the White Bear Tavern, Piccadilly, in 1771, is said to have been hastened by his irregular habits, but if he was indeed sixty-six at the time, his end hardly proves the more expeditious deadliness of evil ways. Possibly his birth is ante-dated by twenty years, for it is hard to believe that the first engraving of so assured a hand was not produced till he was over forty.

Sullivan's miniatures are the only ones by a British artist which have a hint, and there-

70　James Scouler,
An unknown man, 1781

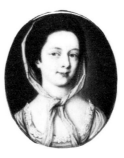

71　James Scouler,
An unknown lady

fore an anticipation, of the French school of Hall and Fragonard. His having been a pupil of the French engraver Le Bas may account for this affinity. His works achieve their effect by their notable sense of colour harmony, by a slight indefiniteness of touch – resembling the watercolour blottesque of Hall – and by their emphasis on the prettiness, sweetness and daintiness of their subjects, especially when they represent women or children (Fig. 69). J. T. Smith gives a glowing and not unjustified critique of him in *A Book for a Rainy Day*:

> Sullivan . . . was in my humble opinion, the most extraordinary of all miniature painters. I have seen three or four of his productions, one of which was so particularly fine, that I could almost say I have it on my retina at this moment. It was a portrait of a most lovely woman as to features, flesh and blood. She was dressed in a pale green silk gown, lapelled with straw-coloured satin; and in order to keep up a sweetness of tone, the artist had placed primroses in her stomacher; the sky was of a warm green, which blended with the carnations of her complexion; her hair was jet, and her necklace of pearls.

The miniatures of T. Redmond, James Reily and Gustavus Hamilton are also of the modest school. These artists have individual personalities of their own, though they are not such as to make themselves apparent in a crowded party. After studying in London, Redmond followed his career in Bath. J. Reily and G. Hamilton worked exclusively in Dublin, the former from about 1750 till his death in 1780, the latter from about 1760 till his death in 1775. From now onwards the cities of Bath and Dublin, distinguished by their Georgian architecture, become centres for the patronage of miniature painting. The rarely encountered S. Finney, who found favour with Queen Charlotte, has a genuine sense of style and feeling for the milk-white English complexion, and the monogrammist J.J. (probably J. Jennings) has again an individual though rather coarser approach to the portraiture of his sitters.

An account of individual artists who contributed to this charming interlude in English miniature painting may be concluded with a reference to James Scouler. He was

born in Edinburgh in 1740, was encouraged by a premium for a drawing from the Society of Arts in 1755, and had set up as a miniature painter by 1763. By 1770 he was drawing extremely well; and, with some occasional miniatures in a larger format, such as the excellent *Diana* of 1773 in the Victoria and Albert Museum, he painted them in his direct masculine style down to 1797 and perhaps later, for he died in 1812. He thus challenges comparison with the great masters, especially John Smart, whose work his somewhat resembles, and he does not suffer unduly by the comparison. His forceful use of gum gives his work the appearance of being painted in oil (Figs. 70, 71). Possibly because his initials were the same as those of Smart, he adopted the then unusual practice of signing his miniatures with his name in full along the edge, a custom generally associated with Continental miniaturists of more recent date.

Chapter 13

The great eighteenth-century miniaturists: (1) Jeremiah Meyer and Richard Crosse

If we were in London in 1763 and wanted a miniature of ourself or of a friend we might, failing a personal recommendation, consult the list in *Mortimer's Universal Director* – a sort of classified trades directory which appeared in that year. In that event we should be faced with a choice between twenty-four artists:

Beauvois	Robert Davy	Thomas Redmond
Mrs Benwell	John Fabian	James Scouler, junior
Brewer	John Finlayson	William Sherlock
Brockmer	Samuel Finney	John Smart
Mrs Carwardine	Charles Handasyde	Gervas Spencer
Richard Cosway	Nathaniel Hone	Francis Sykes
Samuel Cotes	Jeremiah Meyer	Mrs Todderick
Richard Cross	Henry Millington	Wilding

Not all the miniaturists working in the capital at the time took this opportunity to make their wares known, but Luke Sullivan and T. Frye are the only important omissions. Some of these artists we have already met as exponents of the modest school: others are unknown to fame. But the chief interest of this list is that it contains the names of four of the great artists who were to surpass their contemporaries and shed a new lustre on miniature painting in the late eighteenth century – that is, Richard Cosway, Richard Cross(e), Jeremiah Meyer and John Smart. Only George Engleheart, who was thirteen in 1763, and Ozias Humphry, who was working in Bath in that year, are absent from this assemblage of the first-ranking miniaturists of the second half of the eighteenth century.

The *Universal Director* was not, of course, the only or the most important medium whereby an artist could gain encouragement or recommend his wares to the public. In these years the change in patronage had crystallised in institutional form. The Society of Arts, which was formed at the suggestion of Shipley the drawing-master in 1753, had offered prizes for artists from 1755; and in 1760 the first public exhibition of living artists' work ever to be held in England was organised by the Society of Artists in the Society of Arts' rooms. After quarrels and secessions the movement for combined public exhibitions culminated in the foundation of the Royal Academy in 1768. These institutions met an urgent need of the artists and their encouragement helped many

artistic careers. Portrait miniaturists benefited by them no less than painters in other *genres*. As we shall see, Cosway and Smart were prize-winners in the classes for competitors under fourteen years of age in the first year that the Society of Arts distributed premiums, and miniatures were exhibited with the Society of Artists and the Royal Academy from their inception.

Jeremiah Meyer is the senior of those who are outstanding in this epoch of changed conditions and greater public encouragement. He was born in Tübingen in 1735, and his father, who was portrait painter to the Duke of Württemberg, brought him to England when he was about fourteen years old, in 1749. Sympathy for a fellow German or some other motive induced Zincke, then almost retired from the practice of his profession, to give him instruction in 1757 and 1758, at the cost of £200 plus £200 for materials. Thus it came about that Meyer painted enamels as a considerable part of his practice, though more commonly, it seems, in the earlier section of his career. He was never exclusively an enamel painter, however, and the finest portraits of his later years were in transparent watercolour on ivory.

Meyer exhibited with the Society of Artists from the first exhibition of 1760. In 1761 he received a prize of a gold medal from the Society of Arts for a profile of George III drawn from memory. In 1762 he was naturalised, and in 1763 he married an accomplished girl, Barbara Marsden. She also had received a prize from the Society of Arts, in the first year of the award, in the competition for drawings by entrants under fourteen years of age, when she was placed fourth to Richard Cosway's first and John Smart's second. In this year Meyer gave sittings to the Prince of Wales, and the following year he was appointed miniature painter to the queen and painter in enamel and miniature to the king. There is no question that he deserved this distinction on his merits, but it is probable that a kindliness felt by the royal family for a fellow German contributed to his election, as it had to the patronage of Kneller and Zincke. The culminating mark of distinction in his career came when the names of the founder members of the Royal Academy were first listed in 1768, and Meyer was the only miniaturist among them. (N. Hone also figured in this list, but his ambitions then were primarily as an oil painter.) He exhibited yearly with the Royal Academy till 1783, and died at Kew, whither he had retired, in 1789.

With this career of unbroken success Meyer seems to have combined a singularly attractive character, for Hayley the poet says of him: 'Were I required to name the individual whom I believe to have been most instrumental in promoting the prosperity of others (without the advantage of official authority or of opulence) I should say, without hesitation, Meyer.' Possibly this contains a reference to the suggestion made by Meyer that the Royal Academy should make grants from its funds to distressed artists and their dependants.

Meyer was one of the few London artists with whom Romney remained on good terms, and he did his best to advance his prospects, for he admired him greatly. It was he who introduced Romney to his biographer, Hayley. Hayley had intended to become an artist and had studied under Meyer, but was forced to give up, owing to inflammation of the eyes, in 1772. When later Hayley wanted oil portraits of his friends Meyer recommended Romney to him, and Hayley became the chief friend and the spiritual

director of this rising artist. Hayley is especially reproached with having damaged Romney's prospects by dissuading him from exhibiting at the Royal Academy; Meyer at the time did his best to persuade Romney to exhibit.

It is reputedly possible to see the humble origins of Meyer's style in a work of 1750 which bears the monogram signature *JM* and was lent to the Victoria and Albert Museum anonymously between 1920 and 1923. If this is correctly ascribed to Meyer, it is the work of a boy of fifteen, and painted seven years before his apprenticeship to Zincke. While it is not impossible to see in it the beginnings of Meyer's angular draughtsmanship, it is none the less likely that this is the work of a maturer artist with the same initials, such as Joseph Moser. The materials for the assessment of Meyer's development in the 1760s are scanty, but two or three known miniatures referable to this decade when the artist received such emphatic recognition suggest that his miniatures then were not greatly different in ambition and quality from those of N. Hone and Luke Sullivan. It is in the portraits datable after 1770 that he outstrips these more modest competitors. It was from 1770 that the female coiffure began to rise up from the head in large powdered mounds, and at the same time the size of miniatures increased from about 1½ inches to over 3 inches in height. Both these changes suited Meyer, and helped him to deploy the full resources of his style. At the basis of that style is his delicate and expressive use of line. He does not stipple or use broad washes of tone, but the whole surface of his ivory is covered with longer and shorter lines, very fine in width and crossing one another at all angles to achieve the modelling of the face. Even the costumes, in the colour and texture of which Meyer evidently delights, are scored with clusters of vertical lines as well as receiving a heightening of opaque white for the highlights of the cravat or *fichu*. On the face these clusters of lines are often so fine that they can barely be discerned without the glass; but in the hair Meyer takes full advantage of high coiffures and clusters of curls to mass his brush strokes in long sweeping calligraphic rhythms (Fig. 72). He used, unfortunately, a fugitive flesh-tint which has caused his miniatures to suffer more from fading than those of almost any other artist of the period.

Carl Winter has well described Meyer's work as having 'imported into English miniature painting an elegance akin to that of the fine porcelains of Meissen and of Nymphenburg'. Nor does one expect dramatic sculptural intensity of those porcelains, and vivid insight into personality is equally absent from Meyer's miniatures. They are all the more representative of the elegant aspirations of the second half of the eighteenth century. Meyer's linear method introduces a slight angularity into his drawing of mouth, nose and eyes which accounts for the mannerisms by which his miniatures are so easily recognised – somewhat protruding lips and sunk-back eyes (Figs. 73, 74).

These characteristics are exaggerated in the sketch-book of pencil drawings in the Victoria and Albert Museum which is almost certainly rightly attributed to Meyer. In these pages of great beauty the artist sketches heads with an angularity akin to that of Dürer when he dissected heads on cubistical principles. Here, too, Meyer, if it is he, tries his hand at a few figure compositions in the manner of his friends Romney and Cipriani, but not over seriously or effectively. A volume at the Ashmolean Museum, given by a descendant of Meyer's daughter, has mounted into it a number of unfinished miniatures

and portrait sketches by Meyer on ivory or paper, among them a sketch of Queen Charlotte; finished portraits of her and other members of the royal family are in the Royal Collection at Windsor (Plate XIV).

Considering the *réclame* he enjoyed in his lifetime, miniatures by Meyer are encountered less frequently than would be expected; and when they are met with they are sometimes wrongly ascribed to better-known names. The nineteenth century, which exalted Bone into the rank of a master, almost forgot the existence of Meyer and of R. Crosse. The process of forgetting him may be seen at work in the conversation entered by Farington in his *Diary* on 18 February 1808: 'The miniatures of the Mr. Meyer R.A. and of Humphry as being highly esteemed at the period when they were painted was spoken of. – Dance said they were pretty pictures but there was not the least truth of representation in the pictures painted by either of them.' Of recent years this estimate has been overthrown, and we again share the admiration felt by their contemporaries both for Meyer and for Humphry.

The next four miniaturists to call for consideration were almost exact contemporaries. Smart was born *c.* 1741, Crosse and Humphry were born in 1742, and Cosway probably also in 1742. Richard Crosse, like Meyer, Cosway and Smart, graduated to public notice by way of the premiums of the Society of Arts, the exhibitions of the Society of Artists, and the Royal Academy. He was awarded his premium in 1758 at the age of sixteen, and he exhibited at the first exhibition of the Soviety of Artists in 1760 and in the second and subsequent exhibitions of the Royal Academy, from 1770 till 1796. He gained recognition early, for a critique of 1765 about the Society of Artists' exhibition in Spring Gardens included the remark that 'As Miniatures are apt to escape the Eye, unless that of a very curious Observer, it is but Justice to recommend those of Mr. Crosse to the Notice of the Publick.'

Crosse came from a different *milieu* than that of most of the artists who practised professionally at this time. He was the son of members of the landed gentry, whose residence was at Knowle, near Cullompton, in Devonshire, but, like one of his sisters, he had the misfortune to be born a deaf-mute. His aptitude for art is said to have shown itself without special training, and provided him a means of occupation which, in view of the recognition he enjoyed, proved very profitable. A manuscript register of the miniatures he painted between 1775 and 1798 is in the Victoria and Albert Museum, and has been published by B. S. Long in the Walpole Society's volume No. XVII; this shows him to have been a prolific worker who painted about one hundred miniatures in each of the years 1777, 1778, 1779 and 1780. Thereafter his rate of production dropped and in 1785, when he seems to have been ill or on holiday for four months, he only produced twenty-three. In the 1790s his output steadily fell, from twenty-three in 1790 down to seven in 1798, and he probably gave up practice entirely in that year. His prices were modest, being for most of his career eight guineas for a miniature of small size and ten guineas for a larger size. He was probably not financially dependent on his art – and yet in one of his best years he made £960 in its exercise. The ledgers record other features of contemporary practice. An admiral brings two miniatures of ladies to have the heads changed – it was the era of the high coiffure – and Crosse occasionally copied portraits by others. One of his most interesting sitters, who does not figure, how-

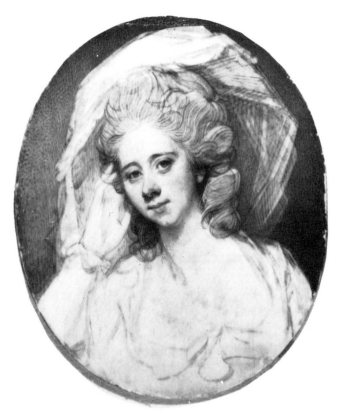

72　Jeremiah Meyer, *Georgiana, Duchess of Devonshire*

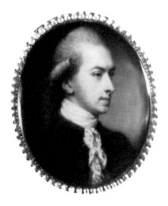

73　Jeremiah Meyer,
Thomas Frankland

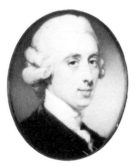

74　Jeremiah Meyer,
An unknown man

ever, in the register, was Sarah Siddons, of whom he painted more than one portrait. The Victoria and Albert Museum has in addition to the large miniature of her (Fig. 75) a note to Crosse in her handwriting. A smaller miniature of her is in private hands.

His physical affliction was not the only or the worst temporal misfortune which befell Crosse. He was deeply in love with his cousin, Miss Sarah Cobley, and proposed to her, it seems, in about the year 1778. She refused him, being already engaged to Benjamin Haydon, and meant never to see him again. Miss Cobley married Benjamin Haydon in 1782, and their son, the famous painter and diarist, B. R. Haydon, was born in 1786. The refusal embittered the life of Richard Crosse and induced him to withdraw further from society. Soon after 1797 he retired to Wells to live with Miss Cobley's brother, a prebendary of the cathedral, and in this way was destined to meet the object of his lifelong devotion once again, on the day before her death in 1807.

Benjamin Robert Haydon, who was at the time twenty-one years old, witnessed their unexpected and affecting meeting and wrote a vivid account of it in his *Autobiography*:

My dear Mother felt her approaching end so clearly that she made every arrangement with reference to her death.

I went to Exeter to get her apartments ready at the hotel, the day before she left home. She had passed a great part of her life with a brother (a prebend of Wells), who took care of a Mr. Cross, a dumb miniature painter. Cross (who in early life had made a fortune by his miniatures) loved my mother, and proposed to her, but she being at that time engaged to my father, refused him, and they had never seen each other since. He retired from society, deeply affected at his disappointment. The day after leaving Exeter, we stopped at Wells, as my mother wished to see my uncle once more.

The meeting was very touching. As I left the room and crossed the hall, I met a tall, handsome, old man; his eyes seemed to look me through; muttering hasty unintelligible sounds he opened the door, saw my mother, and rushed over to her, as if inspired of a sudden with youthful vigour. Then pressing her to his heart he wept, uttering sounds of joy not human! This was Cross. They had not met for thirty years. We came so suddenly to my uncle's they had never thought of getting him out of the way. It seemed as if the great sympathising Spirit once again brought them together, before their souls took flight.

He was in an agony of joy and pain, smoothing her hair and pointing first to her cheek and then to his own, as if to say 'how altered!' The moment he darted his eyes upon my sister and me, he looked as if he *felt* we were her children, but did not notice us much beyond this.

My sister, hanging over my poor mother, wept painfully. She, Cross, and my uncle and aunt, were all sobbing and much touched; for my part my chest hove up and down as I struggled with emotions at this singular and affecting meeting. What a combination of human feelings and sufferings!

Disappointment in love, where the character is amiable gives a pathetic interest to woman or man. But how much more than ordinary sympathies must he excite, who dumb by nature, can only express his feelings by the lightnings of his eye; who, wondering at the convulsions of his own heart, when the beloved approaches him, can but mutter unintelligible sounds in the struggle to convey his unaccountable emotions? . . . Thus had this man been left for thirty years, brooding over affections wounded as for the mere pleasure of torture. For many months after my mother married, he was frantic and ungovernable at her continued absence, and then sank into sullen sorrow.

His relations and friends endeavoured to explain to him the cause of her going away, but he was never satisfied and never believed them; now, when the recollection of her, young and

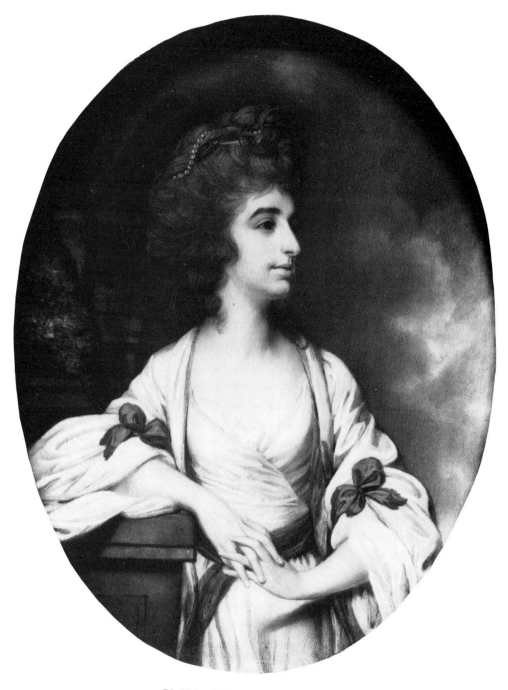

75 Richard Crosse, *Mrs Siddons*, 1783

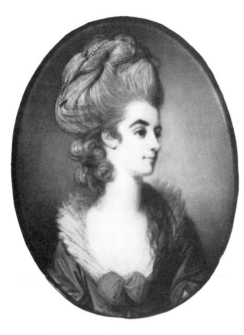

77 Richard Crosse,
A clergyman

76 Richard Crosse, *Mrs Johnstone*

beautiful, might occasionally have soothed his imagination, like a melancholy dream, she suddenly burst on him with two children, the offspring of her marriage with his rival – and so altered, bowed, and weakened, as to root out the association of her youthful beauty with the days of his happy thoughts.

There are great moments of suffering or joy when all thought of human frailties is swept away in the gush of sympathy.

Such a moment was this. His anger, his frantic indignation, and his sullen silence at her long absence, all passed away before her worn and sickly face. He saw her before him, broken and dying; he felt all his affection return, and flinging himself forward on the table, he burst into a paroxysm of tears, as if his very heart-strings would crack. By degrees we calmed him, for nature had been relieved by this agonising grief, and they parted in a few moments for the last time.

Whether Crosse was, as is usually reported of him, appointed miniature painter in enamel to the king in 1789 in succession to Meyer and, if so, whether he held the post conjointly with Collins, who is also said to have held that position in the same years, is difficult to determine. The earliest known reference to the subject is in a memoir on Richard Collins by Ozias Humphry, drawn up in 1796, of which the following sentence is relevant:

One day when he [Collins] was painting at the Queen's House, his Majesty came into the room where he was, and after expressing his approbation of what he was painting the King asked him who it was the Lord Chamberlain had appointed his Enamel Painter, for he understood he had not been content to give him a Miniature Painter only without his approbation [This refers to the appointment of Bowyer, when the King wanted Collins] – but had also named an Enamel painter for him – Upon his Majesty being informed it was Mr. Cross – he replied – that is very

cross indeed of my Lord Chamberlain! However, the King added Lord Salisbury may appoint as many Painters as he pleases but they never shall be employed by me for you *alone* shall paint my portraits in Miniature.

None the less, portraits of George III by Crosse are known, and one is in the Victoria and Albert Museum.

Richard Crosse died three years after his last meeting with Mrs Haydon, in 1810, not at Wells but in his family home at Knowle.

The works of Crosse are plentiful, but still, in spite of B. S. Long's successful attempts to reclaim many of them from oblivion, sometimes not recognised as his. He is a firm and sure draughtsman and, as does Meyer, gives prominence to the mouth in his drawing; but his system of colouring is quite individual. In this he seems to be taking over into miniatures the tonality of early Reynolds portraits, for his small portraits are almost always pervaded by a tint of greenish-blue (Figs. 76, 77). Generally his perception of his sitter's character is straightforward and his drawing correct and evidently like; but occasionally he was seduced into attempting greater 'refinement', as understood by the taste of his times, in his portraits of women. But these are infrequent lapses, and in spite of the quantity of works of his active years he did not fall into mannerisms. His touch is soft and he draws hair with a fine feeling for the grey line of his shadows: he may be thought of as occupying a position in style between Meyer and Engleheart. His extensive practice is one of the many evidences of the great increase in patronage for miniaturists at a time when many more were competing for it, and shows how small a proportion of the output of one man was exhibited at the annual exhibitions of the Society of Artists and the Royal Academy. Their main function was to serve as a shop window which would attract private custom.

The great eighteenth-century miniaturists: (2) Richard Cosway, Smart, Humphry and Engleheart

Nicholas Hilliard expresses the spirit of the court of Queen Elizabeth and Samuel Cooper that of the Cromwellian age. Richard Cosway is also a representative artist who expresses the spirit of the Grand Whiggery of the last years of the eighteenth century, as typified by George IV when Prince of Wales, Charles James Fox and the beautiful Georgiana, Duchess of Devonshire. But it was not until he had attained almost to his fortieth year that he was put in the position to show his talents to the best advantage. He had been a precocious youth who had attained early recognition, and the miniatures he painted in the 1760s and 1770s bear the characteristic mark of his genius, but had he died in 1780 he would not have stood out so transcendently in repute above his best rivals. The reasons why his recognition by the Prince of Wales led to the full blossoming of his style lie in his own peculiar narcissistic and ebullient character.

Cosway was the son of the headmaster of Blundell's School, Tiverton, and was born in 1742. He was sent to London to study to be a painter before he was twelve years old, and was placed first with Thomas Hudson, himself a Devon man. He soon left Hudson for instruction in Shipley's drawing school, and it was presumably while he was working there that he sent in the drawing of a head representing Compassion which gained him the first prize of £5 in the Society of Arts' first distribution of premiums for boys and girls under fourteen years of age. (It was in this competition that Smart took second prize and Barbara Marsden, later to become Jeremiah Meyer's wife, won fourth place.) He won second prize in 1757 for ornamental design, prizes in 1758 and 1759 and a first prize of thirty guineas in 1760 for a drawing from the life, open to young men under twenty-four. As he was only eighteen when he won this last reward he had evidently outstripped all his competitors.

It had been his ambition to become a full-scale portrait painter in oils. He describes himself in his entry of 1763 in *Mortimer's Universal Director* as a painter, not a miniaturist, and for many years he exhibited oil paintings, but he did not attain any notable success in this medium. His handling is heavy and his powers of characterisation seem to be overborne by the more painstaking method of execution. Cosway showed one work – an oil painting – at the Society of Artists' opening exhibition in 1760. He was not represented in the first exhibition of the Royal Academy in 1769, but he entered the Academy's schools in that year and exhibited the next. He was promptly made an A.R.A., and became a full R.A. in the next year, 1771, an election which singled him out

in distinction from the other young miniaturists who were his contemporaries; Humphry did not become a full R.A. till 1791. He was already becoming known also for the foppishness of costume which was the somewhat incongruous accompaniment of his short stature and monkey-like face. In 1772 two prints appeared, one by Dighton, the other published by Darly, satirising him as a 'Macaroni' miniature painter. He proposed to a Miss Woolls in 1773, but she rejected him, and he did not marry till 1781. His bride was Maria Hadfield, who was born in Italy of Irish parents and herself had artistic ability. Fairly soon after their marriage, in 1784, the Cosways moved from Berkeley Street to the centre portion of Schomberg House in Pall Mall. They succeeded as tenants to Dr Graham's notorious Temple of Health and had Gainsborough as their neighbour in the western wing. Here they held a regular *salon* and entertained the *haut monde* at musical parties at which the Prince of Wales, the Duchess of Devonshire, Horace Walpole and many notabilities were visitors. Cosway is said to have obtained the favour of the Prince of Wales by a successful miniature of Mrs Fitzherbert. The Prince first met Mrs Fitzherbert when he was twenty-one, in 1783, so the royal patronage which transformed Cosway's life may have begun at the time of his move to Pall Mall or shortly before. Allan Cunningham indeed says that it was in his Berkeley Street house that Cosway was first in the habit of receiving visits of the Prince. By this association he became recognised as the fashionable miniaturist *par excellence* among the members of the Whig Party who formed with the Prince the motive power of London's freer social life. The proximity of Carlton House to Schomberg House led to the suggestion that Cosway had a private means of access to the Prince's apartments. Certainly in 1788 and 1789 he was working on a ceiling painting of *Apollo and the Hours* for the grand saloon at Carlton House.

The scale and scope of Cosway's parties, visited by many of the loosest livers in Town, gave rise, naturally enough in that age of scandal and satire, to the grossest rumours. 'Anthony Pasquin' (John Williams) in his *The Royal Academy: A Farce, 1786*, accused Cosway of being complaisant to a liaison between his wife and the Prince of Wales; but as it was upheld of Pasquin in a court of law in his lifetime that 'he was so lost to every sense of decency and shame that his acquaintanceship was infamy and his touch poison', little reliance can be placed on his unsupported assertion. Other contemporaries referred to Cosway as Pandarus and described his rooms as 'a first-rate house of assignation'. Whatever the truth of it, the parties held by the Cosways undoubtedly created a stir. It was in about the middle of their tenure of Schomberg House that Cosway began to sign his miniatures at the back with the pompous Latin inscription, 'Rdus Cosway RA Primarius Pictor Serenissimi Walliae Principis Pinxit'. The earliest known example of this signature is of 1787, but in 1786 a caricature of Cosway's engraved self-portrait appeared with the title 'Dicky Causeway in Plain English' and giving an evident parody of this or some such inscription. It may therefore be presumed that the Prince of Wales accorded Cosway the title of Miniaturist, by which he set so much store, in about 1786. Whatever the effect on his vanity, this appointment set the final seal upon his style. None of his works are freer and more assured than those which are datable between 1785 and 1800.

Cosway left Pall Mall in 1791 for Stratford Place. Here again he furnished in lavish

style; but his domestic life was more unsettled. Maria Cosway, who had had an affair with Thomas Jefferson in Paris around 1786 and whose only child was born with great difficulty three or four years later, took to spending more time abroad and apart from her husband. Particularly after the death of their daughter at the age of six, Cosway's eccentricities also became more marked. The last decades of the eighteenth century were remarkable for the impetus they gave to religious fanaticism, and these evangelical outbursts had a fascination for many artists. William Sharp the engraver, de Loutherbourg, Alexander Cozens, Blake and Varley were all devotees of some form of the occult or esoteric. It was at de Loutherbourg's instance that Cosway became concerned in such beliefs; and in his later years he would say that the Virgin Mary had been sitting to him for a half-length figure and that he had been conversing with Charles I on art. But his work and his collection still attracted respect even from men who had been prone to despise him. Lawrence, who was not over-charitable in his judgment of his fellow artists, said – writing to Farington in 1811:

> I have since been to Cosway's, and have seen *an Artist*'s house, such a Mass of his FIT *Materials* and so much Talent and Information in the POSSESSOR (tho' not seeing him in Person), as to make me asham'd of the injustice which prejudice, or say *just* opinion of his Weaknesses or positive faults of Character as a Man, have led me to commit against the general weight of his estimation as an Artist.

Cosway died in 1821, and his wife, who returned from time to time during his declining years and was in London when he died, went to Lodi, where she had founded a college nine years before; she eventually turned the college into a convent. She was made a Baroness by Emperor Francis I in 1834 and died at Lodi in 1838.

Cosway achieved in his life many of the social ambitions which Sir Joshua Reynolds had staked out for the artist. It is possible to fill out his biography with copious further incident and anecdote, for he was constantly in the public eye; but it is singularly hard to trace the development of his early style. The earliest work of all known to be by him is an enamel of a man, signed in full and dated 1753. It is to all appearance authentic and is an astonishing performance for a boy of eleven, having as much authority as anything by N. Hone of the same date and clearly foreshadowing his mature manner. From whom he learned the craft of enamelling so early is not recorded; it was certainly not from Hudson, and the technique most resembles N. Hone's. The assurance of this example makes his success in the Society of Arts' exhibition the next year the more understandable. The Duke of Buccleuch has in his collection an oblong oval miniature of the two Scott brothers, which is signed R. Cosway at the back and dated in the 1760s (the last figure is illegible). Though a useful landmark in view of the paucity of Cosway's early work, this is in fact only a copy after part of a group by Sir Joshua Reynolds which is dated 1758. The most accessible representative of this early period is the miniature of Lady Sarah Napier in the Victoria and Albert Museum which, from the costume, is to be dated *c.* 1765–70. This already has the softness of touch and firmness of modelling of Cosway's later manner, but the head is small in size and the whole miniature modest in conception. The pose and ornamental background imitate the mannerisms of Reynolds's official portraiture, and it is his way of treating the

78 Richard Cosway, *Anne, Countess Winterton*

background above all which reveals that Cosway has not yet discovered, as he was shortly going to do, that the way to profit to the full from the luminosity of his ivory surface was to use transparent pigment and leave the ground to tell as much as possible. The steps which led him to this conclusion are not easy to trace. Possibly Meyer's example was the decisive factor, if it is true that this miniaturist's style broadened and became more calligraphic as the scale of his ivories increased during the 1770s and early 1780s. It is at about this period that Cosway shows himself more aware of the use of line in his drawing of the hair and costume, and his line is softer and more rhythmic than Meyer's rather rectilinear parallelisms. The relatively small miniature of Anne, Lady Winterton in the Falk Collection (Fig. 78) illustrates this phase, in which also for the first time Cosway's exaggeration of the size of the pupil of the eye becomes apparent. Finally, in about 1785 the full glories of his style are displayed; from now onwards his miniatures are generous in scale (3 inches in height as opposed to 1½ inches), brilliant in drawing and dashing in execution. The external circumstances of this comparatively late blossoming (he was over forty) have already been indicated: they included his marriage, his removal to Pall Mall and his patronage by, and close relations with, the Prince of Wales. That it was now that he started to sign and date his miniatures with the addition 'Primarius Pictor Serenissimi Walliae Principis' shows that he also was aware of a consummation of his powers (Plate XV).

Those miniatures by Cosway which are most readily recognised as his, and which command admiration outside the circle of professed collectors of miniatures, belong to this period of *c.* 1785–1805, and some of the finest miniatures of the eighteenth century are among them. In them he severely limits the amount of pigment which he places upon the ivory and ensures that the colours he does use are as transparent as possible. The

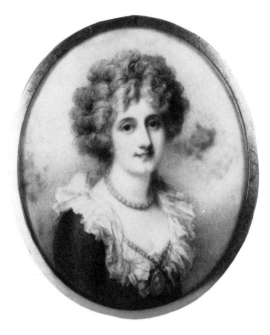

79 Richard Cosway,
Maria Fagnani, third Marchioness of Hertford

methods of shadowing he had already adopted, with short grey strokes in varying directions, ensured that the luminosity of the ivory told even in the darker portions of the face; he now enhances this characteristic, and it is greatly helped by his abandonment of a dark or richly coloured background in favour of one in which the variegated texture is supplied by casual transparent strokes on a light sky. He succeeds to an extraordinary degree in conveying the illusion of a third dimension in the craft of the modelling with which he rounds the face. The means by which he achieves this are a series of long sweeping strokes round the whole contour of the cheek, which merge insensibly its dark edge into the lighter background, and the actual science of his shadowing, which is not conventional but clearly echoes the exact structure of the face. Even the distortions which Cosway introduces at this period in the interests of greater elegance – the long neck and enlarged pupil of the eye – enhance this illusion of the third dimension.

Cosway was accused by some of his contemporaries of flattering his sitters, but he does not lose their individuality while endowing them with the utmost handsomeness that the physical facts of their appearance warrant. This can be seen by comparing his portraits with those of the same person by another artist. Confirmation may be sought, for instance, by comparing the miniatures of Frederick, third Earl of Bessborough, and

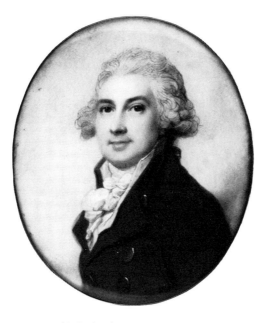

80 Richard Cosway, *Mr Bigland*

his wife – in the Victoria and Albert Museum – with the portraits of the same couple, slightly later in life, by Reynolds at Althorp. Or again we may compare his miniature of de Loutherbourg formerly in Mr Minto Wilson's Collection with Gainsborough's earlier portrait in the Dulwich Gallery. Sometimes indeed he may be thought to have brought out a beauty which was really in the sitter but was difficult to convey. The beauty of Georgiana, Duchess of Devonshire, enjoyed immense contemporary fame, but has been thought disappointing from the portraits of Reynolds and Gainsborough, and was said in her own time to depend upon her animation. The many miniatures of her by Cosway convey her beauty without being conventional images as do those by him of other beauties, such as Maria Fagnani (Fig. 79). Nor does Cosway's foppishness of manner enter into his rendering of character. His portraits of men are firm, strong and masculine (Fig. 80).

When, in the opening years of the new century, Cosway ceased to bask in the favour of the Prince of Wales, and when his difficulties and eccentricities increased, he was forsaken by much of his fashionable clientèle and he began to find it physically more difficult to paint miniatures. But in this last period his style entered a new phase which may be compared in its way with the last phase of Franz Hals; he becomes almost care-

less of colour, but conveys portraiture of a deeper psychological complexity, mainly in dull tones loaded with grey (Figs. 81, 82). It is said that the last miniature he ever painted was one of Lady Berwick, now at Attingham Park, and the miniature itself is quite consistent with this last facet of Cosway's incomparable manner.

In addition to his miniatures and his rarer oil paintings Cosway made a number of portrait drawings, in which the sitter is generally represented full length in pencil and the face alone is worked on in water-colours. He also made many subject and fancy drawings, which, like his portrait drawings, provided fit material for the stipple engravers, and which enabled him to evince a strong leaning toward the style of Correggio, but which fall far below his miniatures in artistic worth.

His miniatures are plentiful and there is scarcely an important collection without some good example of his work. But one at least will never be seen again. When George IV died he had around his neck the miniature by Cosway of Mrs Fitzherbert which he had always worn there, and on his instructions it was buried with him.

The miniatures of John Smart are esteemed by many collectors as ardently as those of Richard Cosway, and some even seek to give him the higher place; but no wider contrast could be found than the careers of these two contemporaries. Cosway lived in the blaze of publicity, Smart quietly, Cosway exhibited with the Royal Academy the year after it was founded and became a full Academician, Smart remained faithful to the rival organisation, the Society of Artists, until 1783, did not exhibit at the Royal Academy until 1784, and was not elected even to the position of A.R.A. Cosway's later styles show a distinct progression from his earlier ones, Smart pursues the even tenor of one manner throughout the whole of his working life.

It is only in their ability to incur moral censure that Cosway and Smart are in any way parallel. It was for long reported that Smart was a paragon of virtue, a member of the strict sect of Glassites or Sandemanians. But the publication in 1951 of the *Memoirs* of Thomas Jones threw a different light upon Smart's private life. He says that the lady who passed by the name of Mrs Pars and who died in Rome of consumption in June 1778 was in fact the wife of John Smart. He alleges that Smart had picked her up in a bagnio near Covent Garden, and, tiring of her, engaged William Pars as her *Cavaliere Servente*. Smart having separated from her, Pars went with her to Italy expecting at any time a case for *crim. con.*, which was only prevented by her early death. Jones describes Smart as 'a Muckworm' and says 'however eminent in his profession . . . he was a man of the most vulgar manners, grossly sensual, and greedy of Money to an extreme (I have often heard him say "D— me Sir I can sit on my A— for 18 hours together without stirring and put four & twenty guineas in my pocket at a sitting")'. The same memorialist, Thomas Jones, more famous as the pupil of Richard Wilson, gives a first-hand account of the drawing academy run by William Shipley, to which he was sent, in 1761, for instruction in art. He describes Shipley as a 'worthy but eccentric character' and remarks that the list of his pupils who were acquiring reputations as artists included 'the Names of Cosway, Smart, Cross, Humphry, W. Pars &c.' Of these only Pars, who became so tragically involved with Smart's wife, was not a miniature painter.

The date of Smart's birth is not definitely known; some evidence points to its being between May 1741 and May 1742. He was a prize-winner in the first competition of

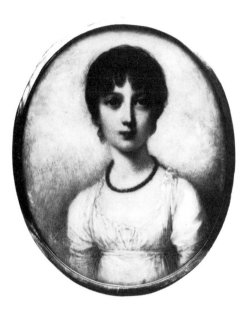

81 Richard Cosway, *Princess Amelia*, 1802

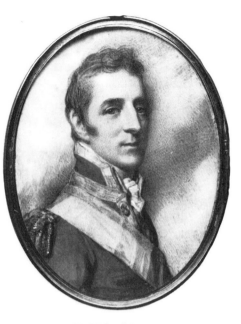

82 Richard Cosway,
Arthur Wellesley, first Duke of Wellington, 1808

the Society of Arts, when he was placed second to Richard Cosway: he won prizes again in 1756, 1757 and 1758, and in 1758 had the satisfaction of being placed first in the class in which Cosway was second. Some of Smart's prize-winning drawings in these competitions are known: that of 1755 representing a nude male figure posed as a river god is certainly a surprisingly finished work for a boy of under fourteen.

The chronological study of Smart's miniatures is helped by the practice he formed at the very outset of his career of adding the date below his signature of a cursive *J.S.* The earliest of his miniatures are dated 1760, and already display the close finish and gem-like brightness which were to be the unvarying qualities of his work.

Mr B. S. Long has shown the extreme improbability of the suggestion that Smart was the pupil of Cosway; and quite apart from the date of the references, which have been misunderstood and would make Smart well over forty at the time he submitted to the tuition of his great rival, there is no vestige of Cosway's influence in Smart's style at any stage.

There was no exhibition of the Society of Artists in 1784. This year marks a turning-point in Smart's life, for not only did he then exhibit for the first time at the Royal Academy but he applied in the same year for permission to sail to India. This proved to be the one adventure of his life, and a very fruitful one. He arrived in Madras with one of his daughters in September 1785 and stayed there for nearly ten years. The prospect

of his arrival gave considerable anxiety to Ozias Humphry, who had settled in Calcutta only the month before and evidently feared that Smart would garner much of the rich harvest he had promised himself from miniature painting in Bengal. In the event, the paths of the two artists did not cross, but Humphry's letters to Miss Boydell are interesting as showing his estimation of Smart's worth and of the relative merits of the other notable miniaturists of the day. He asks Miss Boydell to send him a miniature of herself and especially recommends her to have it done by Smart; failing him, by Jeremiah Meyer or any other but Cosway. Apparently his objection to Cosway was based on his reputation for gallantry with women, and his eagerness to have the lady painted by Smart was increased by his desire to postpone the departure of his rival to India. When he eventually received Smart's miniature of the lady he described it as 'extremely like': the features of her face were rendered with 'exactness' but 'certainly without any flattery', and he thought it 'without air, or any grace in the disposition of it'.

Smart prospered in India and was throughout the period of his stay miniature painter to Muhammad Ali, Nawab of Arcot, and his family. No less than four miniatures of this potentate by Smart are known (Fig. 83), in addition to the sketch on paper in the Victoria and Albert Museum which is probably the working model for these many repetitions. The Fitzwilliam Museum has a fine miniature of a young Indian, probably a member of the Nawab's family. Smart distinguishes his work in India by adding a Roman I after the date. He never painted better than in this decade, as his portraits of Sir Charles and Lady Oakley show. Smart's daughter Anna Maria, who had travelled out with him to India, married Robert Woolf of the Madras Civil Service in 1786; he was later joined by another daughter, Sophia, who arrived in 1789 and married Lieut. John Dighton in 1790.

Smart returned to England in November 1795. The Society of Artists had by then ceased to exist, and Smart, who had been a Director in 1773 and 1783 and Vice-President in 1778, is said to have lost much money at its winding up. He thereupon exhibited fairly regularly at the Royal Academy till his death in 1811. Farington met him once or twice in these latter days. On one occasion in 1806 Smart showed the diarist his miniature of Master Betty, the boy actor. Farington records: 'It was like the boy. Smart was, as usual, very much delighted with his own performance.'

As already noted, the earliest dated miniatures by Smart, of 1760, bear all the marks of his fully developed style. Again there is a contrast to be made with Cosway, for whereas Cosway's style is broad and his colour almost entirely transparent, Smart's style is meticulous and minute in finish and he makes extensive use of body-colour in the smooth brilliance of his sitter's costume. Viewed under the lens his miniatures have none of the calligraphic abandon and brisk assurance of Cosway, but their immediate effect on the unaided eye is of brilliance of colour and *finesse* of modelling. He accentuated the glow on his sitters' faces by leaving a little island of naked ivory for the highlight of the cheek and even a dab of opaque white on the tip of the nose; and he uses a fairly reddish deep flesh colour. The details of the costume, drawn in flat body-colour with great assurance, remain in unfaded brightness, and this emulation of the fine fabrics of eighteenth-century clothes is one of the main sources of his high reputation. His miniatures are of the utmost prettiness, and when, as he occasionally does, he paints

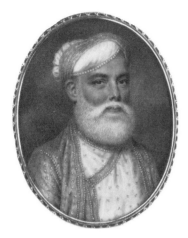

83 John Smart,
The Nawab of Arcot, 1788

on enamel, there is scarcely any perceptible difference in effect. As an interpreter of character Smart is less interesting. While Cosway brings out the utmost elegance and refinement of which his sitters are capable, Smart represents their more plebeian aspect. He is successful proportionately to the age of his sitters: enchanting with children, pretty with youth, but less impressive with old age. The size of his miniatures follows the almost standard variations of the times. He generally used an ivory 1½ inches high up till about 1775; from then on he frequently used one 2 inches high; and in the 1790s and 1800s he sometimes increased the scale to an ivory 3 inches high, as in his fine self-portrait of 1797 in the Victoria and Albert Museum (Plate XVI). These changes are of more than arithmetical importance: the larger ivory gave Cosway scope for enhanced bravura, and though Smart's style did not admit of great dash he managed to retain his *finesse* on the larger surface. The uniformity of style and the gradual increase in size in Smart's miniatures can best be studied in the remarkable collection given by Mr and Mrs Starr to the Nelson Gallery and Atkins Museum, Kansas City. They succeeded in assembling a group of miniatures by him which are signed and dated for every year between 1760, when he was barely nineteen years of age, and 1810, the year before his death (Figs. 84, 85). Here, as elsewhere, we find that as the size of the miniature increased, the bracelet type of slide-frame had become outmoded. The feeling that the portrait was a personal possession of exceptional intimacy was preserved by including the sitter's initials and tresses of hair in the back of the frame. Many such later eighteenth-century miniatures have these personalia combined with blue or opalescent glass laid over patterned foil, and are among the most pleasing minor achievements of the jewellers' art.

Smart made numerous portrait sketches, the same size as the miniatures for which they were intended, in water-colours on paper, and kept them by him, no doubt in case repetitions were required. Three large collections of these sketches on paper from the

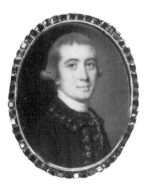

84 John Smart,
An unknown man, 1767

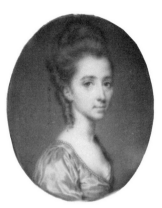

85 John Smart,
An unknown lady, 1776

possession of the artist's great-grandchildren were dispersed in the salerooms in 1936 and 1937, and individual items from this dispersal are frequently met with. These sketches are often inscribed with the sitter's name, and they then provide valuable material for purposes of identification.

Besides his illegitimate son John Smart, junior, who produced a few miniatures on ivory and rather more portraits on paper or card, Smart had a close follower in Samuel Andrews, who set up as a miniaturist in Madras in 1791 and moved into Smart's house when he returned home from India in 1795. Andrews eventually moved north to Calcutta, and died in Patna in 1807 at the age of forty. His miniature of Lieut. Nuthall, in the Victoria and Albert Museum, shows that he was at times capable of a very creditable imitation of his master's style.

Ozias Humphry, who was born in 1742, was not able to sustain such a long career of activity as a miniaturist as his fellow Devonian Cosway, or as Smart, owing to the failure of his eyesight when he was aged about fifty. His miniatures of the 1760s and 1770s, when he was at his best, are fully able to bear comparison with those of the leading miniaturists.

He was born in Honiton, and though his father carried on the trade of peruke-maker and mercer and his mother that of lace-maker he was himself given to the foible, which grew on him in his later years, of dwelling on the nobility of his ancestry. When he was thirteen years old he was sent to London for instruction in drawing, but he returned to Devonshire the next year and, unlike his great contemporaries, made his début as a miniature painter in a provincial centre, at Bath. Here he was the pupil of Samuel Collins and, as we have seen, when that erratic gentleman had found it expedient to remove to Dublin to avoid his creditors the young pupil succeeded to his connection. He may well have derived more instruction from his acquaintanceship with Gainsborough, who was in Bath at the same time. Gainsborough was just about to descend upon London, and Humphry, who had powers of observation and self-expression, has left a

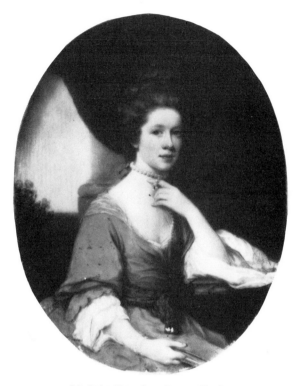

86 Ozias Humphry, *Queen Charlotte*

valuable account of his studio technique. Humphry boarded with the family of musicians, the Linleys, of whom Gainsborough made such celebrated portraits.

In 1764 on the emphatic advice of Sir Joshua Reynolds he left Bath to settle in London; and at first he seems to have taken it amiss that Reynolds did not take a more active part in furthering his career when he arrived. He soon prospered, and began to exhibit with the Society of Artists. In the second year in which he exhibited, 1766, his large miniature of John Mealing, a well-known model who became porter at the St Martin's Lane Academy, excited considerable attention. Humphry, who was not backward in proclaiming his own merits, said that it 'excited universal wonder from its vigour and superiority over all the surrounding examples of his contemporaries'. George III bought it from the exhibition for the large sum of 100 guineas, and it is still in the Royal Library at Windsor Castle, though till recently it was wrongly identified as a portrait of the actor George Frederick Cooke (Plate XVII). This mark of royal favour was followed by commissions for miniatures of Queen Charlotte (Fig. 86) and the Princess Royal. Humphry's account books for the year 1768 show that he painted well over sixty portraits in that year, probably all miniatures, earning over £850 at his standard rate of twelve guineas for a miniature.

In 1769 Ozias Humphry was one of the Directors of the Incorporated Society of

Artists who voted for the expulsion of the dissident artists who had formed the Royal Academy. He did not make his peace with the Royal Academy till 1779, when he became an A.R.A. Indeed in 1770 he is found paying a woman model, who worked both for the Incorporated Society and the Royal Academy, for information on the proceedings of the rival institution.

Meanwhile Humphry had travelled in Italy with Romney, with whom he was closely acquainted. He had had a bad accident while riding in 1771 which seems to have been the origin of the disabilities that eventually led him to abandon miniature painting. When he left for Italy in 1773 it was already with the intention of giving up miniatures and concentrating on oil painting. He studied hard to this end but neither as a student nor subsequently on his return to London in 1777 did he impress his contemporaries as being in any way so proficient in the larger scale. His greatest triumph in oils was a posthumous and short-lived one. In 1912 the Huntington Art Gallery bought a picture of the ladies Waldegrave as a Romney for the sum of £20,000. Doubts arose on its authenticity, and in the course of a lawsuit it was established that the picture was in fact by Ozias Humphry.

After his return from Italy Humphry did not keep to his resolve to work in oils only. Finding that he was not making as much money as he wished, he decided in 1784 to go to India, encouraged by the reports of the fortune Tilly Kettle had made there. Humphry's concern at the prospect of Smart's being in India at the same time as himself has already been illustrated. He was as nearly engaged to Miss Boydell, niece of Alderman Boydell, as was possible without a formal undertaking, and it was by means of her portrait that he hoped to hinder Smart's departure. While he was out in India Miss Boydell broke off the correspondence and returned Humphry's presents; but not before she had received from him an entertaining letter in which he described the ship-load of unmarried women going out to India in the hope of finding husbands there. There is little doubt that Humphry was activated by mercenary considerations in his advances to Miss Boydell, who had expectations, no less than in his voyage to India. In the event both these hopes were disappointed. The climate of India did not agree with him and his failure to get payment for the miniatures he painted at Lucknow of the Nawab of Oudh embittered the rest of his life. He returned to England, a disappointed man, in 1787; his sight permitted him to paint miniatures for only another five years; meanwhile he had taken to pastel portraiture and was appointed portrait painter in crayons to the king. This again was only a temporary alleviation, and in 1797 he virtually gave up his art, though he lived till 1810.

Humphry had been appointed a full Academician (the next miniaturist after Hone, Meyer and Cosway to attain this rank) in 1791. Two years before this election the Academicians had been edified by a spectacular quarrel between Humphry and Cosway. Cosway had taken the chair at an Academy meeting in the President's absence, and Humphry, who was infuriated by this act of presumption, 'under the inspiring influence of Bacchus delivered his sentiments with great warmth and freedom. However, little Dickey very prudently made allowance for the situation of his rival and did not exhibit any other than pacific emotions.'

Phillips told Farington in 1807 how he had heard Humphry 'quizzed in consequence

of boasting of his ancestry' at Petworth. 'He was laughed at and told he was descended from a Jew Pedlar.' But Lord Egremont was generous to the disabled artist, granting him an annuity of £100 per annum in exchange for a painting attributed to Raphael. During the time his eyes were failing he could write and read his own handwriting; and this is one of the causes of the considerable amount of literary material he left behind him. Farington met him, two years before his death, attempting to counteract a weakness of the stomach and an habitual disposition to diarrhoea by wearing six waistcoats. Humphry's ruling passion was strong in death, for by his dying instructions a man was sent to tell West, the President of the Royal Academy, immediately he was dead. 'This arose from Humphry's habitual desire of self-importance and the fear of this event not being properly published.' But much of his frailty can be forgiven him for his friendship to Blake, whom he encouraged at a time when few other artists would.

There is not as a rule the same close resemblance between the miniature painting and large-scale painting of the late eighteenth century as exists between the portraits of Kneller and the miniatures of Bernard Lens and his school. The different demands of the two methods, especially since the introduction of ivory, and the widely ranging creative originality of the period, have dictated quite different approaches to the details of drawing and form. It is true that Reynolds's description of Gainsborough's manner might be taken to give a fair account of Cosway's procedure: 'All those odd scratches and marks ... which ... appear rather the effect of accident than design: this chaos, this uncouth and shapeless appearance, by a kind of magick, at a certain distance assumes form, and all the parts seem to drop into their proper places.' Humphry is also somewhat of an exception, for his miniatures do provide a fairly close small-scale analogy to the temperament and vision of Sir Joshua Reynolds. This is, no doubt, to be traced in part to the encouragement which Reynolds gave to the young man, though it may be noted that Humphry's early acquaintanceship with Gainsborough and his later friendship with Romney did not have any appreciable effect on the style of his miniatures.

Humphry shows his especial affinity with Reynolds in his masculine approach to character and the sturdy grace with which he assesses it, in the easy distinction of his sitters' pose, and in such details as drawing the tip of the nostril with an angular edge. More often than other miniaturists of the time he makes half-length, three-quarter-length or full-length portraits, and in the easy management of the poses in these more ambitious undertakings he shows up the flaccid uncertainty of Cosway's full-length compositions. Indeed Humphry's ambition to be an oil painter is apparent in his miniatures, and shows to better advantage in them than in his oil painting itself; the purpurean depth of his colouring springs from the same ambition.

Two manners are to be distinguished in Humphry's style, the dividing date between them being roughly provided by his visit to Italy in 1773–7, although, as Humphry rarely dated his miniatures, the chronology of them, depending mainly on consideration of costume, cannot be pressed too closely. His early manner springs naturally from the prevailing style of the 1760s in which he was initiated by S. Collins, but throughout the finely fused brush-strokes and small compass are apparent from the first his strength of perception of character and his novel harmony of rich colouring (Fig. 87). The masterpiece of this early phase is the miniature of John Mealing in a

87 Ozias Humphry, *Penelope Carwardine*, 1767

scarlet coat trimmed with fur, bought by George III for the Royal Collection. In his later manner he works with great breadth and freedom, drawing on the ivory with unfused lines as did Meyer and Cosway in their later styles. This manner appears first in Humphry's work in his sketches on ivory for miniatures, or in unfinished miniatures, and it may partly have been his pleasure in the greater freedom of these sketches which led him to adopt the method for his finished work. His failing eyesight, which prevented him attending to close detail, may have been a contributing factor, as may the example of Meyer and Cosway and the general progression of the late eighteenth-century miniaturists to larger ivories and calligraphic treatment. This second phase of Humphry's style is represented in the collections of the Victoria and Albert Museum by his unfinished portrait of Warren Hastings (Fig. 88), and by the portrait of Colonel Carnac, dated 1786, and therefore made in India (Alan Evans Collection). It is also seen in the subject miniature *A Fortune-teller*, which he gave as his Diploma Work on election to the Royal Academy in 1791.

George Engleheart, the last of this group of late eighteenth-century miniaturists of the first rank, began his career some fifteen years later than his chief competitors. He was born in 1750, one of the sons of a German-born plaster modeller, and did not make an unduly rapid start as a miniaturist. Before setting up his own practice in about 1775 he had studied under George Barret, R.A., without displaying any notable qualifications as a painter of landscape in water-colours, and then he was received into the studio of Sir Joshua Reynolds. Reynolds adopted a policy of *laissez-faire* with his pupils, but shortly after he started work on his own Engleheart set himself to copy in

88 Ozias Humphry, *Warren Hastings*

89 George Engleheart, *William Hayley*

miniature a number of Reynolds's works and thus helped to instruct himself in portrait drawing.

Engleheart's fee books from 1775 to 1813 are still in the possession of his family, and have been published by Dr Williamson and H. L. D. Engleheart. Their astonishing record of industry and prolific patronage provides almost the only published incidents in his career for those years, and indeed the miniaturist worked so assiduously that he can have had little time for extraneous adventure. Some relaxation was provided by his visits to William Hayley at Felpham, the Sussex village well known from Blake's biography (Fig. 89). Hayley encouraged his friends to visit him there, and his 'little clan' included Romney, Meyer and Cowper, besides Blake and Engleheart.

In 1813, when the entries in his fee book cease, Engleheart left his town address in Hertford Street to return to the country. Although no longer professionally active he still painted miniatures and small water-colour portraits on paper when he felt inclined, and one of these is known to be dated 1829, the year of his death at the age of seventy-eight.

In the thirty-nine years covered by his fee books, Engleheart painted no less than 4,853 miniatures – an average of 124 a year. His most productive year was 1788, when

90 George Engleheart,
An unknown lady

he accounted for 228 portraits; in that year his prices ranged from eight to ten guineas. It is hardly surprising that some monotony of effect should be found in so vast an output of work; the surprising thing is how high a standard, under these circumstances, he was able to maintain.

Engleheart lingered less long than his compeers in the modest phase of miniature painting, owing to his later start in the century. His works from 1775 till about 1780 qualify for this designation; they are, as we are accustomed to expect, small in size and have a certain naïve uncertainty which compares well with the over-confidence of his middle period. This first phase of Engleheart's style, which might easily be overlooked by anyone who is only familiar with his maturer manner, is well exemplified by some works in the Victoria and Albert Museum, e.g. the portrait of the girl believed to be Miss Eldridge (No. 357 – 1901). From 1780 we tread the more accustomed ground of his middle period. In the twelve years from 1780 till 1791 inclusive he painted 2,172 miniatures; small wonder that this period is a familiar representative of his style (Plate XVIII). The linear massing of the hair, the diagonal grey stroke at the corner of the mouth and the zigzag outlining of the drapery with opaque white are all developed in this phase, as is the idiosyncratic relationship of heavy eyebrows beetling over large deep-blue eyes. Within this period is included a whole *chapeau de paille* phase, in which all the female sitters are crowned with an enormous straw hat poised rakishly on their heads and drawn with evident gusto (Fig. 90). It was a fashionable headdress of the eighties, but with Engleheart it is almost a studio property, not always appropriately used.

Engleheart's third period, from about 1795, is heralded by the more consistent use of larger ivory, about 3 to 3½ inches high. Owing to his later birth, Engleheart entered the nineteenth century in full command of his powers; the change in temper which is to be discerned in these later works of his is therefore first-hand testimony of a change in the national character and not merely to be dismissed, as we might be tempted to dismiss it were the late works of Cosway and Smart our only guide, as the result of a tiredness and old age in the artist. Engleheart produced copious miniatures which show no technical falling off even up to the year of his death, and if the impression we gain from his

miniatures of 1775 to 1800 is that England was a nation of aristocrats, the impression we gain from those after 1800 is that it has become a nation of shopkeepers. This judgment is accentuated by, though not entirely based on, the circumstance that colour suddenly goes out of dress, especially men's dress, and it may also be that, responding to the spirit of the age and the new style of Andrew Robertson, Engleheart painted his sitters in a sense of greater realism, eschewing compliment and setting down plain ugliness of feature when he saw it, which was commonly enough. Whatever the reasons, the year 1800 marks the end of an epoch, and we can trace its dividing line in the chronological survey of Engleheart's portraiture.

Another ominous symptom in Engleheart's later period is his frequent recourse to a rectangular format in place of an oval one. There are sporadic examples of rectangular portrait miniatures from Hilliard's time onwards, but not till after 1800 did they become common, under Robertson's stimulus, and Engleheart probably helped to give them vogue. This change was more disastrous than might at first sight appear. The primary *raison d'être* of the portrait miniature had been that it was possible to wear it on the person. The increase in size of oval miniatures toward the end of the eighteenth century was a step toward the abandonment of this position. When the miniature became a rectangular portrait boxed up in a leather-covered case with plush lining, even the pretence of portability was discarded and it became a small portrait to stand publicly on the sideboard, not different in kind from the oil paintings on the wall or water-colour portrait drawings. It lost in intimacy accordingly, and was helpless to defend itself against the photograph which, a glazed rectangular portrait, stands in its position on the desk today.

The flowering of the late eighteenth-century school of miniaturists in England coincided with a corresponding peak of achievement in Europe. It was initiated from Scandinavia, where Alexander Cooper had helped to implant the seeds of a continuing interest. These culminated in the careers of Niclas Lafrensen or Lavrience (1737–1807) and Pierre Adolf Hall (1739–93), both Swedes who worked largely in France, and the Dane Cornelius Høyer (1741–1804) who worked in France, Germany, Russia and Sweden. They were followed by two artists trained at Nancy by painters to King Stanislas of Poland, Jean-Baptiste-Jacques Augustin (1759–1832) and Jean-Baptiste Isabey (1767–1855), who dominated French miniature painting during and after the Napoleonic age. Continental critics prefer the miniatures of Hall and Fragonard to those of Meyer and Cosway because they made considerable use of gouache applied in broad impasto instead of finely hatched transparent strokes of water-colour. Later, the Continental miniaturists responded to the austerity introduced by David and his followers into large-scale portraiture during the Revolutionary period.

Any debate about relative worth between the advocates of these two schools ultimately resolves itself into a question of national temperament. The French masters delighted in the counterpoint between broad areas of brilliant opaque colour and the ivory ground which they had inherited from Rosalba, who was a pastellist as well as a miniaturist. The English preferred to treat the ivory as a light shining behind transparent hatches and washes, and cultivated the linear rhythms which are equally apparent in the contemporary water-colour drawings of this elegant age.

Chapter 15

The lesser miniaturists, 1760–1800

The marathon exploits of George Engleheart serve to bring into prominence one especially remarkable feature of the late eighteenth century – the great quantity of miniature portraits which were then demanded, compared with the numbers in any preceding period. Not only were the acknowledged masters kept fully occupied – we have noted that Crosse painted over one hundred in a year, Humphry sixty and Engleheart once as many as 228, and these artists were working at the same time. A considerable number of lesser but, none the less, excellent artists were tempted into the field of miniature painting and many of them were almost equally prolific, and found adequate financial reward in practising their craft. This chapter gives a brief description of some three dozen miniaturists who worked between 1760 and the end of the century, and many more whose works are known have been omitted.

The evidences of a greatly increased demand for miniatures at this time are entirely genuine; for a miniature, unlike a historical painting which may be painted in hopeful expectation, and again unlike the drawings which may fill an unsuccessful artist's studio, is useless, and will not come into existence, unless it had been commissioned. The growth in population and in wealth had something to do with it – the population of England is said to have grown from about 5½ millions in 1700 to 9 millions in 1800. This virtual doubling of the people evidently more than doubled the number with the means and the social pretensions to desire portraits of themselves or their nearest relations. The emergence of public exhibitions taught this receptive public what they might buy, and recommended the artists who would suit them. The increased artistic sensitivity of the later eighteenth century, observable in its furniture and its houses no less than in its water-colours and its portraits, is again instanced by this parallel social phenomenon of the endemic portrait miniature. Jane Austen portrayed all the inhabitants of Highbury on her 'two inches of ivory', including Harriet Smith, the illegitimate daughter of a tradesman, and a similarly wide range of sitters was painted in miniature by the dozens of late eighteenth-century miniature painters.

Of the minor miniaturists who began their career between 1760 and 1770 it will be sufficient to instance John Bogle, James Nixon and William Grimaldi. John Bogle brings a Scot's vision into London miniature painting. He was born about 1746, and studied in a Glasgow school of drawing. His earliest known dated miniature, of a boy in 1765, is said to have probably been painted in England; but he was working and

91 John Bogle,
The Dutch Governor of Trincomalee, 1780

92 James Nixon, *An unknown youth*

exhibiting in Edinburgh between 1767 and 1770. He worked in London for most of the years between 1770 and 1790 and then returned to Edinburgh where he died in 1803. His miniatures show from first to last a patient deployment of a minute stippling touch, and are quite lacking in any attempt at brisk linear treatment or vivacity of handling. But they have, all the same, a shrewd perceptiveness of character and inconspicuous integrity. He seems usually to have signed his work with a Roman *IB* followed by the date, but sometimes he wrote his name in full. The Victoria and Albert Museum has a number of his miniatures, ranging in date from 1773 to 1797 and of marked uniformity in treatment and in merit (Fig. 91).

James Nixon (born about 1741, died 1812) began to exhibit, with the Incorporated Society of Artists, in 1765, and pursued his active career till 1807. He attained official honours, for he was appointed A.R.A. in 1778, became a limner to the Prince of Wales, and miniature-painter to the Duchess of York in 1792, but these positions did not protect him from the need to seek a pension from the Royal Academy in the last years of his life. A certain number of miniatures are assigned to him because they bear the same signature of a cursive N; unfortunately the miniatures thus identified do not show a uniform style or progression of style, and suggest that Nixon is one of those artists whose works are difficult to identify because they were capable of absorbing other painters' styles, and of working in more than one manner of their own. The earliest of these miniatures is in the Victoria and Albert Museum (Alan Evans Collection); it is dated 1765, the year in which Nixon first exhibited, and has been thought to represent Joseph Farington at the age of eighteen. Nixon, who venerated the Royal Academy, remained on friendly terms with this *éminence gris*, who recorded in his *Diary* for July

93 William Grimaldi, *An officer*, 1793

1799 his painting a miniature of the Duke of Artois in Edinburgh, and his critical opinion of the Scots. A group of miniatures in a small format show a rather scratchy technique with clearly defined vertical brush-strokes on the face and the background. By their side are to be placed a few larger miniatures of impressive power. The details of technique vary, but they agree in conveying much of the force, and the lighting, of an oil painting. In such a manner Nixon painted the actress Mrs Hartley in the character of Elfrida; the original miniature, which was engraved by W. Dickinson in 1780, was included in the exhibition of miniatures at the Burlington Fine Arts Club, 1889. Another good example of Nixon in his spacious manner is the portrait of a boy in the Salting Bequest at the Victoria and Albert Museum (Fig. 92). The calibre of these more ambitious pieces provokes the regret that we do not know more of the artist's work, which would certainly repay reconstruction.

William Grimaldi (1751–1830) was descended from the Grimaldi family of Genoa, and related to the princely house of Monaco. He was born in Shoreditch, and after studying and exhibiting in England he continued his studies, between the years 1777 and 1783, in Paris. This cosmopolitan training, which almost all his British contemporaries avoided, gives to his miniatures a startling esoteric appearance, with their use of opaque white in the hair and on the face, boiling backgrounds and bright red shading in the nostril and eyes (Fig. 93). Although he exhibited at the Free Society of Artists from 1768 to 1770 and at the Incorporated Society of Artists in 1772, nothing is known by him before his journey abroad. Many of his miniatures are copies of oil paintings by the fashionable painters Reynolds, Hoppner, Beechey and so forth. He is sometimes

erroneously referred to as an R.A., and himself used to follow his signature (which he wrote, Continental fashion, in full, around the side of the miniature) with the letters *AR*, meaning Académie Royale, but he was not a member of that institution either. He did, however, hold the titles of miniature and enamel painter to the Duke and Duchess of York and enamel painter to the Prince of Wales. For, as well as being a miniaturist of distinct individuality, he practised the art of enamelling. His enamel copy of Enoch Seeman's portrait of John, Duke of Marlborough, which was exhibited at the Royal Academy in 1806, is now in the Wallace Collection. He recorded its cost: the enamel plate was half-a-guinea; the cost of firing sixteen times was £1 12s. and the price to the purchaser, the Marquis of Blandford, was £52 10s. for the picture and 10 guineas for the frame.

The records of miniaturists who began to exhibit or otherwise attract notice between 1770 and 1780 bring various new talents forward, beside those of Engleheart. These newcomers include Charles Shirreff, Samuel Shelley, J. Saunders, Horace Hone, Edward Miles, Richard Collins, the Irishmen Charles Robertson and George Place, to say nothing of T. Hull, P. J. McMoreland and others.

Charles Shirreff, indeed, who first began to exhibit in 1770, probably came to London in about 1768, and was a student at the Royal Academy Schools in 1769. He came from Edinburgh, but it is not known whether he had instruction from any professional miniaturist there before his visit to London (Bogle was working in Edinburgh at this time). Having enrolled as a student in the Royal Academy's School, he gradually became well known as a miniaturist. Though deaf and dumb he took a keen interest in the stage, for he was able to follow the action of a play through the facial expressions of the actors. This interest led to him executing portraits of Mrs Hartley, Mrs Siddons and Kemble; and more than one of his miniatures showed an actor and actress *en scène*. To judge from an engraving after his representation of Kemble and Mrs Siddons as Tancred and Sigismunda he was more successful in these compositions, in which the features of his subjects were animated, than in his routine miniature portraiture. After working in Bath Shirreff went to India in 1796, in fulfilment of a plan he had made eighteen years before, and stayed there till 1809. On returning to London he exhibited till as late as 1831.

Shirreff's method of execution is notable for the regularity of his criss-cross hatching, both in the modelling of the features and on the background. His portraits are neat but extremely plain; not only does he not flatter, but he sees the uglier side of his sitter's appearance. It must be admitted, however, that we only know a limited range of his work, from about 1785 to 1800, of which the greater proportion, probably, was painted during his stay in India.

When Andrew Robertson was noticed as a rising miniaturist in London in 1801 he was told that Cosway and Shelley were virtually the only rivals he had to emulate. This linking of Shelley's name with Cosway may well seem surprising now, since time has dealt so differently with the two men's reputation. Like those of many late eighteenth-century British artists, Shelley's ambitions were directed towards imaginative figure painting, and a substantial proportion of his Academy exhibits were 'fancy figure subjects'. Seven sketchbooks used by him in the period around the 1780s, in the Victoria

94 Samuel Shelley, *An unknown lady*

and Albert Museum, show the fluency of his ideas for poetical compositions. He chooses his subjects from an immense range of texts, beginning with Homer and Aeschylus, proceeding through Spenser, Shakespeare, Tasso, Collins, Walpole and Sterne, and coming down to such recent literature as Goethe, in the last interview between Werther and Charlotte. He worked out many of these ideas in miniature form, either a vertical or horizontal oval; his ivory of *Macbeth Saluted by the Witches*, exhibited at the Royal Academy in 1782 and now in the Victoria and Albert Museum, is an example. At other times he embodied his concepts in such water-colours as *Memory Gathering the Flowers Mowed Down by Time* in the Victoria and Albert Museum. It was his feeling that such works were unfairly overshadowed by oil paintings at the Academy's exhibitions which prompted him to become one of the founders of the 'Old' Water Colour Society in 1804.

Shelley is first heard of as the winner of a premium from the Society of Arts in 1770, but he did not begin to exhibit until 1773. As a portrait miniaturist he is of high rank. He uses a yellowish-green flesh tint peculiar to himself, and follows assiduously the fashionable practice of enlarging the pupil of the eye. He adds something of the force of oil painting to his miniatures by using a quantity of gum with his water-colour pigments, thus increasing their depth and glossiness (Fig. 94). The collection of Mr Bernard Falk, which is at present on loan to the Fitzwilliam Museum, contains numerous examples from which the variations of his style can well be studied.

The name of Joseph Saunders has been enrolled in the list of noteworthy late

eighteenth-century miniaturists only within the last fifty years. Before then he was known just as a name in the catalogues of exhibitions and by one miniature – his portrait of Beechey in the Victoria and Albert Museum. Since then several miniatures signed IS have come to light, and the quality of one alone is sufficient to place him high in the ranks of the lesser-known artists and to arouse curiosity about the remainder of his work (Fig. 95). Unfortunately the signed works do not tell a completely consistent story, other than that Saunders was a versatile artist whose style varied within wide limits. It is tempting to attribute to him many of the nameless portraits of women marked by a prettiness of the degree of this one, and many such miniatures are to be found among the vast number of late eighteenth-century portraits. Our knowledge of his work is still too fragmentary to justify a wholesale consignment of unclaimed goods at his door; but the few known miniatures are so capable that it is strange to find no contemporary opinion on them and almost no biographical framework. Joseph Saunders of London exhibited miniatures and mezzotints at the Free and the Incorporated Societies of Artists between 1772 and 1776, miniatures at the Royal Academy between 1778 and 1800 and again at the British Institution in 1808. He has been confused with one John Sanders, was was born in 1750 and died in 1825.

Horace Hone was the son of Nathaniel Hone, and commenced miniature painting at about the time his father was confining himself to oil portraits. He began to exhibit at the Royal Academy in 1772, at the age of eighteen, and from that time painted many miniatures in water-colour and some (but considerably fewer, to judge from the frequency of their appearance now) in enamels. In 1782 he returned to Dublin, his father's birthplace, and practised successfully there for nearly twenty years. The union of England and Ireland in 1800 reduced his practice, as many of his sitters came to London, and Horace Hone accordingly returned there himself in 1804. He continued to exhibit at the Royal Academy until 1822, and died in 1825. Farington's *Diary*, which has already been quoted on the subject of the father's and the son's habit of praising their own works, reveals also that after his return to London Horace Hone suffered from a sense of professional disappointment. Horace Hone is one of those late eighteenth-century miniaturists, like Nixon and Shelley, whose works emulate the rich colouring and the force of oil painting. They are free-and-easy, somewhat loose in drawing and give the impression of a lackadaisical, hit-or-miss temperament (Fig. 96).

George III declared, attacking both the Prince of Wales and Cosway, that there were no fops among his miniaturists. It is easier to credit this statement than to understand precisely the system under which artists were allocated the title of Miniature Painter, or Enamel Painter, to the king. On Meyer's death in 1789 these offices were divided. That of Miniature Painter to the king was assigned to Robert Bowyer, who hardly seems in the few works known to be by him to have deserved his high contemporary reputation in some quarters, though not with George III. 'Bowyer! Who is Bowyer? He is no painter! I never heard of him', said the king on learning of his appointment. Richard Crosse at the same time became Miniature Painter in Enamel to the king; and Richard Collins appears to have acquired the same title in the same year. Whereas Crosse is recorded to have painted only one portrait of George III, Engleheart is said to have painted the king twenty-five times.

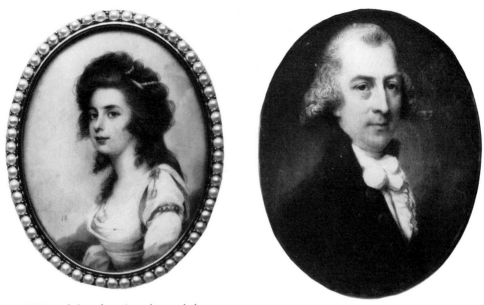

95 Joseph Saunders, *An unknown lady*

96 Horace Hone, *An unknown man*, 1787

Richard Collins, who began to exhibit at the Royal Academy in 1777, was a pupil of Meyer and of Ozias Humphry. The latter, with whom he lodged from time to time, left a manuscript memoir of his friend which is the main source of our information about the earlier part of his career. In particular, Humphry records the circumstances of Collins' appointment as Enamel Painter to the king. Collins had, just before George III's derangement in 1789, lost his wife, and his inexpressible grief had so impressed itself upon the king that soon after his recovery he asked who had been appointed his miniature painter in place of Meyer, and expressed his desire that Collins should have the post. It was explained to him that Bowyer and Crosse had been appointed, but evidently His Majesty was able to circumvent those appointments. Humphry says that from 1788 till 1791 Collins painted only portraits of the royal family, but thereafter took up his public practice again. There are versions of Collins' portraits of George III and Queen Charlotte in the Royal Library, Windsor Castle; each is copied from Gainsborough's portraits of 1781. He was a competent craftsman, whose style was minute and precise with a *sfumato* effect, and again with an aspiration toward the glossy tones of oil painting.

Edward Miles, who began to exhibit at the Royal Academy at the age of twenty-three in 1775, is also notable for his connection with the court. Although he had no higher-sounding title than Miniature Painter to the Duchess of York, and later to Queen Charlotte, his excellent miniature portraits of members of the royal family (Fig. 97) are found not only at Windsor Castle but in the Queen of the Netherlands' Collection, and are therefore seen to have had official sponsorship. All his work is stylish and elegant

with a certain voluptuous exuberance, and his habit of accentuating the mouth in a sculptural fashion suggests that he modelled his drawing on that of Meyer, of whom indeed he was no unworthy follower. He left England in 1797, spending about ten years in Russia at the court of the Czar, and then settling in Philadelphia, where he died in 1828. Apparently he had made sufficient money to retire from the active practice of miniature painting in America, for it is said that while there he painted only portraits of his friends, and gave a few lessons to selected pupils.

Dublin continued to provide a field for Irish-born miniaturists, some of whom came temporarily or permanently to work in London. The best of the late eighteenth-century Irish miniaturists was Charles Robertson, who was born in Dublin about 1760. His juvenile performances were in the unpromising medium of 'designs and likenesses in hair', but from 1775 till 1821, the year of his death, he exhibited miniatures properly so called. Apart from a visit of eight years to London from 1785 till 1792, and again in 1806, he worked in Dublin. His miniatures are distinctive in colour through the slaty grey-blue of the flesh tones, and attract attention to their technique through the sensitively controlled delicacy of the soft and minute strokes of the brush (Fig. 98). It may be that Charles Robertson's elder brother, Walter Robertson, should share the fame of his serious and refined portraiture, but few miniatures known to have been painted by him in England or Ireland have yet come to light. Walter Robertson, after going bankrupt in Dublin in 1792, went the next year with Gilbert Stuart to America, where he painted a miniature of George Washington. Although he worked there for less than three years before leaving for India, some miniatures by him have been identified in American collections which give him a high place among the miniaturists working in that land and show a close affinity with his brother's style.

George Place, S. T. Roch(e) and Adam Buck all began their careers as miniaturists in Ireland before 1780. Place, who worked in London in the 1790s, has at his best a force of drawing which anticipates Comerford. Sampson Towgood Roche (he also spelt his name Roch) is another of the deaf and dumb to have found a vocation in miniature painting. His earliest known miniature is dated 1779, and he worked for a time in Dublin, but left for Bath in 1792 and settled there for thirty years. Here he found ample patronage for his unpretentious portraits of sitters who generally have an incipient smile curling the corners of their mouths.

Adam Buck is associated in most people's minds with the figure drawings which he supplied for popular sentimental subjects with such titles as *Archness* and *I have Learnt my Book, Mamma*. These were the fruits of his English career in the first decade of the nineteenth century; but twenty years before this he was working in Cork, his native city, as a portrait miniaturist. After he settled in London in 1795 he continued to paint miniatures, as well as full-length portrait drawings of larger format. He is seen at his inconsiderable best in the self-portrait in the Victoria and Albert Museum; but he excelled his younger brother Frederick Buck, who spent his whole career as a miniaturist in Cork. The reason for the machine-made appearance of the latter's many portraits of officers with brick-red complexions is given by Mr Strickland in his *Dictionary of Irish Artists*: 'During the Peninsular War, when Cork was a busy port of embarkation of troops, Buck had so many orders for portraits of officers and others

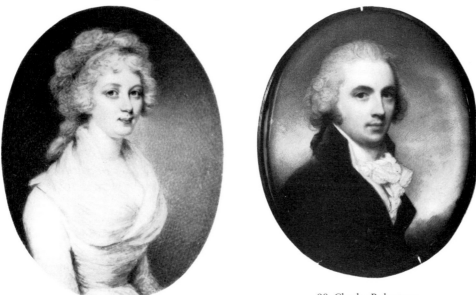

98　Charles Robertson,
Stephen Moore, second Earl Mountchashell

97　Edward Miles, *Princess Charlotte Augusta*

going to the seat of war that he kept a supply of partly painted ivories to which he added the heads and the regimental finerys, etc., when his customers gave him hurried sittings.' Doubtless Fred Buck was not the only miniaturist of the time who hit upon this method of mass-production.

The enamel miniature was continued in the second half of the eighteenth century by Henry Spicer and Johann Heinrich Hurter. Spicer, who worked from 1765 till 1804, was a pupil of Gervase Spencer and at one time a protégé of Ozias Humphry. Hurter, who was born at Schaffhausen, came to England about 1777, when he was over forty; his portraits were usually reduced copies of oil paintings. The craft enjoyed a wider popularity through the career of Henry Bone. He began as a painter on china for Cookworthy at Plymouth; his first essays in portrait miniature on ivory were attractive, as his portrait of his wife, dated 1779, in the Victoria and Albert Museum, demonstrates. Soon after this he began to make the enamel copies of oil paintings which established his fortune and contemporary reputation. He did not confine himself to the portraiture of contemporaries, but made many copies of portraits of historical worthies; he also made copies of famous old master painters. He was elected R.A. in 1811, and this year marks the apogee of his vogue, for he then sold an enamel copy of *Bacchus and Ariadne* after Titian for 2,200 guineas. Such purely reproductive work bears now a diminished glory, and the work of his followers, Henry Pierce Bone, William Essex and the like is equally lacking in originality.

It was however of intense interest for successive generations of the royal family. Henry Bone never wearied of inscribing on the back of his enamel copies the statement

that he was enamel painter to the Prince of Wales. Henry Spicer had been appointed to this title in 1789, and it seems that their tenure of the position was concurrent with that of Grimaldi. Henry Pierce Bone became enamel painter to Queen Victoria. She had a deep love of the miniature portraits of her family, and arranged for William Essex, John Simpson, and other mid-nineteenth-century enamellists to make a large series of copies of miniatures and oil paintings of her ancestors and descendants.

Of the newcomers to miniature painting during the 1780s, John Barry is the first to attract our attention. He exhibited at the Royal Academy from 1784 till 1827, and achieved a consistently high level of portraiture, although his work is not yet well known. He always fell into the mannerism of drawing the upper contour of the eyebrow with a pronounced angle, and this, no less than the soft grey shadowing of the features and the sometimes meaningless massing of the hair as though it were wisps of cotton-wool, facilitates the identification of his miniatures (Fig. 99).

Andrew Plimer first exhibited at the Royal Academy in 1786. The story goes that, having spent two years with a band of gipsies, he became a servant to Cosway in 1781, and took advantage of this circumstance to learn the art of miniature painting. Andrew Plimer's miniatures are plentiful and he had an aristocratic clientèle; they are easily recognised, and a place has been claimed for him beside the five great miniaturists of the late eighteenth century, Crosse, Cosway, Meyer, Smart and Engleheart, but dispassionate consideration will not bear out this rating. Andrew Plimer's earlier works, of the years between 1785 and 1789, when he signed his miniatures on the front *AP* and added the date, have a certain charm but are hesitant in attack. Thereafter he developed the manner by which he is generally known, working in a larger format with a specious elegance. He gives all his sitters a large, long nose, wide-open eyes and a gipsy complexion (Fig. 100), and, as he was not good at catching a likeness, all his portraits, of women especially, look very much the same. Fakers have paid him the compliment of imitating his style more often than that of any other miniaturist, and indeed it is a style which lends itself to imitation. The genuine works of Andrew Plimer can be distinguished by the thin cross-hatching in the background to left and right of the sitter, and by the thin strokes in and across the hair. When the collection of miniatures in the Huntington Art Gallery was being formed as a parallel in little to the grand assemblage of oils by Reynolds and Gainsborough, Plimer was accorded equal status with Cosway in the acquisitions. Even though there was some uncertainty over the attributions, some two dozen works are there to attest to the high regard in which he was then held. Among them is his most celebrated piece, *The Three Graces*, a group portrait of the three daughters of Lord Northwick, showing them at three-quarter length (Fig. 101). Andrew Plimer's brother Nathaniel is said to have shared his experiences with the gipsies and as a servant to Cosway. The miniatures he painted before 1790 closely resemble the early work of his brother, but he did not so completely forsake this manner and in his later portraits he made use of stipple far more than line.

Henry Edridge, A.R.A. (1768–1821), was a more honest and skilful craftsman than these brothers. He began to exhibit miniatures at the Royal Academy in 1786, but after 1800 the bulk of his output in portraiture took the form of full-length pencil drawings on paper, with the face finished in water-colour. In his miniatures Edridge shows him-

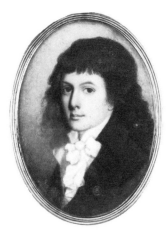

99 John Barry, *William Linley*

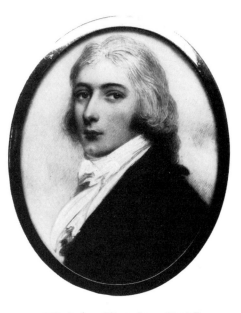

100 Andrew Plimer, *James Daniell*

self a bold modeller and acute observer of his sitters; his miniature of Thomas Girtin in the possession of his descendants is a case in point. He emphasises his sitters' eyes by giving a pronounced shadow to the socket under the eyebrows (Fig. 102). He was a skilful painter of landscapes in water-colour, adding a picturesque note to the style of his early mentor Thomas Hearne. He also gave play to his fondness for landscape in the backgrounds of his full-length portraits, in which he produced the nearest equivalent in British art to the portrait drawings of Ingres.

Philip Jean (1755–1802) was born in Jersey and, after serving under Rodney in the navy, had begun to paint miniatures some years before he first exhibited at the Royal Academy in 1787. He was praised by his contemporaries, and did make a number of pleasant portraits in an unkempt manner of drawing which was flowing and accurate despite its looseness. The actual details of his handling vary widely between piece and piece, which makes it hard to identify his unsigned works. Amongst his most interesting achievements was a group of eleven portraits of the family of Jonathan Tyers, who owned the pleasure gardens at Vauxhall. These are mostly dated in 1787 or 1788, and are now dispersed. Two are in the Starr Collection in the Nelson Atkins Museum, Kansas City (Fig. 103); one in the Fitzwilliam Museum, and another in the Fondation Custodia, Paris.

Until recently a batch of miniatures with easily recognisable characteristics – broad lighting, smooth modelling, smutty eyes, and gummed water-colour – were assigned to Abraham Daniel, or 'Daniel of Bath' as synonymous artists. The matter has been complicated by the discovery that Abraham had a brother Joseph, who also practised in Bath, and that Abraham was in fact more employed in Plymouth, where there was a

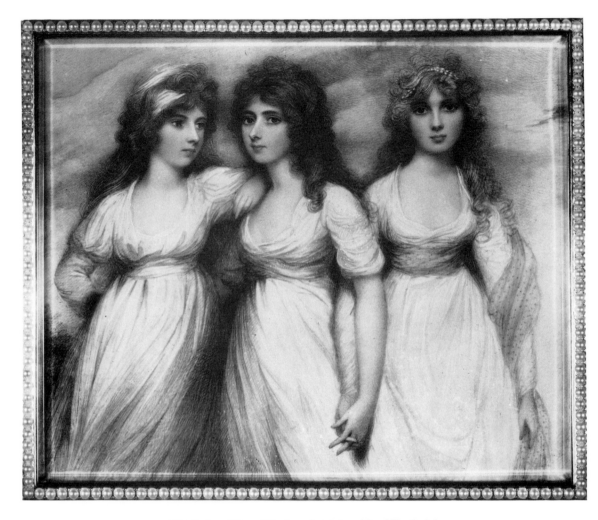

101 Andrew Plimer, *The three daughters of Lord Northwick*

sufficiently large Jewish community for him to become a benefactor of the Synagogue. The signatures which appear on some works of this group have not so far given much assistance in distinguishing between the two rival brothers. Joseph Daniel died in Bath aged forty-three in 1803; Abraham Daniel in Plymouth in 1806 at an undisclosed age.

Few miniaturists even attempted to imitate the peculiar elisions of Cosway's style, but William Wood (1769–1810) is one who did so with considerable success. More is known of Wood than most of his contemporaries, since his manuscript list of sitters has been preserved and is now in the Library of the Victoria and Albert Museum. From this we learn that Wood painted 1,211 miniatures from 1790 till 1808, an average of over

103 Philip Jean, *Miss Tyers*

102 Henry Edridge,
A man, perhaps Sir George Armyard

sixty a year. As he was in no more favourable position than many of his competitors, these figures are another index of the extraordinary bulk of miniature paintings in this period. Wood's journal is of unique value for the study of the late eighteenth-century miniaturists' technique. He notes the sizes of his ivories and their preparation, and the pigments he uses, with comments about their durability. In some entries he has inserted a tracing, which can now help to identify his sitters. He also records his practice of 'breathing' on his miniatures to make his colours flow into one another more smoothly. It was no novelty for him to have to repaint a coiffure which had gone out of fashion, to alter a uniform to provide for an officer's promotion, and so forth. Wood's interpretation of the Cosway manner is a recognisable and individual one, charac-terised by bold dotting in the background and on the face and by the ruddy complexion which he often gives to his sitters (Fig. 104). He had a deeper and more signified concep-tion of character than another follower of Cosway's, Mrs Mee.

Mrs Mee, *née* Foldsone, began to paint miniatures while still in her teens in 1788. Her earlier works, generally head and bust portraits in the usual oval form, are not without charm for all their aping of Cosway's large eyes and simpering expressions. In later years, when she had an established following among people of fashion, her mannerisms became more emphatic. The main monument of this later style of hers is the series she called the 'Gallery of the Beauties of George III' which she painted at the request of the Prince Regent and which are at Windsor Castle. This remarkable series provides a Regency parallel to Lely's 'Beauties of Hampton Court'. It portrays on large sheets of ivory seventeen of the ladies whom the Prince Regent admired. Lady Abdy, who

104 William Wood, *Lieut. Gother Mann*, 1797

appears twice, is shown as a Bacchante (Fig. 105), and the tempestuous brushwork and boiling colour emphasise the sensuality of the presentations.

The early miniatures of George Chinnery suggest that he too caught the inspiration of Cosway's manner, but his style varies too widely to permit of safe generalisation. This versatile artist, who had a genius above the standard level of his day, led an unsettled life. He was born in London in 1774 and first exhibited, at the Royal Academy, in 1791. About 1794 he went to Dublin and stayed there for eight years. In 1802 he left for India and was the last considerable English artist to settle there. Here he stayed for twenty-four years, painting oil portraits, landscapes and miniatures, and making drawings of rare calligraphic power. In 1825 he moved again to escape his debts and his wife, and settled finally at Macao, where he died in 1852. Miniature painting forms a relatively small part of the total production of this flamboyant and eccentric character, which has been more deeply studied in the oil portraits, street scenes, landscape drawings and pencil sketches which he produced in great profusion to the end of his long life. But he retained his enthusiasm for this branch of the art (Fig. 106), and expounded his method of working and his theories in a long correspondence with his pupil, the amateur Mrs Maria Browne, during the years 1811 till 1821, when they were in Calcutta. This was supplemented by a manuscript treatise on miniature painting partly written by him and partly completed from his instruction by Mrs Browne. He seems to have left off painting miniatures before he settled in China, where

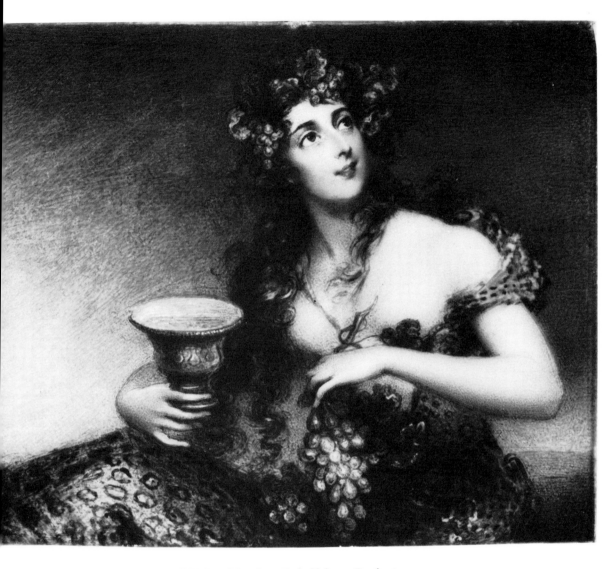

105 Anne Mee, *Anne, Lady Abdy as a Bacchante*

his oil paintings led to the establishment of the school of native painters led by his one-time assistant Lamqua.

While Chinnery was in Ireland he met John Comerford (*c.* 1770–1832), who was only slightly older than himself; and it was probably his example and encouragement which induced Comerford to abandon oil painting for miniatures and small portrait drawings. In this sphere Comerford became the most notable of the later Irish-born artists, and the rest of his career, which he pursued in Dublin, was a successful one

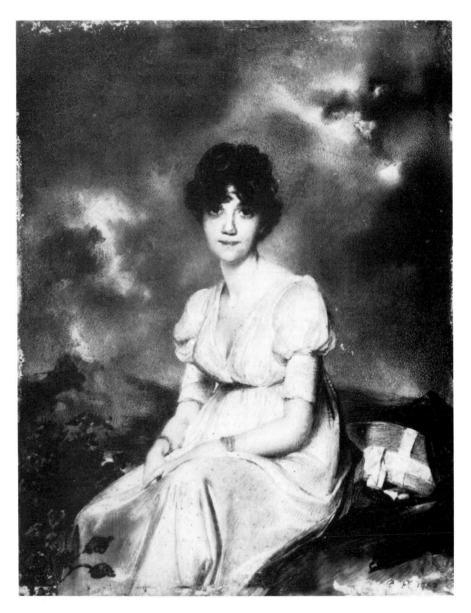

106 George Chinnery, *Mrs Robert Sherson*, 1803

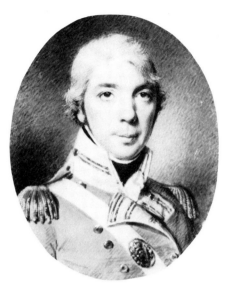

107 John Comerford, *An officer*

(Fig. 107). In their use of gum and moist-looking lights Comerford's miniatures have the appearance of small oil paintings, and he was adept at extracting the utmost of interest from the features of what were at first sight unprepossessing old men.

The Scottish miniaturists did not enjoy the same degree of talent as the Irishmen, but Alexander Gallaway, who worked between 1794 and 1812 in Glasgow and Edinburgh, made honest, rather naive miniatures in his minute technique of stippling. A linear descent may be traced from Bogle's work to his, whereas that of John Caldwell is even more unaccommodating in character.

J. T. Barber Beaumont is the only talented miniaturist to have become an insurance magnate. He was born as plain John Thomas Barber in 1774 and began to paint miniatures in 1794. He soon became a miniature painter to members of the royal family; but in 1806 he 'drifted into insurance', as he put it, founding the Provident Institution and subsequently the County Fire Office and the Provident Life Insurance Company. Amongst other enterprises which have survived to the present day are his foundation of the Duke of Cumberland's Sharp Shooters, now part of the Greenjacket Brigade, and of the Beaumont Institute, now the Queen Mary College. About 1820 he took the additional name of Beaumont to mark his claim of connection with the family of which Sir George Beaumont was head. It can only be presumed that his business responsibilities left him little leisure for miniature painting, and the transference of energy is the more regrettable since he had shown himself the possessor of a keen, frank eye, firm drawing and an energetic technique (Fig. 108).

Miniature painting in England in the last decade of the eighteenth century was diversified by the arrival from abroad of a number of foreign miniaturists who had already formed their styles in their native countries. The French Revolution was the

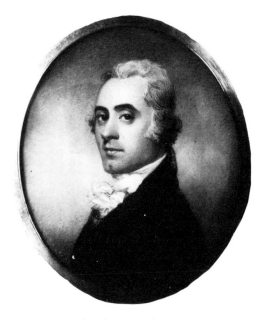

108 John Thomas Barber Beaumont,
An unknown man, 1797

main cause of this influx. J. L. Mosnier, whose brilliant style is represented in the
Victoria and Albert Museum by a work of his French period, was one of the first French
artists to emigrate to this country after the Revolution; he came in 1791, the year after
Violet, and went to Russia at about the end of 1796, shortly before Edward Miles
travelled there. Louis Ami Arlaud, the grand nephew of Jacques Antoine Arlaud whose
brief visit to England has been described in Chapter 10, came from Geneva to England
in 1792 and stayed here ten years before returning to his native city. François Ferrière
also left Geneva for England after the Revolution. The works of this Swiss-born painter
are unusual in that they are often executed in oil on ivory, and they generally have the
opaque background usual in Continental miniatures but almost never seen in the work
of English artists. When Ferrière left England in 1804 he too went to St Petersburg – the
frequency of this migration shows that miniature painting even in those revolutionary
times continued to find support in the courts of monarchies. Shortly after the close of
the century, in 1802 or 1803, J. F. M. Hüet-Villiers, a son of the painter, J. B. Huet, came
to England and remained till his death in 1813. He had imbibed more of the Directoire
style of portraiture, and the miniatures he painted in England accordingly are cast in a
more classical mode than those of our own artists. An *émigré* from a more unusual
source was W. J. Thomson, who was born in Georgia, and whose father brought him
to England after losing his post through the American Revolution. He exhibited at the
Royal Academy from 1795, and in 1812 went to Edinburgh, where he was conspicuous
in official posts in the artistic life of Scotland. His solemn manly style raises his work
above the general run of early nineteenth-century painting.

The founders of the American school had been influenced by English miniature painting, and when artists established here travelled to the United States they found a receptive climate. John Hazlitt, the brother of the essayist, was taken to America in 1783 and worked as a miniature painter on the East Coast before returning to London four years later. Though much of his work lay in copying, his *ad vivum* miniatures are distinctively lit, giving them a direct and searching expression. Edward Miles has already been discussed as an early eighteenth-century immigrant, as were Alexander and Archibald Robertson, elder brothers of Andrew Robertson, whose prominence in London is described in the next chapter. In a later generation George Lethbridge Saunders (1807–1863) worked in Richmond, Virginia, and other American centres.

The nineteenth century

The beginning of the nineteenth century marks within a year the origin of the next and concluding phase in the mainstream of English miniature painting, for on 2 June 1801 Andrew Robertson arrived in London, and consciously developed a 'new style' which eventually carried all before it.

Andrew Robertson was born in Aberdeen in 1777 and had been intended for the medical profession; he took his M.A. degree at Aberdeen in 1794, but had already been compelled by family necessities to work at art for a living. When he was about sixteen he met Raeburn, who encouraged him and allowed him to copy some of his portraits. The impress of Raeburn's manner, his bland lighting and squareness of modelling, remained in Robertson's mind for ever after.

When he arrived in London, Andrew Robertson had already painted many miniatures in the provincial centres of Scotland. He had soon made a large miniature copy, measuring 8 inches by 7 inches, of Van Dyck's portrait of Cornelius van der Geest, which is now in the National Gallery, reduced in size since its cleaning, but was at that time still in the Angerstein Collection and catalogued as a portrait of Govartius. This copy proved a powerful advertisement for the new manner he wished to propagate. Shee, the future P.R.A.,

> declared the want of a good Miniature painter in London, to paint in sterling style, founded upon the Great Masters' works . . . Cosway and Shelley he allowed had their merit but a person is wanted, he says, to paint large miniatures in the style of that picture of Govartius.

West, Cosway, Smart and Humphry saw this copy and were all astonished to hear that it was in water-colours, as they had taken the medium for oils. Even if there were no extant works of Andrew Robertson from which to judge, his own letters show the nature of the revolution in which he was engaged. Just as the water-colour painters of the same decade had resolved to emulate the colour and depth of oil painting, so Robertson wanted to imitate those qualities of oils in his miniatures. Hence his choice of rich colours, gummed and even varnished, and his preference for the large rectangular ivory. At one time he intended to make a series of copies of Old Masters, similar to Bone's enamels, but fortunately he changed this course for that of miniature portraiture from the life.

His outlook necessitated a certain lack of sympathy with the prevailing fashions of

miniature painting. Of Cosway's miniatures he said in 1802, 'they are pretty things, but not pictures. No nature, colouring or force.' At the same time he observed and endorsed the movement towards the larger, rectangular format for miniature portraits apparent in George Engleheart's later work, writing of the Academy in 1803: 'Oval miniatures [are], at best, but *toys*: I should like to aspire to paint *pictures*, and in the exhibition this year, oval miniatures have disappeared, as they are not so much worn.'

The two elder brothers of Andrew Robertson, Archibald and Alexander, went to America in the early 1790s, and founded a drawing academy in New York. Before he came to London Andrew had received from Archibald in 1800 a treatise setting out his method of miniature painting. Eight years later, in 1808, Andrew sent a treatise on his methods back to his brother, and a comparison of the two provides interesting data for the development of Andrew's own style. Andrew was evidently a slow and painstaking workman, for he logs a trial portrait, which took him 22½ hours of sittings with the subject, to which were added ten to twelve hours on the background and three on the coat, and some time on experiments – 'a week's hard labour'. He refers to the miniatures of Cosway and his followers as sketches, but says of himself:

> I have not acquired much fame for my colouring, for although perhaps I was among the first miniature painters who endeavoured to explode the pink cheek and lips, and blue beards of the old style, and to introduce truth, warmth and harmony – still my colouring wants delicacy. What has recommended me to the public has been my careful drawing and correct form, upon which depend entirely likeness, expression, sentiment, character, in short the marrow of the picture.

This is an accurate self-appraisal, and later Robertson also succeeded in his aim of becoming a bolder colourist. Besides their evident qualities of hard, methodical work and the reflection of Raeburn's type of lighting and Scotchness of vision, Robertson's best miniatures have a humanity and geniality which would hardly be expected from his systematic and determined self-awareness. His high degree of finish and attempt to confuse water-colour with oil painting were well calculated to appeal to early nineteenth-century patronage, but in his hands the end justified the means.

In 1805 Robertson was appointed miniature painter to the Duke of Sussex, and in 1807 he was at Windsor making miniatures of the king's daughters. One of these, showing the Princess Amelia in a blue bonnet and jacket, is one of his early masterpieces. He recorded in his diary that the princess sat in her outdoor dress, concealing her fine hair, because the Duke of Sussex liked that costume. 'She is quite indifferent about her looks. She cannot be unconscious about her beauty, but no one ever thought less of it.' He was summoned back to Windsor about ten days before her tragically early death in 1810, to make a replica of the original miniature for which George III had a special veneration; and he was called on for other, posthumous copies (Fig. 109). His large rectangular miniature of Chantrey working on his bust of George IV, dated 1831, is also in the Royal Collection.

When Andrew Robertson looked at the miniatures exhibited in the Royal Academy during the later years of his life he was pleased to observe that the best were contributed by his pupils, with the exception of those by his friendly rival A. E. Chalon, and even

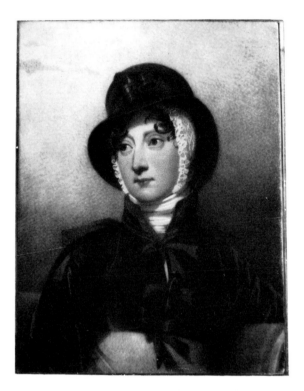

109 Andrew Robertson, *Princess Amelia*

Chalon admitted to having been influenced by the head of Coxe which he had shown in 1802. Alfred Edward Chalon was born in Geneva in 1780, and his father brought him to England in 1789, in consequence of the outbreak of the French Revolution. Chalon, whose elder brother J. J. Chalon achieved distinction in oil and water-colour painting, was instructed in miniature painting by his fellow Genevan L. A. Arlaud, who was in London, as we have seen, in the 1790s. Chalon, who became R.A. in 1816, was for a considerable time a fashionable miniaturist and painted many miniatures of the notable figures in late Georgian and early Victorian society. He is said to have lost half his fashionable clientèle toward the middle of the century by indiscreetly asking the Countess of Blessington to pay him the money she owed him for her portrait.

Chalon was devoted to the rectangular portrait miniature on an ivory of fairly large size. There is a Gallic elegance about his soft evanescent washes and a suggestion of drapery fluttering under strong sunlight. Indeed, at times there is a smack of the milliner's assistant about his love of the ribbons and trimmings of early Victorian dress, but he is in that trait also true to his age (Fig. 110).

A comparable movement in style was apparent at about the same time in France, when Jean-Baptiste Isabey abandoned the Republican austerity of his Napoleonic images in favour of the gauze-veiled frivolity of his later portraits. Chalon's genuine

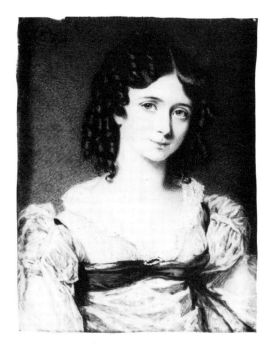

110 Alfred Edward Chalon,
A lady of the Chambers family

sense of fun is to be seen in his admirable and surprising water-colour caricatures of actors and actresses, of which there are a number in the British Museum and the Victoria and Albert Museum. He is the first miniaturist we have so far considered to have lived into the age when the art was menaced by photography. It is recorded that Queen Victoria suggested to him that photography would ruin his profession, and that Chalon replied, 'Ah, non, Madame, photographie can't flattère.' Adequate means were found, however, to make photography sufficiently flattering, and the Queen's prophecy has been abundantly borne out by events.

Sir William Charles Ross, R.A., is the last miniaturist to challenge comparison with the standards of Cooper and Cosway. He was born in 1794 and won a number of prizes from the Society of Arts between the ages of thirteen and twenty-three. In 1807 Andrew Robertson had expressed his intention of taking on an assistant to work on the backgrounds and more mechanical parts of his miniatures as soon as he should have sufficient custom to justify it. In 1814 Ross was employed by Robertson in such a role, and though his preferences, encouraged by the recognition of his talent also in the R.A. schools, would have led him to take up history painting, he decided to continue in the career of a miniaturist. In due course he was recognised as the leading man in this branch of art. He was elected R.A. and knighted in the year 1842. His prolific and successful course was halted by a paralytic stroke in 1857, and he died in 1860. His stature was recognised in a most exceptional way by the Society of Arts, who mounted

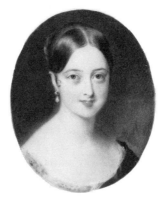

111 Sir William Charles Ross,
Queen Victoria, 1838

a memorial exhibition containing more than two hundred of his miniatures in the year of his death.

Ross was by no means so slow a workman as his master A. Robertson, for he painted more than 2,200 miniatures in his life, but his style is lineally descended from his teacher's. He aimed at a rich Rubenesque flesh tone, vibrating with blues and reds, and his handling is spirited, for all his accuracy of drawing and the large scale on which he often chose to work. Spiritually, his miniatures breathe the *bonhomie* and prettiness found in Victorian portraiture at its best, as in the oil paintings of Winterhalter, and his portraits of notable people emphasise their homely, simple qualities.

Thanks to his broad general grounding in other branches of art Ross possessed, to a degree exceptional among miniaturists, the ability to paint full-length figures on ivory and to compose them into pleasing pictures. These large pieces were a logical extension of the change which had overtaken the miniature, making it less frequently an intimate portrait of portable size and more often the larger rectangle favoured in the nineteenth century. The wish for such bigger portraits, designed more for hanging than for carrying about, was strengthened by the growing vogue for full-length portrait drawings in pencil, or pencil and water-colour, on paper. This requirement was met by a number of artists, such as Henry Edridge, Adam Buck and George Richmond, and many English visitors to Rome were anxious to extend their patronage of the *genre* to Ingres in the first decade of the century.

Ross managed to combine the relatively casual nature of the portrait drawing with the glowing colour and brilliant precision of the portrait miniature. His merits were soon recognised by Queen Victoria, who appointed him as her miniature painter in 1837. His earliest known miniature of her is of 1838 (Fig. 111) and he must have won her heart by the success of his small oval miniature of Prince Albert painted the year before her marriage, in 1839. This was soon followed by the formal but elegant three-quarter portrait of him wearing the star and ribbon of the Garter and other orders, a portrait of state which was painted in 1840 and exhibited at the Royal Academy in

1841. From then on her patronage was unstinted (Plate XIX), and extended beyond her own immediate family to its ramifications on the Continent, the Saxe-Coburgs, the King and Queen of the Belgians and the King and Queen of Portugal. One of the most excellent, which achieves a feeling of intimacy in spite of its size, is his composition showing Ernst and Edward, the young sons of the Queen's half-brother Charles, Prince of Leiningen, teasing her Skye terrier, Islay, by feeding her pet macaw (Royal Library, Windsor Castle; Fig. 112). It was painted in 1839, the same year as Landseer's oil, *Islay and Tilco with a Red Macaw and Two Love Birds*, and shows no less an understanding of animal behaviour. When he is making a more straightforward portrait of a sitter of mature character, as in his full-length of the Baroness Burdett-Coutts (National Portrait Gallery), he gives the impression of providing a good likeness and at the same time showing the sitter at her most amiable.

Queen Victoria formed a large collection of Ross's works at Windsor (Fig. 113), and valued them so much that she had watercolour copies by Faija and enamel copies by W. Essex and J. Simpson made for her other homes. He was as much the leader of miniature painting in the nineteenth century as was Hilliard in the sixteenth century, Cooper in the seventeenth century and Cosway in the eighteenth century.

The change of fashion which had encouraged the success of Robertson and his followers was an internal reaction against the earlier predominance of Cosway, and not prompted by Continental influences. Foreign artists might practise their art here and settle in the country, but they had little influence on the style of painting adopted by English miniaturists or favoured by English patrons. This self-sufficient momentum of the national school prevented it from reflecting any of the realistic portraiture of the school of David, which had a strengthening effect on the miniaturists of France, of Germany and on the Continent generally. After the predominantly courtly style of the foreign schools that concession to realism comes almost with a shock, and certainly brings a much-needed sense of actuality into their early nineteenth-century miniatures. The French artists of that epoch who came to England and were well received here were trained when the austere movement had spent its force. The later style of Isabey is as redolent of courtly flattery as his early style is of republican ruthlessness in the search for truth. The brothers Simon-Jacques and François-Theodore Rochard are the most eminent French miniaturists to visit England for any length of time in the nineteenth century, and their style has the same sunlit charm and disarming flattery as Chalon's. Simon-Jacques, the elder of the two brothers, who was born in 1788 and trained in the school of Isabey and Augustin, came to England with influential introductions in 1816, and was successful for the period of his sojourn, which lasted till 1846 when he went to Brussels (Fig. 114). The younger brother, born in 1798, came to assist his brother in 1820 and worked till 1855; he retired and died in England. The work of both brothers is brilliant, and often difficult to distinguish, since many miniatures are signed 'Rochard' without initials. One of the most effective, ascribed to Simon-Jacques, is the double full-length portrait of Master and Miss Stirling, 1826, in the Victoria and Albert Museum. The pose is easy, the lighting admirable; but in such works the distance between the water-colour portrait drawing and the miniature has been reduced to a minimum, and is indeed confined to the ivory on which the latter is painted. Even the

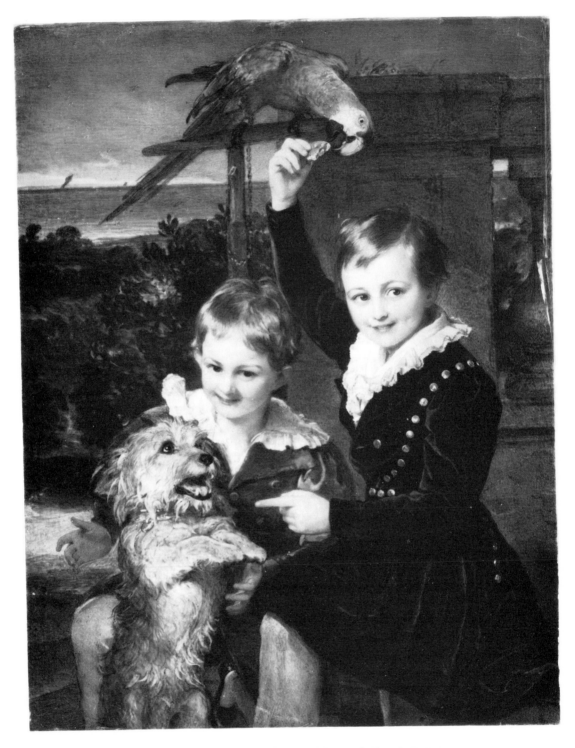

112 Sir William Charles Ross, *The Princes Ernst and Edward of Leiningen*

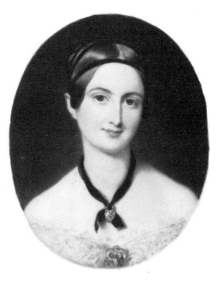

113 Sir William Charles Ross,
The Hon. Margaret Dillon, 1838

heavily moulded gilt frame testifies to the artist's ambition to compete with oil painting on its own level.

Besides Ross, Andrew Robertson had one other pupil who attained eminence – Frederick Cruickshank. He was born in Scotland in 1800 and was presumably Robertson's pupil in about 1820, as he began to exhibit in 1822. As well as acquiring a base in London he would visit country houses to paint miniatures in them. His active career lasted till 1860. In it he showed a closer assimilation of Robertson's manner than that of Ross – possibly a feature of the common nationality of artist and pupil – but he was never a slave of his master's work, and found it fully possible to express his own conception of a sitter's temperament in a style reminiscent of Raeburn. Stories are told about his independence of character; how he would go out of his back door while sitters were waiting their turn, and how he eventually walked out from his family in the same abrupt way. His unfinished miniature of William Ebenezer Pattison (Victoria and Albert Museum; Fig. 115) is a notable amalgam of a realised likeness and a forcefully blocked-in costume and background. Cruickshank's pupil Margaret Gillies (1803–87) echoes his style, though her later study under Ary Scheffer gave it a more austere note. In 1839 at her own earnest request she went to Rydal Mount to paint a double portrait of Wordsworth and his wife Mary. The version which hangs in Dove Cottage is of an almost unbearable homeliness, and confirms Crabb Robinson's comment that Wordsworth had not married Mary for her beauty, and that she must have had a higher motive than his beauty for accepting him.

Of course the 'new style' inaugurated by Andrew Robertson was not the only one in the field in 1800. An able exponent of the more traditional manner was J. C. D. Engleheart, nephew and pupil of George Engleheart. Born in 1784, he began to exhibit at the

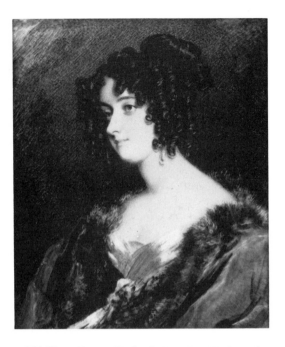

114 Simon-Jacques Rochard, *Georgiana Dashwood*

Royal Academy in 1801. There is some uncertainty in his rendering of the Engleheart manner, and he is at times misled by a desire to construct allegorical and mythical compositions on ivory, for which he was not sufficiently equipped. But his best works are more engaging than his uncle's during the period when they were both at work; although weaker in characterisation, they show a more original and subtler sense of colour than George Engleheart ever possessed. A yet later major exponent of the stipple and the sketchily covered ivory was John Linnell, best known as a landscape painter and friend of William Blake. His miniatures, which all date from the earlier part of his career, from about 1805 to 1827, are not frequently met with, but are marked by the strong, sensitive idiosyncrasy of stippling and the rough surface which have become so admired in the watercolours of his son-in-law Samuel Palmer. Portraiture seems to have been a task he undertook for subsistence although his inclinations were for landscape and imaginative work. Fanny Burney was allowed to attend the sittings which Princess Sophia gave to Linnell for her miniature portrait in 1821 (Fig. 116). Although a replica was required in the following year the artist did not think he had satisfied his client, the Duke of York. He wrote of his portraits of the royal family 'I ventured to make my pictures to look really like them, though as favourable as truth would admit; and I calculate it was on that account I had no more from that connection.' His lack of favour may however have been due to his insisting on collecting the delayed payment for several portraits of Princess Charlotte, for which he was owed £102 10s. His practical acts of friendship toward Blake are undisputed good deeds in a life which attracted

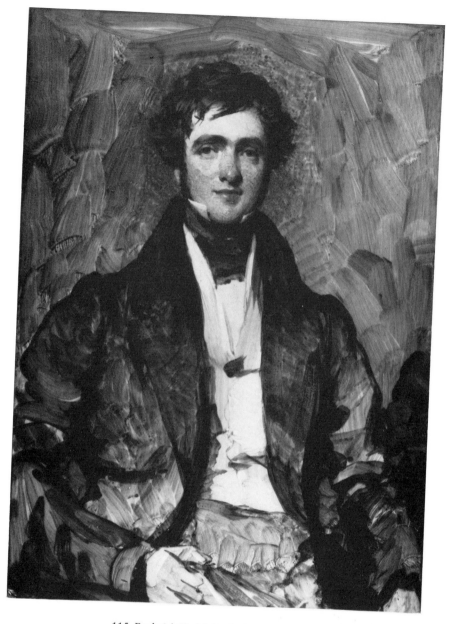

115 Frederick Cruickshank, *William Pattison*

much obloquy, and the excellence of his miniature portrait of Blake in the Fitzwilliam Museum stimulates regret that Linnell was not encouraged to work more in this *genre*, however reluctant he may have been to practise it.

Sir William John Newton (1785–1869) competed with Ross for the fashionable patronage of the first half of the nineteenth century. He had a start of ten years over the man who was to be the more successful rival, and was knighted five years earlier, in 1837, an honour which infuriated Benjamin Robert Haydon. Smarting with indignation at his own lack of recognition he wrote in his diary:

> Yesterday Her Majesty sat to Sir David Wilkie for her state Portrait. Today her Majesty sat to Mr. Hayter. On Friday Her Majesty sat to Pistrucci. On Saturday Her Majesty knighted Mr. Newton, Miniature Painter. On Sunday her Majesty went to Church with Sir Augustus Calcott, the Landscape Painter. On Monday Her Majesty sat to Mr. Tomkins, the Black Chalk drawer. On Tuesday Her Majesty sat to Jenkins the lead pencil outline designer. On Wednesday Her Majesty knighted Smith, Tomkins and Jenkins.

Newton's style was, however, by no means comparable with that of Ross in dash of execution and strength of drawing, and has something about it of the more unpleasing sentiment of the Books of Gems and Keepsakes of the age. He was probably the originator of the elephantiasis which overtook the miniature, for he invented a method of uniting several separate pieces of ivory, and in 1845 painted two works of monster size, each 27 inches by 37 inches, portraying the marriage of Queen Victoria and Prince Albert and the christening of the Prince of Wales.

An entertaining impression of the aspect presented by a minor miniaturist at this time is afforded by Charles Dickens's portrait of Miss La Creevy in *Nicholas Nickleby*, said to have been drawn from his aunt, Mrs Janet Barrow. Miss La Creevy's premises were in the Strand.

> A miniature-painter lived there, for there was a large gilt frame screwed upon the street door, in which were displayed, upon a black velvet ground, two portraits of naval dress coats with faces looking out of them, and telescopes attached – one of a young gentleman in a very vermilion uniform, flourishing a sabre; and one of a literary character with a high forehead, a pen and ink, six books, and a curtain. There was, moreover, a touching representation of a young lady reading a manuscript in an unfathomable forest, and a charming whole-length of a large-headed little boy, sitting on a stool with his legs foreshortened to the size of salt-spoons. Besides these works of art, there were a great many heads of old ladies and gentlemen smirking at each other out of blue and brown skies, and an elegantly-written card of terms with an embossed border.

Later on in the story when Miss La Creevy is painting Kate Nickleby's miniature, she has the

> street-door case brought upstairs in order that she might be the better able to infuse into the counterfeit countenance of Miss Nickleby a bright salmon flesh-tint, which she had originally hit upon while executing the miniature of a young officer therein contained, and which bright salmon flesh-tint was considered by Miss La Creevy's chief friends and patrons to be quite a novelty in art – as indeed it was.

In fact, the portrait by Mrs Barrow of Charles Dickens' brother Frederick, in the

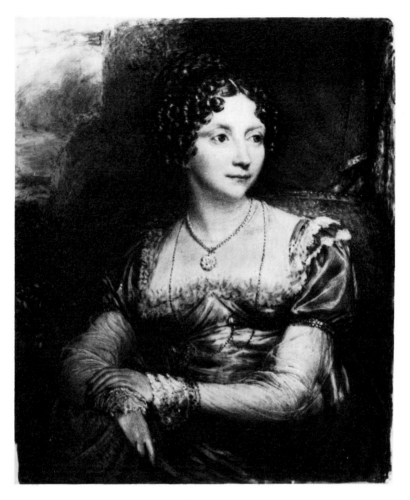

116 John Linnell, *Princess Sophia*, 1821

Victoria and Albert Museum, is notable for its salmon flesh-tint, which supports the identification of Miss La Creevy with that lady.

The Royal Academy had been favourably disposed to the exhibition of the portrait miniature since its foundation. In 1837 over two hundred miniatures were shown in the annual exhibition. In 1870 their number had shrunk to barely more than thirty. This remarkable decline was attributed at the time to the improvement in photography to the stage at which it could, in Alfred Tidey's words, supply what satisfies 'the never ceasing and most cherished feelings of humanity . . . *likeness in little*'. However, Queen Victoria, who had so enjoyed arranging her miniature collection with Prince Albert, remained a firm supporter of the art to the end of her life. In a miniature by Ernest Rinzi, painted in her Diamond Jubilee Year, 1897, she is shown wearing a bracelet round her

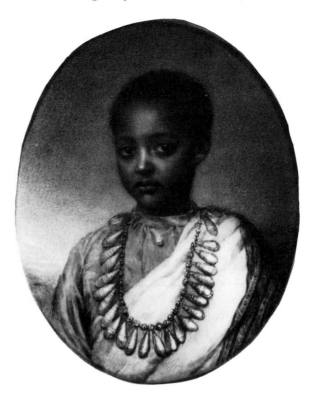

117 Reginald Easton,
Alamayou, son of Theodore, Emperor of Abyssinia

wrist set with a small oval miniature portrait of the Prince Consort. Though Ross was deservedly her favourite miniature painter he had died relatively early in her reign, and she was obliged to turn to other talented exponents. Indeed she had never allowed one artist to monopolise all her custom. One of the earlier portraits of her as the Princess Victoria was painted in 1836 by Henry Collen. He had been a pupil of Sir George Hayter, who had himself practised as a miniature painter as well as pursuing his more conspicuous career as painter in oils to Her Majesty. Hayter was styled miniature painter to the Princess Charlotte and Prince Leopold of Belgium, later King. Collen became miniature painter to Queen Victoria and her mother, the Duchess of Kent; he shared the former title with Newton and with Ross. In the first year of her reign the Queen gave her mother a bracelet with portraits of her nephews Ernst and Edward, Princes of Leiningen, by William Egley. By 1840 she had begun to employ Guglielmo Faija, who was born in Palermo and had studied miniature painting in Paris under F. Millet. Though he was well capable of original work, as his self-portrait shows, the royal patronage was apparently confined to commissioning copies of existing portraits, ranging from Winterhalter to Petitot and Madame de Mirbel. The majority of his works at Windsor are after Ross and are so faithful that they would be deceptive were they not

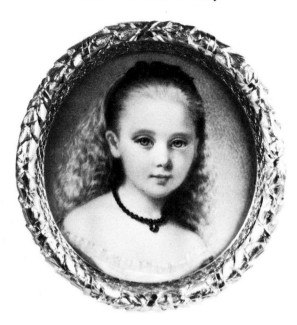

118 Annie Dixon, *Princess Beatrice*

fully inscribed. He was also entrusted with the conservation and repair of the historic miniatures in the Royal Collection.

Amongst the fellow miniaturists whose work Faija was called upon to copy were Reginald Easton and Robert Thorburn. Easton continued to paint miniatures through the period when the art was losing its popularity. His portrait of Alamayou, son of the Emperor of Abyssinia, at Windsor is a notably agreeable example of his style (Fig. 117). Thorburn gave in more readily to the shift in fashion. He had been a star pupil at the Royal Institute of Scotland in Edinburgh and arrived in London around 1836. He made his reputation as a miniaturist by exhibiting a portrait of Queen Victoria in 1846 and at about the same time made an impressive and large full-length composition on ivory of Charlotte, Duchess of Buccleuch, with her son and a cousin, which is in the Buccleuch Collection. But he began to send oil paintings to the Royal Academy in 1858, and eventually forsook miniature painting because the successful competition of photography was ruining him.

Queen Victoria's pleasure in her children is perpetuated in the portraits she commissioned of them, notably in oil by Winterhalter and in miniature by Ross. But in the frame of miniatures of her nine children in the Royal Library, each shown at about the age of four, only eight are by Ross. The ninth, of Princess Beatrice, who was born in 1857, was painted to complete the set by Miss Annie Dixon (1817–1901). The young sitter was not particularly gracious to the artist, and remarked 'I don't like *Paint Bodies*' (Fig. 118). Miss Dixon continued the Ross tradition, exhibiting till 1893, and had sufficient custom to paint over 1,000 miniatures. Recollections of her extended well

into the present century. When Basil Long was compiling his monumental *Dictionary of British Miniaturists* he recorded the reminiscences of a gentleman who recalled her visit to a country house to paint miniatures about 1865, and that she was 'small, dowdy, and dressed in black'.

A different light on the resilience of the miniaturist when under attack from photography is provided by the career of H. C. Heath (1829–98). He was a son of the master engraver Charles Heath, and entered into the existing tradition of miniature painting by becoming an assistant to Robert Thorburn. Then he began to involve himself with photography. Two portraits at Windsor of Victoria, Princess Royal, painted in 1858, the year she became Empress of Germany, are presented as miniatures on ivory but appear to have been painted over a thinly imprinted photograph. Two small ovals of 1860 of Alexandra, Princess of Wales, in the same collection are undisguisedly coloured photographs, and Heath appears to have concentrated on this activity for a number of years. Then in 1872 he resumed the practice of miniature painting. He too received the title of miniature painter to the queen, and in 1894 became one of the original members of the Society of Miniature Painters which, under its current title of the Royal Society of Miniature Painters, Sculptors and Engravers, presides over the present fortunes of the art.

Miniature painting was established in this country through the initiative taken by Henry VIII. Four centuries later his successor on the throne, Queen Victoria, maintained her active interest in and patronage of the *genre*, even though it was in partial eclipse. It is fitting that this survey of its history should close with the artists to whom she turned as the living repositories of the grand tradition.

Select bibliography

The following notes are intended to provide a short guide to further reading, and have been limited in the main to the most recent contributions to the literature on portrait miniatures. These will in their turn provide other and more detailed references for individual artists.

Basil Long's *Dictionary of British Miniaturists*, 1929, although outdated in many ways, is still an essential recourse for its list of collections and meticulous account of the earlier literature.

Daphne Foskett's *A Dictionary of British Miniaturists*, 2 vols., 1972, is the most recent basic work of reference, listing a number of artists not in Long and comprehensively illustrated. The same author's *Collecting Miniatures*, 1979, revises some of the information in the *Dictionary* and has many illustrations of works by minor artists.

The English Miniature, edited by John Murdoch, 1981, is a comprehensive survey of the course of the art with contributions by four hands, with chapters on the sixteenth century by Roy Strong, on the seventeenth century by John Murdoch, on the eighteenth and nineteenth centuries by Patrick Noon, and an analysis of the miniaturists' techniques by Jim Murrell. It is cited as 'Murdoch' in what follows.

T. Holck Colding's *Aspects of Miniature Painting*, 1953, gives a searching analysis of the origins of the art and of its progress in Europe as well as in England.

Amongst recent *catalogues raisonnés* of collections of miniatures may be mentioned those for the Wallace Collection by the present author, 1980, for the Yale Center for British Art (including portrait drawings) by Patrick Noon, 1979, and for the Fitzwilliam Museum by Robert Bayne-Powell, 1985.

WORKS ON INDIVIDUAL ARTISTS

Chapter 1
All the known documents about the Hornebolte family and their visits to England are examined in: Lorne Campbell and Susan Foister, 'Gerard, Lucas and Susanna Horenbout', *Burlington Magazine*, CXXVIII, 1986, pp. 712–27. A reconstruction of the work of Luke Hornebolte is given by Roy Strong, *The English Renaissance Miniature*, 1983, pp. 30–44, 189–90. The most recent examination of Holbein's miniatures is contained in John Rowlands, *Holbein*, 1985, pp. 150–2, 239–40. A different assessment is provided by Strong, *op. cit.*, pp. 46–50.

Chapter 2
Mary Edmond, *Hilliard and Oliver*, 1983, gives a full account of the artist's life based on recent discoveries. It supplements and corrects the standard monograph, by Erna Auerbach, *Nicholas Hilliard*,

1961, which gives a list of works by him. Roy Strong and Jim Murrell, *Artists of the Tudor Court*, 1983, and Roy Strong, *The English Renaissance Miniature*, combine much new material with some unsound judgments. There is a new edition of Nicholas Hilliard's *The Arte of Limning* by R. K. J. Thornton and T. G. S. Cain, 1981. His technique is described by Jim Murrell in *The Waye Howe to Lymne*, 1983.

Chapter 3
Mary Edmond, *Hilliard and Oliver*, puts together Isaac Oliver's biography. A work list is provided by Jill Finsten, *Isaac Oliver*, 2 vols., 1981. See also Strong and Murrell, and Strong, *The English Renaissance Miniature*. The rediscovered *The Entombment* by Isaac and Peter Oliver is fully discussed by Dominique Cordellier, 'La mise au tombeau d'Isaac Oliver au Musée d'Angers', *La Revue du Louvre*, XXXIII, 3, 1983, pp. 178–87.

Chapter 4
For Peter Oliver see Murdoch, pp. 88–95; for Laurence Hilliard see Edmond, *Hilliard and Oliver*. The first draft of Norgate *Miniatura* is edited by Thornton and Cain, *op. cit.*

Chapter 5
Murdoch discusses John Hoskins and his son on pp. 95–104 and gives a proposed list of works for John Hoskins, junior, on p. 217. See also his article ' "Hoskins" and Crosses: Work in Progress', *Burlington Magazine*, CXX, 1978, pp. 284–90. The legal document signed in York by John Hoskins, junior, Samuel and Alexander Cooper in 1658 is published by Mary Edmond, *Burlington Magazine*, CXXVII, 1985, pp. 83–5. A valuable discussion of the miniaturists discussed in Chapters 4–7 and their relation to the large-scale painting of the time is given by Oliver Millar, *The Age of Charles I*, the catalogue of an exhibition at the Tate Gallery, 1972.

Chapter 6
Daphne Foskett, *Samuel Cooper*, 1974, is the most recent monograph; its illustrations are supplemented by the same author's catalogue of the exhibition at the National Portrait Gallery, *Samuel Cooper and his Contemporaries*, 1974. His birth date and places of residence are established by Mary Edmond, 'Limners and Picturemakers', *Walpole Society*, XLVIII, pp. 98–102, which also gives much new information on Hoskins, Gibson and other limners.

Chapter 7
For Alexander Cooper see Görel Cavalli-Björkman, *Svenskt Miniatyrmåleri*, 1981, pp. 18–25; also her 'Alexander Cooper in the National Museum', *National Museum Bulletin*, Stockholm, Vol. 1, 1977, No. 3. For Petitot see Ronald Lightbown, 'Jean Petitot: étude pour une biographie et catalogue de son œuvre', *Genava*, Musée d'Art et d'Histoire, Geneva, XVIII, 1970, pp. 81–103. For David des Granges see Murdoch, pp. 135–9.

Chapter 8
For the Beale circle see E. Walsh and R. Jeffree, 'The Excellent Mrs Mary Beale', the catalogue of an exhibition at the Geffrye Museum and the Towner Art Gallery, Eastbourne, 1975–6. For Flatman, Murdoch, pp. 149–53; for Thach, *ibid.*, pp. 140–2; for Snelling, *ibid.*, pp. 142–7. For Richard Gibson and the problem of the supposed D. Gibson, see Murdoch and Murrell, 'The monogrammist DG: Dwarf Gibson and his Patrons', *Burlington Magazine*, CXXIII, 1981, pp. 282–9; also Murdoch, pp. 129–35. For Mrs Rosse see *Samuel Cooper's Pocket-Book*, Graham Reynolds, 1975.

Chapter 9
For Peter Cross see Murdoch, *Burlington Magazine*, CXX, 1978, pp. 284–90; Mary Edmond, 'Peter Cross, Limner; Died 1724', *Burlington Magazine*, CXXI, 1979, pp. 585–6; Murdoch, pp. 157–62. For N. Dixon, Murdoch, pp. 154–7.

Chapter 10
For Boit and Richter see G. Cavalli-Björkman, *Svenskt Miniatyrmåleri*, 1981, pp. 38–46, 68–9.

Chapters 11–16
For the artists discussed in these chapters see Patrick Noon in Murdoch, pp. 163–209. On Smart, see Daphne Foskett, *John Smart, the Man and his Miniatures*, 1964.

Index

(The main references to miniaturists are given in bold figures. The titles of paintings and limnings, sitters represented in miniatures, etc. are in italic.)